CENNINO D'ANDREA CENNINI

The Craftsman's Handbook

THE ITALIAN "IL LIBRO DELL' ARTE"

TRANSLATED BY DANIEL V. THOMPSON, JR.

DOVER PUBLICATIONS, INC., NEW YORK

Published in Canada by General Publishing Company, Ltd., 30 Lesmill Road, Don Mills, Toronto, Ontario.
Published in the United Kingdom by Constable and Company, Ltd., 10 Orange Street, London WC 2.

This Dover edition, first published in 1954, is an unabridged and unaltered republication of the Thompson translation originally published by Yale University Press in 1933.

Standard Book Number: 486-20054-X
Library of Congress Catalog Card Number: 54-3194

Manufactured in the United States of America
Dover Publications, Inc.
180 Varick Street
New York, N. Y. 10014

TO

EDWARD WALDO FORBES

PREFACE

THE Italian text of the *Libro dell'Arte* has been edited four times.[1] It has been translated twice into English, twice into German, and once into French.

The first translations, Mrs. Merrifield's (1844),[2] and Victor Mottez' (1858),[3] were based upon the (1821) edition of Tambroni.[4] As has been shown,[5] Tambroni's version was incomplete and inaccurate. The manuscript which he edited[6] was an eighteenth-century copy, and its original,[7] our *L*, has since been published. *L*, and another independent manuscript,[8] our *R*, unknown to Tambroni, formed the bases of an improved edition published (1859) by Carlo and Gaetano Milanesi.[9] Three translations were made from this: the first, by Albert Ilg,[10]

[1] Giuseppe Tambroni, *Di Cennino Cennini trattato della pittura, messo in luce la prima volta con annotazioni* (Rome, 1821).

Carlo and Gaetano Milanesi, *Il libro dell'arte o trattato della pittura, di Cennino Cennini da Colle Valdelsa; di nuovo pubblicato con molte correzioni e coll'aggiunta di più capitoli tratti dai codici fiorentini* (Florence, 1859). A considerable extract from this edition appears in Carlo Linzi, *Tecnica della pittura e dei colori . . .* (Milan: Hoepli, 1930).

Renzo Simi, *Cennino Cennini da Colle Valdelsa, Il libro dell'arte. Edizione riveduta e corretta sui codici* (Lanciano: R. Carrabba, 1913).

Daniel V. Thompson, Jr., ed., Cennino d'Andrea Cennini da Colle di Val d'Elsa, *Il Libro dell'Arte* (New Haven: Yale University Press, 1932), I, *Italian Text*. See the Preface of that volume, pp. ix–xiii, for an account of the prior editions of this work.

[2] *A Treatise on Painting, written by Cennino Cennini in the year 1437* [This is an error: see I, Preface, p. ix.]; *and first published in Italian in 1821, with an introduction and notes, by Signor Tambroni: containing practical directions for painting in fresco, secco, oil, and distemper, with the art of gilding and illuminating manuscripts adopted by the old Italian masters. Translated by Mrs.* [Mary Philadelphia] *Merrifield. With an introductory preface, copious notes, and illustrations in outline from celebrated pictures* (London, 1844).

[3] *Le livre de l'art ou traité de la peinture par Cennino Cennini . . . traduit par Victor Mottez* (Paris and Lille, 1858). A later edition (Paris, 1911) was issued to include the chapters first published in 1859 by the Milanesi.

[4] *Cit. supra.* [5] I, Preface, p. x. [6] Rome, Ottobonian MS 2974.

[7] Florence, Biblioteca Mediceo-Laurenziana, MS 23, P. 78.

[8] Florence, Biblioteca Riccardiana, MS 2190. [9] *Cit. supra.*

[10] *Das Buch von der Kunst oder Tractat der Malerei des Cennino Cennini da Colle di Valdelsa. Übersetzt, mit Einleitung, Noten* [most useful ones] *und Register versehen . . .* (Vienna, 1871).

formed the first volume in the Vienna series of "Quellenschriften für Kunstgeschichte und Kunsttechnik des Mittelalters und der Renaissance." The next translator, Lady Christiana J. Herringham (1899),[11] found Ilg's German version "a most valuable book of reference in translating difficult passages."[12] The last translation, that of Willibrord Verkade (1913),[13] preserves the best features of its predecessors, and adds others of its own. I acknowledge freely and gratefully my indebtedness to all. The inadequacy of Tambroni's edition largely vitiates the translations made from it; and faults in the Milanesi's edition are reflected in the translations which it underlies. Though my publication of the Italian text[14] represents no such major improvement as the Milanesi's wrought over Tambroni's, it seems to me a sounder basis for translation than has hitherto been available.

The Milanesi edition rendered obsolete Mrs. Merrifield's translation from Tambroni; and Lady Herringham's *Book of the Art*,[15] incorporating the Milanesi's improvements, became the standard English version of Cennino's work. I venture to criticize it here, not in dispraise of her translation, for it has shown its merit, but rather to justify a new one.

As an example of the disabilities inherited from the Milanesi may be cited the following passage: "Vuole essere la colla più forte di verno che di state; chè di verno il metter di oro vuole essere il tempo umido e piovoso."[16] Lady Herringham recognized that this could not be translated as it stood, for it is nonsense; so she took liberties with it. *Vuole essere la colla più forte* becomes "Size is stronger"; and *chè di verno,* "and in winter." The resulting translation makes sense, but not the sense of the original. Turning to the source manuscripts, we find[17] that *L* has: *Vuole essere la cholla piu forte di verno*

[11] *The Book of the Art of Cennino Cennini, a contemporary practical treatise on quattrocento painting. Translated from the Italian, with notes on mediaeval art methods* . . . (London, 1899). The subtitle is based on the erroneous supposition that the *Libro dell'Arte* was composed in 1437: what Cennino describes is *trecento* painting of the Giottesque Gaddi tradition.

[12] *Ibid.*, Preface, p. v.

[13] *Des Cennino Cennini Handbüchlein der Kunst, neuübersetzt und herausgegeben* . . . (Strassburg: Heitz, 1916).

[14] *Cit. supra,* I. [15] *Cit. supra.*

[16] Milanesi, *ed. cit.*, p. 75; Herringham, *op. cit.*, p. 95. [17] See I, 68, ll. 17, 18.

che di state che di verno; but *di verno che* was canceled, and with it, by mistake, the final *di state.* Judicious editing thus gives the proper reading: *Vuole essere la cholla piu forte di state che di verno.* That is, "Size wants to be stronger in summer than in winter." And this every good craftsman knows, none better than Lady Herringham herself.

Even as a translation of the Milanesi text, however, Lady Herringham's work is not without flaws. Sometimes through misconception based on Mrs. Merrifield's version,[18] sometimes through carelessness, she falls into error. Thus, in Chapter 33,[19] she translates *aguzza . . . si come stanno i fusi* as "sharpen . . . as if they were tin." Like Mrs. Merrifield, in Chapter 136, she confuses *smeriglio* with *smeraldo.* In describing the breathing tubes for casting from life, she translates *più aperte che di sotto* as "more open below"; and *sieno spesso forate dal mezzo in su con busetti piccoli* as "let a small hole be pierced through the middle of each."[20] It is not necessary to extend this list, and I am too conscious of the possibility of similar errors in my own work to wish to bring a heavy indictment against my predecessor.

Some defects in the Herringham translation must be attributed to a lack of understanding, generally shared by the others. So in the case of *stagna dorato,* in Chapters 95–99 and elsewhere, the distinction between "golden" and "gilded" has been missed.[21] In Chapter 62 the translation "lye or a little roche alum," for *lisciva e un poco d'allume di rocca,* may be due to carelessness; but the readings, in the same chapter, "rich and deep," and "deep" alone, for *violante* in the original, betray the translator's failure to recognize that *violante* is a color

[18] See Herringham, *op. cit.,* Preface, p. v.

[19] References are to the chapter numbers of Lady Herringham's edition, which are given in arabic numerals.

The Roman numerals used for chapter numbers in this volume are printed in the form in which they appear in the MSS, as that was adopted for the volume of text: the only peculiarities are the use of "IIII" for "IV," "VIIII" for "IX," "XXXX" for "XL," and "LXXXX" for "XC." It seems more important that numerals in this volume should correspond with those in Volume I than that the few affected by these peculiarities should be given the more familiar forms.

[20] See below, p. 125.

[21] See n. 3, pp. 61 ff., below. In general I have translated *mettere d'oro* as simply, "gild," except in one or two cases where the context requires a literal translation. This, I confess, is not for any fault in the expression, "lay with gold," but rather to throw into relief this very distinction between *mettuto d'oro,* "gilded," and *dorato,* "golden," *vermeillonné.*

term and means "inclining to violet." The translation of *urina* as "wine," in Chapter 153, is doubtless a typographical error, as is "beat" for "heat," in Chapter 173.

Another class of error, all too easy to fall into, must be mentioned. From Chapter 47 Lady Herringham has omitted the translation of the sentence "La sua tempera non vuol d'altro che di colla"; from Chapter 107, "E tria bene queste cose insieme, come puoi sottilissimamente"; from Chapter 138, "E così a poco a poco va' brunendo un piano prima per un verso, poi"; and, farther on, "per altro verso"; while from the chapter on gilded glass she has left out the important direction "lascialo seccare sanza sole per spazio d'alcuni dì."[22]

Lady Herringham makes no pretense of consistency in the translation of technical terms. Her freedom in this respect robs her translation of much weight, and often leads her astray. One or two instances must suffice as illustrations here. "Fatness" and "leanness" of pigments are qualities which are sometimes found puzzling. Without entering upon any elaborate discussion, I may say that wet clay would be called "fat," and wet sand, "lean." The corresponding adjectives in Italian are *grasso* and *magro*. Lady Herringham translates *grasso* now as "unctuous,"[23] which is good; now as "full bodied,"[24] which is less good; again as "opaque,"[25] which is not good at all; and, finally, as "rich,"[26] which is, at the best, ambiguous. She translates *magro* quite consistently as "transparent," even in the phrase "transparent and drying," in translation of *magra e asciutta,* to characterize sinoper,[27] which is as opaque as a pigment can be.

These examples of defects in Lady Herringham's rendering are advanced, let me repeat, reluctantly, with all gratitude and respect for the good qualities in her work, only to justify the publication of a new translation. It is not to be supposed that my interpretation of the text will prove final in all details, but I hope that it will be found to represent the sense of Cennino's treatise more accurately than previous translations have done. Such improvement as may be found in it is due partly to close familiarity with the text itself; partly to familiarity

[22] See below, p. 112. [23] Ed. Herringham, Chapter 45.
[24] *Ibid.*, Chapter 51. [25] *Ibid.*, Chapter 37.
[26] *Ibid.*, Chapter 37. [27] *Ibid.*, Chapter 38.

with other medieval tracts of similar nature; but the real business of translation is a "laboratory" matter, involving a knowledge of each rule in practice. This knowledge Lady Herringham possessed in some degree. If my translation reveals a better understanding, the credit belongs to others: first, and in greatest measure, to Edward Waldo Forbes, to whom these volumes are inscribed, who first expounded Cennino to me, and whose researches are embodied in every page; then to the masters under whom, through the liberality of Mr. Forbes, I carried on my study: Nicolas Lochoff, the peerless copyist of early Italian painting, and Federigo Ioni, master of archaic styles and methods; and, finally, to the students who have carried out Cennino's precepts under my direction, and translated for me—with their paintbrushes.

The *Libro dell'Arte* was "made and composed," its author tells us,[28] "for the use and good and profit of anyone who wants to enter the profession." I have accordingly tried in my translation to give first place wherever possible to the convenience of the practicing student and painter. It must remain for another volume to analyze Cennino's materials and methods in detail; but every effort has been made in this to translate them into the resources of modern commerce and the idiom of modern craftsmen. Thus, *minio* is translated as "red lead," and *verzino,* as "brazil."[29] The *braccio* and the *spanna* having passed out of fashion, I give equivalents in feet or inches, rather than translate them.[30] The "finger," as a measurement, is too indefinite to be reduced to any fraction of an inch, but is not hard to understand; nor are those rule-of-thumb proportions, "beans," "lentils," etc. Measures of time are dealt with similarly: thus, *xv dì, o venti* becomes "two or three weeks." By an extension of the principle, *azzurro della Magna* appears as "azurite," rather than "German blue" or, as formerly in English,[31] "asure of Almayne"; and *verde azzurro,* as "malachite": these being the names not of modern pigments, for they are not found generally in trade, but of the minerals from which, as I believe, they

[28] See below, p. 1. [29] See n. 5, p. 39, below.

[30] These equivalents are based on a *braccio* of twenty-three inches, and a *spanna* of nine.

[31] See *NED, s.v.* "azure," 2: *sub anno* 1502.

were made, and may be made today. In the same way, *campeggiare* is translated as "lay in"; *raffermare,* as "crisp up"; *ritrovare,* as "shape up," etc., in the belief that those expressions represent the nearest equivalents to Cennino's terms which can be found in colloquial use by modern English-speaking painters.[32]

There are many couplets in the text, such as *triare o ver macinare, tavola o vero ancona, bicchiere o ver miuolo,* the terms of which have generally been regarded as synonyms.[33] I do not think that they are quite that, though it is often difficult to define the members. Cennino is more likely to indicate a synonym by *cioè* than by *o vero,* and I have followed his practice strictly. Thus, *triare* is translated "work up," and *macinare,* "grind." They are almost interchangeable, but *triare* is a little more likely to be used than *macinare* when the case calls for grinding *dry,* "triturating." *Tavola* is translated "panel," and *ancona,* being a word in good standing in our fine-arts vocabulary, is kept in the Italian form. Those terms are not synonymous: the "ancona" is a compound panel.[34] "Goblet" and "glass" serve to distinguish *mugliuolo* and *bicchiere,* though perhaps the terms are really interchangeable.

In some cases, Cennino's materials have no modern commercial equivalents. This is true of his *bianco San Giovanni,* which I translate as "lime white."[35] In other cases, such as his *sinopia,* the meaning is too general to be reduced to any single commercial term. The word "sinoper" is not in common use by painters now, but I have pressed it into service, because, like its cognate *sinopia,* though a generic term, it may be used in a specific sense. To translate *sinopia,* "Venetian red," would be to fix arbitrarily upon one of many perfectly good earth reds, all of which Cennino would unhesitatingly have called *sinopia;* and that to no good purpose, for there are almost as many shades of Vene-

[32] That is, of course, barring downright slang; for the best translation of *raffermare* is "bake." I have often been inclined to use slang of this sort, and should have done so, but that fashions in it change so quickly. Some idioms almost defy translation without it. Among these is one much used to suggest progressive action: *"Va' raffermando," "Va' toccando,"* etc. I have sometimes devised means to translate this, but usually a simple imperative has to serve. Much more like the original would be the studio slang: "Creep up on it, crisping it up"; and, "Come up on it with your accents."

[33] See Tambroni, *ed. cit.,* Preface, p. xvi. [34] See n. 1, p. 3, below.

[35] See n. 2, p. 23, below.

tian red in modern trade as there are colormen who sell that universal pigment. The mixed color, *verdaccio,* likewise, is not a definite quantity, but merely a dark, greenish or brownish tone for outlining and shading. The Italian expression seems to fill a want in our painters' *lingua technica,* for it is readily adopted by students.

There are a few materials which cannot be identified as yet with perfect certainty. Among these are *giallorino* and *arzica,* both yellows: the former a fairly bright, opaque one; the latter transparent and fugitive. Rather than risk a faulty identification, I have kept Cennino's names for them. Another question of identity arises in connection with *vernice liquida;* but whatever its ultimate solution, the phrase must be translated here as "liquid varnish."

In my efforts to preserve the professional character of this handbook, I have been forced into some awkwardness at times. Cennino's *verdeterra* has no other equivalent among English-speaking painters than the French name *terre-verte.* This has become, in certain quarters, so far anglicized that I am tempted to create the spelling "turvurt," to conform with the pronunciation common in trade. In the same way, the Italian *gesso* has been assimilated to our tongue as substantive, verb, and adjective. It has bred up a horrid trio: "gessos," "gessoed," and "gessoing," all of which will, I regret to say, be met with in these pages. If they give offense, be it remembered that the root word has still further potentiality for evil! I have consented to the extension of its grip upon us, and kept not only *gesso,* but two adjectives from the Italian as well: *grosso* and *sottile.* For this my justification follows.

The obvious translations, "thick" and "thin," are closed to us, for a reason which does not first appear. The modern practice of gessoing (*absit injuria!*), as performed commercially by frame-makers and the like (who have the decency to call it "whitening"), involves the use of "thin white" and "thick white," which might be supposed to parallel Cennino's *gesso sottile* and *gesso grosso,* but this is not the case. Modern "thin white" corresponds to Cennino's second preliminary sizing, but contains a small amount of whiting; the "thick white" is the gesso proper, containing much whiting, and forms the final surfacing material; whereas Cennino's *gesso grosso* simply serves as a

foundation for the *gesso sottile* which comes after. These tempting modern *similia,* therefore, differ in application, and also in composition. Furthermore, *gesso sottile* must refer not only to a thin mixture, but to a material which is by nature "thin" or "subtle." In practice, this *thinness* becomes apparent; this *subtlety,* in comparison with the crude whiting of the modern gilder, or the heavy impasto of the *gesso grosso.* Painters and gilders who once work with it care not by what outlandish name it may be called; the only sufferers are those who read and do not paint; and this translation is for the painters.

In one section, that on casting, I have balked at consistency in the use of this word "gesso." *Gesso* there means "plaster," "plaster of Paris," and I have so translated it. (Among modern sculptors, "gesso" in English has this meaning; but painters understand by it a white priming preparation containing size, or the white filling of such preparation.) "Plaster," alas, has to do heavy duty in this little book: to serve as a noun for *gesso* here, for *intonaco* and *smalto,* and sometimes for *pasta;*[36] and for *smaltare* as a verb. For we are poor, in English, in terms for plasterwork, and I suppose no tongue is richer than Italian.

I have endeavored, in the main, to avoid this sort of freedom, and to confine myself as far as possible, even at great cost to style, to a single English equivalent for every technical expression of the Italian. In some cases I have had to admit defeat. *Colla,* for example, just means "adhesive" in general; and no one English word will fit it always. There we are richer than Cennino, and I have been obliged to use "glue," "size,"[37] and "cement," to translate the one word *colla.* So also with *penna,* which means sometimes "quill," and sometimes "pen"—"quill pen," of course. In a few cases the Italian possesses both singular and plural of a word which with us exists in only one. Thus, "charcoal," for *carbone,*[38] has to become "coals," for *carboni.*

Some of the matters of which Cennino writes are unfamiliar to the

[36] *Pasta* is also used for "batter."

[37] "Size," in English, is doubly ambiguous: apart from the idea of dimension, it is the word for a solution of glue or gelatine, and is also the only proper translation of the Italian *assiso,* in the sense of "gold *size.*"

[38] *Carbone* is also used by Cennino in the general sense of "crayon," black or white. (See I, 101, l. 9, and n. 2, p. 106, below.)

general reader, and no ingenuity in translation will make his words clear without comment. The tool called a "slice," the composition known as "vermeil," colors in the form of "clothlets," are likely to need explanation to some readers, at least, though all these words are proper English, and the best translations to be found. In such cases the *New English Dictionary* is specifically cited; and it may be consulted generally as authority for definitions here.

In Cennino's occasional attempts at rhetoric, as in the first chapter, he is apt to lose himself in complications. He does not always finish his sentences, and has a disconcerting habit of changing persons and tenses and moods in the middle of an instruction. It has seemed to me pointless to preserve lapses of this sort in my translation, when his intention can be understood. In some parts, it must be confessed, a good deal of sympathy is called for; elsewhere, his little slips are easy to understand and overlook. I have tried to keep something of the flavor of his writing, but have felt as free to recast an awkward sentence as to spell correctly the words with which I translate the misspelled words of my original.

If I speak slightingly of Cennino's rhetoric, let it not be supposed that I take no joy in his expression. In the very heart of the tangle of his first chapter[39] lies a sentence, defining the "occupation known as painting," which seems to me as precious as anything in the book. By this definition, painting "calls for imagination, and skill of hand, in order to discover things not seen, hiding themselves under the shadow of natural objects, and to fix them with the hand, presenting to plain sight what does not actually exist." And therein lies the secret of much good work.

There are some obvious lacunae in the text, not to be supplied from manuscripts of the *Libro dell'Arte* now in existence. Some of these can be filled out fairly satisfactorily; and I have generally attempted to repair them in this translation, either by inserting, in pointed brackets (⟨ ⟩), such words as I think necessary to complete the sense, or by indicating in footnotes the possible character of the omissions.[40] Pointed brackets are used also for a few words introduced into

[39] See below, p. 1.

[40] In addition to these minor defects, I suspect that at least one fairly considerable

the translation to make the meaning clearer. The only editorial additions not so bracketed are the chapter headings which I have supplied from the point where the titles in the manuscripts cease.[41]

When Tambroni first published the *Libro dell'Arte*, he devised titles and numbers for the chapters which followed Cap. CXL, in his manuscript.[42] Seventeen new titles were supplied by the Milanesi to account for chapters in *R* which they brought to light. These follow the chapter numbered CLX by Tambroni. Tambroni and the Milanesi made up these titles, in most cases, out of extracts from the text itself. They are consequently rather apt to be long, and sufficiently archaic in flavor to convey a false sense of authenticity.[43] There seems to be some convenience to the reader in having the text divided into chapters and in having these chapters provided with headings of some sort. I have, therefore, made such divisions, and furnished them with titles. These titles are not bracketed, but are printed in italics, to remind the reader that they are modern inventions. In the number and wording of these headings, I have departed freely from the Tambroni-Milanesi formula.

No chapter numbers are attached to these spurious headings in this edition. As I have pointed out,[44] neither of the existing systems of numbering is "to be considered as an accepted standard; and the two together constitute a mechanism of more than doubtful utility." Since, however, references to this work are often made by chapter number, I give in footnotes the numerals attached by Tambroni and the Milanesi to their divisions of the text. Thus, "T., CLXXI; M., CLXXXIX" stands for "the chapter numbered CLXXXIX in the Milanesi edition, the translations of Ilg, Lady Herringham, and Verkade, and the revised edition of Mottez' translation; and the same chapter, numbered CLXXI in the Tambroni edition, in Mrs. Merrifield's translation, and Mottez' as originally published." More than

portion of Cennino's text is lost: the beginning of the section on mosaic-painting. See n. 1, p. 114, below.

[41] The last chapter heading in the MSS is that of CXL. Thereafter neither MS has any original headings or numbers. See I, 84, n. 1; and n. 5, p. 86, below.

[42] See n. 6, above.

[43] For an example of their misleading effect, see n. 1, p. 114, below.

[44] I, Preface, p. xvi.

this I cannot do: the reader must determine for himself to which series of numbers his reference belongs!

In adding these chapter headings, I have gone a step farther, and continued the division of the work into "sections,"[45] as begun by Cennino. Five of these sections are indicated in the text, and deal with the following subjects:

 I. Drawing.

 II. Colors.

 III. Fresco-painting.

 IV. Oil-painting and embellishments for the wall.

 V. Glues, sizes, and cements.

The conclusion of the fifth section is erroneously marked in the manuscripts as the conclusion of the fourth.[46] I have distinguished the following divisions of the remainder, not specifically indicated in the manuscripts:

 VI. Panel-painting and gilding.

 VII. Mordant embellishments.

 VIII. A short section on varnishing.

 IX. A short section on illuminating.

 X. A section dealing with work on cloth.

 XI. A short section on operations with glass.

 XII. Part of a section dealing with mosaic.

 XIII. A section dealing with miscellaneous incidental operations.

 XIV. The final section, devoted to casting.

These divisions are not very significant, but may serve to emphasize the orderly character of Cennino's composition.

I hope eventually to bring out a digest of the medieval writings prior to Cennino's which deal with subjects treated in the *Libro dell'Arte*. On that account I have been sparing, in my notes, of references to those sources; preferring to assemble them methodically later. I have not hesitated, however, to anticipate a little, when a quotation would serve to clear up some difficulty in the text, or confirm the accuracy of a rendering pointedly different from my predecessors'. I have likewise postponed for future treatment most of the comments

[45] *Parti.* See I, 1, l. 12, etc. [46] See I, 66, l. 19.

which I have to make upon the theory and practice of the techniques here described. The purpose of the present volume is to translate the text: its fuller interpretation will be undertaken separately.

To this translation my teachers, students, friends, and colleagues have all contributed. Edwin Cassius Taylor, Chairman of the Department of Painting at Yale, has fostered the modern application of Cennino's methods, to my great benefit. To my colleague, Lewis E. York, I owe not only the two drawings which illustrate Cennino's casting methods, but also a great deal of helpful practical criticism. More thanks are due, I fear, than the quality of this work entitles me to render, but I cannot leave unrecorded the generous interest extended over many years by Francis Peabody Magoun, Jr., *hortatu praeceptisque.*

D. V. T., Jr.

Yale University,
 New Haven, Connecticut,
 March 1, 1933.

CONTENTS

CONTENTS

NOTE: The following chapter numbers and headings are not original to the *Libro dell'-Arte*. The headings have been invented merely to serve as a running guide to the content of the text; the numbers are those attached to the chapters in the editions of Tambroni and the Milanesi, and are included here for convenience in locating references to those editions or to translations based upon them. (See Preface, p. xviii, above.)

VII

VIII

IX

[1] This chapter in Tambroni's edition comprises also Cap. CLXXVIII of the Milanesi's edition.

CONTENTS

CENNINO D'ANDREA CENNINI

THE CRAFTSMAN'S HANDBOOK

IL LIBRO DELL'ARTE

HERE BEGINS THE CRAFTSMAN'S HANDBOOK, made and composed by Cennino of Colle, in the reverence of God, and of The Virgin Mary, and of Saint Eustace, and of Saint Francis, and of Saint John Baptist, and of Saint Anthony of Padua, and, in general, of all the Saints of God; and in the reverence of Giotto, of Taddeo and of Agnolo, Cennino's master; and for the use and good and profit of anyone who wants to enter this profession.

THE FIRST CHAPTER OF THE FIRST SECTION
OF THIS BOOK.

In the beginning, when Almighty God created heaven and earth, above all animals and foods he created man and woman in his own image, endowing them with every virtue. Then, because of the misfortune which fell upon Adam, through envy, from Lucifer, who by his malice and cunning beguiled him—or rather, Eve, and then Eve, Adam—into sin against the Lord's command: because of this, therefore, God became angry with Adam, and had him driven, him and his companion, forth out of Paradise, saying to them: 'Inasmuch as you have disobeyed the command which God gave you, by your struggles and exertions you shall carry on your lives.' And so Adam, recognizing the error which he had committed, after being so royally endowed by God as the source, beginning, and father of us all, realized theoretically that some means of living by labor had to be found. And so he started with the spade, and Eve, with spinning. Man afterward pursued many useful occupations, differing from each other; and some were, and are, more theoretical than others; they could not all be alike, since theory is the most worthy. Close to that, man pursued some related to the one which calls for a basis of that, coupled with skill of hand: and this is an occupation known as painting, which calls for imagination, and skill of hand, in order to discover things not seen, hiding themselves under the shadow of natural objects, and to fix them[1] with the hand, presenting to plain sight what does not actually exist. And it justly deserves to be enthroned next to theory, and to be

[1] *Fermarle.* Perhaps read *formarle* "give them shape."

crowned with poetry. The justice lies in this: that the poet, with his theory, though he have but one, it makes him worthy, is free to compose and bind together, or not, as he pleases, according to his inclination. In the same way, the painter is given freedom to compose a figure, standing, seated, half-man, half-horse, as he pleases, according to his imagination. So then, either as a labor of love for all those who feel within them a desire to understand; or as a means of embellishing these fundamental theories with some jewel, that they may be set forth royally, without reserve; offering to these theories whatever little understanding God has granted me, as an unimportant practicing member of the profession of painting: I, Cennino, the son of Andrea Cennini of Colle di Val d'Elsa,—(I was trained in this profession for twelve years by my master, Agnolo di Taddeo of Florence; he learned this profession from Taddeo, his father; and his father was christened under Giotto, and was his follower for four-and-twenty years; and that Giotto changed the profession of painting from Greek back into Latin, and brought it up to date; and he had more finished craftsmanship than anyone has had since),—to minister to all those who wish to enter the profession, I will make note of what was taught me by the aforesaid Agnolo, my master, and of what I have tried out with my own hand; first invoking ⟨the aid of⟩ High Almighty God, the Father, Son, and Holy Ghost; then ⟨of⟩ that most delightful advocate of all sinners, Virgin Mary; and of Saint Luke, the Evangelist, the first Christian painter; and of my advocate, Saint Eustace; and, in general, of all the Saints of Paradise, A M E N.

HOW SOME ENTER THE PROFESSION THROUGH LOFTINESS OF SPIRIT, AND SOME, FOR PROFIT.
CHAPTER II

It is not without the impulse of a lofty spirit that some are moved to enter this profession, attractive to them through natural enthusiasm. Their intellect will take delight in drawing, provided their nature attracts them to it of themselves, without any master's guidance, out of loftiness of spirit. And then, through this delight, they come to want to find a master; and they bind themselves to him with respect for authority, undergoing an apprenticeship in order to achieve per-

fection in all this. There are those who pursue it, because of poverty and domestic need, for profit and enthusiasm for the profession too; but above all these are to be extolled the ones who enter the profession through a sense of enthusiasm and exaltation.

FUNDAMENTAL PROVISIONS FOR ANYONE WHO ENTERS THIS PROFESSION.
CHAPTER III

You, therefore, who with lofty spirit are fired with this ambition, and are about to enter the profession, begin by decking yourselves with this attire: Enthusiasm, Reverence, Obedience, and Constancy. And begin to submit yourself to the direction of a master for instruction as early as you can; and do not leave the master until you have to.

HOW THE SCHEDULE SHOWS YOU INTO HOW MANY SECTIONS AND BRANCHES THE OCCUPATIONS ARE DIVIDED.
CHAPTER IIII

The basis of the profession, the very beginning of all these manual operations, is drawing and painting. These two sections call for a knowledge of the following: how to work up or grind, how to apply size, to put on cloth, to gesso, to scrape the gessos and smooth them down, to model with gesso, to lay bole, to gild, to burnish; to temper, to lay in; to pounce, to scrape through, to stamp or punch; to mark out, to paint, to embellish, and to varnish, on panel or ancona.[1] To work on a wall you have to wet down, to plaster, to true up, to smooth off, to draw, to paint in fresco. To carry to completion in secco: to temper, to embellish, to finish on the wall. And let this be the schedule of the aforesaid stages which I, with what little knowledge I have acquired, will expound, section by section.

[1] By *ancona* is to be understood a compound panel, one with its moldings integrally attached. It may be large or small; complex, as a polyptych, or merely a "self-framed" panel. The *tavola,* the simple "panel," has no moldings.

HOW YOU BEGIN DRAWING ON A LITTLE PANEL; AND THE SYSTEM FOR IT.
CHAPTER V

As has been said, you begin with drawing. You ought to have the most elementary system, so as to be able to start drawing. First take a little boxwood panel, nine inches wide in each direction; all smooth and clean, that is, washed with clear water; rubbed and smoothed down with cuttle such as the goldsmiths use for casting. And when this little panel is thoroughly dry, take enough bone, ground diligently for two hours, to serve the purpose; and the finer it is, the better. Scrape it up afterward, take it and keep it wrapped up in a paper, dry. And when you need some for priming this little panel, take less than half a bean of this bone, or even less. And stir this bone up with saliva. Spread it all over the little panel with your fingers; and, before it gets dry, hold the little panel in your left hand, and tap over the panel with the finger tip of your right hand until you see that it is quite dry. And it will get coated with bone as evenly in one place as in another.

HOW TO DRAW ON SEVERAL KINDS OF PANELS.
CHAPTER VI

For that purpose, a little panel of old fig wood is good; and also certain tablets which tradesmen use, which consist of sheep parchment gessoed and coated with white lead in oil,[1] following the treatment with bone according to the system which I have described.

[1] The *Liber illuministarum pro fundamentis auri et coloribus ac consimilibus,* Munich, Staatsbibliothek, MS. germ. 821, compiled about 1500 at Tegernsee (Oby.), contains (fol. 33) a rule for these, quoted by Ludwig Rockinger in "Zum baierischen Schriftwesen im Mittelalter," *Abhandlungen der historischen Classe der königlichen bayerischen Akademie der Wissenschaften,* XII (1872), 1te Abteilung, p. 18. A translation of this rule follows:

"White parchment tablets are made in this way. Take calf parchment, and put it on the stretcher, and stretch it well; and dry it thoroughly in the sun. And do this thrice. And then take thoroughly powdered white-lead, and mix it with linseed oil until it comes out thin, while still preserving the white color of the white-lead. And paint that calfskin with that liquid color. And then dry it in the sun. And do this nine times; and by all means of the same thickness[?] And one coat is not to be applied unless the previous one be thoroughly dry. This done, you will shape up as many leaves of this calfskin as you wish, and make tablets. And you can write on them with

WHAT KIND OF BONE IS GOOD FOR TREATING
THE PANELS.
CHAPTER VII

You must know what bone is good. Take bone from the second joints and wings of fowls, or of a capon; and the older they are the better. Just as you find them under the dining-table, put them into the fire; and when you see that they have turned whiter than ashes, draw them out, and grind them well on the porphyry; and use it as I say above.

HOW YOU SHOULD START DRAWING WITH A STYLE,
AND BY WHAT LIGHT.
CHAPTER VIII

The thigh bone of a gelded lamb is good, too, and the shoulder, calcined in the way described. And then take a style of silver, or brass, or anything else, provided the ends be of silver,[1] fairly slender, smooth, and handsome. Then, using a model, start to copy the easiest possible subjects, to get your hand in; and run the style over the little panel so lightly that you can hardly make out what you first start to do; strengthening your strokes little by little, going back many times to produce the shadows. And the darker you want to make the shadows in the accents, the more times you go back to them; and so, conversely, go back over the reliefs only a few times. And let the helm and steersman of this power to see be the light of the sun, the light of your eye, and your own hand: for without these three things nothing can be done systematically. But arrange to have the light diffused when you are drawing; and have the sun fall on your left side. And with that system set yourself to practice drawing, drawing only a little each day, so that you may not come to lose your taste for it, or get tired of it.

a lead, tin, copper, or silver style, or even with ink, and erase the letters with saliva [not *salvia*, "sage," as in ed. Rockinger] and write again. And when all the whiteness has disappeared, whiten them again with white-lead and saliva like the ordinary tablets, or with scrapings of shells, bones, or powder of calcined bones, and saliva."

[1] A convenient device is to obtain from a jeweler an inch or two of silver wire of the same caliper as a pencil lead. This can then be used in place of the lead in a propelling pencil, and needs only a little shaping of the point to make an admirable "silver style" at trifling expense.

HOW YOU SHOULD GIVE THE SYSTEM OF LIGHTING, LIGHT OR SHADE, TO YOUR FIGURES, ENDOWING THEM WITH A SYSTEM OF RELIEF.
CHAPTER VIIII

If, by chance, when you are drawing or copying in chapels, or painting in other adverse situations, you happen not to be able to get the light off your hand, or the way you want it, proceed to give the relief to your figures, or rather, drawing, according to the arrangement of the windows which you find in these places, for they have to give you the lighting. And so, following the lighting, whichever side it comes from, apply your relief and shadow, according to this system. And if it happens that the light comes or shines through the center straight ahead, or in full glory, apply your relief in the same way, light and dark, by this system. And if the light shines from one window larger than the others in these places, always follow the dominant lighting; and make it your careful duty to analyze it, and follow it through, because, if it failed in this respect, your work would be lacking in relief, and would come out a shallow thing, of little mastery.

THE METHOD AND SYSTEM FOR DRAWING ON SHEEP PARCHMENT AND ON PAPER,[1] AND SHADING WITH WASHES.
CHAPTER X

To get back to our main track: you may also draw on sheep parchment and on paper. On the parchment you may draw or sketch with this style of yours if you first put some of that bone, dry and powdered,

[1] *In carta pecorina e 'n banbagina.* Cennino distinguishes two types of *carta:* one, parchment, chiefly from sheep- or goat-skins; the other, *carta banbagina,* paper. The adjective, *banbagina,* I do not translate as "cotton," for two reasons.

In the first place, whatever the nature of this *carta banbagina* may have been, Cennino uses the term for no other purpose than to distinguish it from *carta* meaning "parchment." I see no indication that Cennino gave any thought to the composition of the material itself, and the distinction between the natural product, parchment, and the artificial one, paper, requires no such expedient in English. To translate *banbagina* in this phrase would be to impose a specific meaning where, I believe, none was intended.

In the second place, it is not at all certain that *banbagina,* in this phrase, means "cotton." Joseph Karabacek, in "Neue Quellen zur Papiergeschichte," *Mitteilungen aus der Sammlung der Papyrus Erzherzog Rainer,* IV (Vienna, 1888), Section VI, "Die

like dust or pouncing rosin, all over the parchment, sprinkling it on, spreading it about, and dusting it off with a hare's foot. If, after you have drawn with the style, you want to clear up the drawing further, fix it with ink at the points of accent and stress. And then shade the folds with washes of ink; that is, as much water as a nutshell would hold, with two drops of ink in it; and shade with a brush made of minever tails, rather blunt, and almost always dry. And so, according to the darks, you make the wash blacker in this way with more little drops of ink. And you may likewise work and shade with colors and with clothlets[2] such as the illuminators use; the colors tempered with gum, or with clear white of egg well beaten and liquefied.

HOW YOU MAY DRAW WITH A LEADEN STYLE.
CHAPTER XI

You may also draw, without any bone, on this parchment[1] with a style of lead; that is, a style made of two parts lead and one part tin, well beaten with a hammer.

HOW, IF YOU HAVE MADE A SLIP IN DRAWING WITH THE LEADEN STYLE, YOU MAY ERASE IT, AND BY WHAT MEANS.
CHAPTER XII

On paper you may draw with the aforesaid lead without bone, and likewise with bone. And if you ever make a slip, so that you want to

Entstehung der Fabel vom Baumwollenpapier," pp. 117–122, maintains that "es hat niemals ein aus roher Baumwolle erzeugtes Papier gegeben," and that this misconception arose through the confusion of Latin, *bombycina* ("cotton") <Greek βομβύκινος <βόμβυξ ("silkworm"), with *bambycina,* "Bambycene" <Greek βαμβύκη, a city of northern Syria.

Whatever the etymology of Cennino's *banbagina* may be, I feel confident that he used it in a traditional, general, uncritical sense, simply to distinguish one application of the generic term *carta* from another; and that the single English word "paper" translates adequately the whole phrase, *carta banbagina.* Whenever *carta* is used unqualified, the meaning is ambiguous. In such cases I have elected the translation "paper," except when "parchment" seems in some way indicated by the context, as on p. —, below.

[2] *NED.*

[1] *Nella detta charta:* translated "parchment" because the *carta* of the preceding rule is specifically *pecorina,* and because the use of the leaden style on paper, *carta banbagina,* is treated separately in the next chapter.

remove some stroke made by this little lead, take a bit of the crumb of some bread, and rub it over the paper, and you will remove whatever you wish. And you may shade on this paper in the same way with ink, with colors, and with clothlets, using the temperas aforesaid.

HOW YOU SHOULD PRACTICE DRAWING WITH A PEN.
CHAPTER XIII

When you have put in a year, more or less, at this exercise, according to what liking or enjoyment you have taken, you may sometimes just draw on paper with a pen. Have it cut fine; and then draw nicely, and work up your lights, half lights, and darks gradually, going back to them many times with the pen. And if you want your drawings to come out a little more seductive, put some little washes on them, as I told you before, with a blunt minever brush. Do you realize what will happen to you if you practice drawing with a pen?—That it will make you expert, skilful, and capable of much drawing out of your own head.

HOW TO LEARN TO CUT THE QUILL FOR DRAWING.
CHAPTER XIIII

If you need to learn how this goose quill should be cut, get a good, firm quill, and take it, upside down, straight across the two fingers of your left hand; and get a very nice sharp penknife, and make a horizontal cut one finger along the quill; and cut it by drawing the knife toward you, taking care that the cut runs even and through the middle of the quill. And then put the knife back on one of the edges of this quill, say on the left side, which faces you, and pare it, and taper it off toward the point. And cut the other side to the same curve, and bring it down to the same point. Then turn the pen around the other side up, and lay it over your left thumb nail; and carefully, bit by bit, pare and cut that little tip;[1] and make the shape broad or fine, whichever you want, either for drawing or for writing.

[1] Apparently the slit in the nib was made with the knife at this stage. This is a delicate operation, and a different method may be followed by members of our post-Gillot civilization with better chances of success.

After the first horizontal cut, which removes the last half inch or so of the lower half of the quill, a small slit is started with the knife at the middle of the end of the

HOW YOU SHOULD ADVANCE TO DRAWING ON
TINTED PAPER.
CHAPTER XV

To approach the glory ⟨of the profession⟩[1] step by step, to start trying to discover the entrance and gateway to painting, you should take up a system of drawing different from the one which we have been discussing up to now. And this is known as drawing on tinted paper; either paper, that is, or parchment. Let them be tinted; for one is tinted in the same way as the other, and with the same tempera. And you may make your tints inclined toward pink, or violet, or green; or bluish, or greenish gray, that is, drab colors; or flesh colored, or any way you please; for they all take the same temperas, the same time for grinding the colors; and you may draw on them all by the same method. It is true that most people generally use the green tint, and it is most usual, both for shading down and for putting lights on. Although I am going to describe later on the grinding of all the colors, and their characters, and their temperas, I will give you briefly a short method now, to get you started on your drawing and your tinting of the papers.

HOW THE GREEN TINT IS MADE ON PAPER FOR
DRAWING; AND THE WAY TO TEMPER IT.
CHAPTER XVI

When you want to tint a kid parchment, or a sheet of paper, take as much as half a nut of terre-verte; a little ocher, half as much as that; and solid white lead to the amount of half the ocher; and as much as a bean of bone dust, using the bone which I described to you above for drawing; and as much as half a bean of vermilion. And grind all these things up well on the porphyry slab with well or spring or river water; and grind them as much as ever you can stand grinding them,

upper half. Holding the tip of the right thumb firmly against the top of the quill half or three quarters of an inch from the end, a small stick is inserted a short way into the quill with the left hand, and given a sharp twitch upward. This action normally causes the slit started with the knife to break back neatly to the point where the pressure of the thumb arrests it. The rest of the operation follows as Cennino describes.

Detailed practical instructions for pen cutting may be found in Edward Johnston, *Writing, Illuminating, & Lettering,* 11th ed. (London: Putnam, 1920), pp. 51–60.

[1] See Chapter XXXV, p. 20, below.

for they can never be done too much; because the more you grind them, the more perfect tint it becomes. Then temper the aforesaid substances with size of the following quality and strength: get a leaf of druggists' glue, not fish glue, and put it into a pipkin to soak, for the space of six hours, in as much clear, clean water as two common goblets will hold. Then put this pipkin on the fire to temper it; and skim it when it boils. When it has boiled a little, so that you see that the glue is all dissolved, strain it twice. Then take a large paint pot, big enough for these ground colors, and put in enough of this size to make it flow freely from the brush. And choose a good-sized soft bristle brush. Then take that paper of yours which you wish to tint; lay some of this tint evenly over the ground of your paper, running your hand lightly, with the brush about half dry, first in one direction and then in the other. And put on three or four coats of it in this way, or five, until you see that the paper is tinted evenly. And wait long enough between one coat and the next for each coat to dry. And if you see that it gets shriveled from your tinting, or horny from the tinting mixture, it is a sign that the tempera is too strong; and so, while you are laying the first coat, remedy this. How?—Put in some clear warm water. When it is dry and done, take a penknife, and rub lightly over the tinted sheet with the blade, so as to remove any little roughness that there may be on it.

HOW YOU SHOULD TINT KID PARCHMENT, AND BY WHICH METHOD YOU SHOULD BURNISH IT.
CHAPTER XVII

When you want to tint kid parchment, you should first soak it in spring or well water until it gets all wet and soft. Then, stretching it over a board, like a drumskin, fasten it down with big-headed nails, and apply the tints to it in due course, as described above. If it should come about that the paper or parchment is not smooth enough to suit you, take this paper, and lay it on a walnut board, or on a flat, smooth slab; then put a sheet of good clean paper over the one which you have tinted; and, with the stone for burnishing and working gold, burnish with considerable strength of hand; and so, in this way,

it will get soft and smooth. It is true that some people like very much to burnish directly on the tinted paper, that is, to have the burnishing stone touch it and penetrate it, so that it acquires a little polish. You may do as you please, but that first method of mine is better. The reason is this: that rubbing the burnishing stone over the tint offsets, by reason of its polish, the polish of the style when you draw; and furthermore the washes which you put on with your ink[1] do not look so well blended and clear on this as in the method first described. But, nevertheless, do as you please.

HOW YOU SHOULD TINT PAPER TURNSOLE COLOR.[2]
CHAPTER XVIII

Now apply yourself to the making of these tints. To tint your paper turnsole color, or purple, for the number of sheets which I mentioned before, that is, . . .,[3] take half an ounce of coarse white lead; and as much as a bean of hematite; and grind them together as much as ever you can; for ample grinding will not spoil it, but improve it constantly. Temper it in the regular way.

HOW YOU SHOULD TINT PAPER WITH AN INDIGO TINT.
CHAPTER XVIIII

The indigo tint. Take the number of sheets mentioned above; take half an ounce of white lead, and the size of two beans of Bagdad

[1] This reading, with *R*, is probably to be preferred. *L* omits "with your ink." (See I, 11, ll. 9, 10.)

[2] *Morella.* Ilg, in his edition of Cennino, *Das Buch von der Kunst,* in "Quellenschriften für Kunstgeschichte . . .," I (Vienna, 1871), 144, insists that this is the *solatrum hortense.* (*NED, s.v.* "morel," *solanum nigrum.*) I believe, however, that it is rather to be identified with the *morella,* or *folium,* of the *Liber diversarum artium* (in *Catalogue général des MSS des bibliothèques publiques des départements,* I [Paris, 1849], 756, 757), the *Liber de coloribus illuminatorum siue pictorum* from Sloane MS 1754 (§ VII: ed. D. V. Thompson, Jr., *Speculum,* I [1926], 298), the *torna-ad-solem* of the Naples *De arte illuminandi* (§ 10, ed. A. Lecoy de La Marche, *l'Art d'enluminer* [Paris, 1890], pp. 80–81), etc. This is the "annual euphorbiaceous plant, *Crozophora tinctoria,*" of *NED,* "turnsole," 2, a. For this identification, consult bibliography in O. Stapf, *Iconum botanicarum Index Londinensis . . .* (Oxford, 1929), *s.v.* "Chrozophora tinctoria." The plant is known also as *Croton tinctorium.*

[3] A numeral seems to have been omitted. The direction in Chapter XVI might be understood to apply to one parchment, or one sheet of paper.

indigo;[1] and grind them together thoroughly, for thorough grinding will not spoil the tint. Temper it with your tempera as described above.

HOW YOU SHOULD TINT PAPERS WITH REDDISH COLOR, OR ALMOST PEACH COLOR.
CHAPTER XX

If you wish to tint with a reddish color, take, for the number of sheets mentioned above, half an ounce of terre-verte; the size of two beans of coarse white lead; and as much as one bean of light sinoper.[2] Grind in the usual way; and so temper it with your size or tempera.

HOW YOU SHOULD TINT PAPERS WITH FLESH COLOR.
CHAPTER XXI

Likewise, to make the tint a good flesh color, you should take, for the number of sheets mentioned, half an ounce of coarse white lead; and less than a bean of vermilion. And you should grind everything together; and temper in the regular way described above.

HOW YOU SHOULD TINT PAPERS GREENISH GRAY, OR DRAB.
CHAPTER XXII

You will make a greenish gray, or drab, in this manner. First take a quarter of an ounce of coarse white lead; the size of a bean of light ocher; less than half a bean of black. Grind these things well together in the regular way. Temper as I have taught you for the others, always putting in, for each batch, at least as much as a bean of calcined bone. And this must suffice you for papers tinted in various ways.

[1] Coupled with the doubtful *indacho macchabeo* of L, the meaningless *macalico* of R suggests a joint heritage of illegibility, and we may venture to rationalize these readings as *Baccadeo*, "Bagdad," to correspond with the form found in I, 34, l. 5.

The *Liber diversarum artium*, in a chapter "De cognitione indici . . .," *ed. cit. supra*, p. 750, states: "Diversis nominibus nominatur, quia in diversis partibus conficitur; ergo bagadeus eligatur, et quod magis açurinum est."

[2] See *NED, s.v.* "sinoper," 2, a.

HOW YOU MAY OBTAIN THE ESSENCE OF A GOOD FIGURE OR DRAWING WITH TRACING PAPER.
CHAPTER XXIII

You should be aware[1] that there is also a paper known as tracing paper which may be very useful to you. To copy a head, or a figure, or a half figure, as you find it attractive,[2] by the hand of the great masters, and to get the outlines right, from paper, panel, or wall, which you want to take right off, put this tracing paper over the figure or drawing, fastening it nicely at the four corners with a little red or green wax. Because of the transparency of the tracing paper, the figure or drawing underneath immediately shows through, in such shape and manner that you see it clearly. Then take either a pen cut quite fine or a fine brush of fine minever; and you may proceed to pick out with ink the outlines and accents of the drawing underneath; and in general to touch in shadows as far as you can see to do it. And then, lifting off the paper, you may touch it up with any high lights and reliefs, as you please.

THE FIRST WAY TO LEARN HOW TO MAKE A CLEAR TRACING PAPER.
CHAPTER XXIIII

If you do not find any ready-made, you will need to make some of this tracing paper in this way. Take a kid parchment and give it to a parchment worker; and have it scraped so much that it barely holds together. And have him take care to scrape it evenly. It is transparent of itself. If you want it more transparent, take some clear and fine linseed oil; and smear it with some of this oil on a piece of cotton. Let it dry thoroughly, for the space of several days; and it will be perfect and good.

[1] I, 12, l. 30 should begin: "Bisogniati essere," and the corresponding footnote should be: "30. *L* Biisongniati esere."

[2] *L aromo*: literally, "savory." The meaningless *huon'* of *R* was corrected by the Milanesi to *buono*. The reading *L* is doubtless the right one.

A SECOND WAY TO MAKE TRACING PAPER: WITH GLUE.
CHAPTER XXV

If you want to make this tracing paper in another way, take a good smooth slab of marble or porphyry. Then get some fish glue and some leaf glue, which the druggists sell. Put them to soak in clear water, and arrange to have one porringerful of clear water to six leaves. Then boil it until it is all melted, and after boiling strain it two or three times. Then take this size, all strained, melted, and warm, and a brush; and lay it on these slabs just the way you tint tinted papers. The slabs must be clean; and they should be greased with olive oil previously. And when this size which is laid on them has dried, take the point of a penknife, and start to pry this size far enough away from the slab here and there for you to get a grip on the skin or paper thus formed. And work cautiously, so as to pry this skin off the slab in the form of a paper, without damaging it. And if you want to find this skin or paper ⟨more durable⟩[1] before you pry it off the slab, take some linseed oil, boiled the way I shall teach you for mordants; and with a soft brush lay a coat of it all over. And let it dry for two or three days, and it will be good tracing paper.

HOW TO MAKE TRACING PAPER OUT OF PAPER.
CHAPTER XXVI

This same tracing paper which we have been discussing may be made out of paper, the paper, to begin with, being made very thin, smooth, and quite white. Then grease this paper with linseed oil, as described above. It becomes transparent, and it is good.

HOW YOU SHOULD ENDEAVOR TO COPY AND DRAW AFTER AS FEW MASTERS AS POSSIBLE.
CHAPTER XXVII

Now you must forge ahead again, so that you may pursue the course of this theory. You have made your tinted papers; the next thing is to draw. You should adopt this method. Having first prac-

[1] Something seems to have been dropped from the text here. What follows is a method intended to overcome the tendency of "gelatine tracing paper" to cockle.

ticed drawing for a while as I have taught you above, that is, on a little panel, take pains and pleasure in constantly copying the best things which you can find done by the hand of great masters. And if you are in a place where many good masters have been, so much the better for you. But I give you this advice: take care to select the best one every time, and the one who has the greatest reputation. And, as you go on from day to day, it will be against nature if you do not get some grasp of his style and of his spirit. For if you undertake to copy after one master today and after another one tomorrow, you will not acquire the style of either one or the other, and you will inevitably, through enthusiasm, become capricious, because each style will be distracting your mind. You will try to work in this man's way today, and in the other's tomorrow, and so you will not get either of them right. If you follow the course of one man through constant practice, your intelligence would have to be crude indeed for you not to get some nourishment from it. Then you will find, if nature has granted you any imagination at all, that you will eventually acquire a style individual to yourself, and it cannot help being good; because your hand and your mind, being always accustomed to gather flowers, would ill know how to pluck thorns.

HOW, BEYOND MASTERS, YOU SHOULD CONSTANTLY COPY FROM NATURE WITH STEADY PRACTICE. CHAPTER XXVIII

Mind you, the most perfect steersman that you can have, and the best helm, lie in the triumphal gateway[1] of copying from nature. And this outdoes all other models; and always rely on this with a stout heart, especially as you begin to gain some judgment in draftsmanship. Do not fail, as you go on, to draw something every day, for no matter how little it is it will be well worth while, and will do you a world of good.

[1] This unconventional figure of speech is fairly typical of Cennino when he abandons exposition for rhetoric. He seems to have had some half-formed conception of his course of study as an architectural layout, with steps rising and gates opening; but this is confused with ideas of journeys, by land and, as here, by sea.

HOW YOU SHOULD REGULATE YOUR LIFE IN THE IN-
TERESTS OF DECORUM AND THE CONDITION OF
YOUR HAND; AND IN WHAT COMPANY; AND
WHAT METHOD YOU SHOULD FIRST
ADOPT FOR COPYING A FIGURE
FROM HIGH UP.
CHAPTER XXVIIII

Your life should always be arranged just as if you were studying theology, or philosophy, or other theories, that is to say, eating and drinking moderately, at least twice a day, electing digestible and wholesome dishes, and light wines; saving and sparing your hand, preserving it from such strains as heaving stones, crowbar,[1] and many other things which are bad for your hand, from giving them a chance to weary it. There is another cause which, if you indulge it, can make your hand so unsteady that it will waver more, and flutter far more, than leaves do in the wind, and this is indulging too much in the company of woman. Let us get back to our subject. Have a sort of pouch made of pasteboard,[2] or just thin wood, made large enough in every dimension for you to put in a royal folio, that is, a half; and this is good for you to keep your drawings in, and likewise to hold the paper on for drawing. Then always go out alone, or in such company as will be inclined to do as you do, and not apt to disturb you. And the more understanding this company displays, the better it is for you. When you are in churches or chapels, and beginning to draw, con-sider, in the first place, from what section you think you wish to copy a scene or figure; and notice where its darks and half tones and high lights come; and this means that you have to apply your shadow with washes of ink; to leave the natural ground in the half tones; and to apply the high lights with white lead.

[1] See Filippo Baldinucci, *Vocabolario toscano dell'arte del disegno, s.v.* "palo," in his *Opere* (Milan, 1809), III, 33, 34.

[2] *Fogli inchollati:* literally, "sheets glued," or "sized," or "pasted." I understand this to mean sheets of paper pasted together for greater thickness and strength. Sheets of paper glued together at the edges to produce a large surface for a full-sized cartoon are called for in I, 106, ll. 10, 11: *sfogli di charta inchollati insieme.* (See p. 111, below.)

HOW YOU SHOULD FIRST START DRAWING ON PAPER
WITH CHARCOAL, AND TAKE THE MEASUREMENT
OF THE FIGURE, AND FIX IT WITH A
SILVER STYLE.
CHAPTER XXX

First take the charcoal, slender, and sharpened like a pen, or like
your style; and, as the prime measurement which you adopt for draw-
ing, adopt one of the three which the face has, for it has three of them
altogether: the forehead, the nose, and the chin, including the mouth.
And if you adopt one of these, it serves you as a standard for the whole
figure, for the buildings and from one figure to another; and it is a
perfect standard for you provided you use your judgment in estimat-
ing how to apply these measurements.[1] And the reason for doing this
is that the scene or figure will be too high up for you to reach it with
your hand to measure it off. You have to be guided by judgment; and
if you are so guided, you will arrive at the truth. And if the propor-
tion of your scene or figure does not come out right at the first go,
take a feather, and rub with the barbs of this feather—chicken or
goose, as may be—and sweep the charcoal off what you have drawn.
That drawing will disappear. And keep starting it over from the be-
ginning until you see that your figure agrees in proportion with the
model. And then, when you feel that it is about right, take the silver
style and go over the outlines and accents of your drawings, and over
the dominant folds, to pick them out. When you have got this done,
take the barbed feather once more, and sweep the charcoal off thor-
oughly; and your drawing will remain, fixed by the style.

HOW YOU SHOULD DRAW AND SHADE WITH WASHES
ON TINTED PAPER, AND THEN PUT LIGHTS
ON WITH WHITE LEAD.
CHAPTER XXXI

When you have mastered the shading, take a rather blunt brush;
and with a wash of ink in a little dish proceed to mark out the course
of the dominant folds with this brush; and then proceed to blend the
dark part of the fold, following its course. And this wash ought to be

[1] See n. 6, p. 43, below.

practically like water, just a little tinted, and the brush ought to be almost always practically dry. Without trying to hurry, go on shading little by little, always going back with this brush into the darkest areas. Do you know what will come of it?—If this water is just a little tinted, and you shade with enjoyment, and without hurrying, you will get your shadows well blended, just like smoke. Remember always to work with the flat of the brush. When you have gone as far as you can with this shading, take a drop or two of ink and put it into this wash, and mix it up well with this brush. And then in the same way pick out the very bottoms of those folds with this brush, picking out their foundations carefully; always remembering your ⟨system of⟩ shading, that is, to divide into three sections: one section, shadow; the next, the color of your ground; the next, with lights put on it. When you have got this done, take a little white lead well worked up with gum arabic. (I will explain this to you later on, how this gum is to be dissolved and melted; and I will explain about all the temperas.) Ever so little white lead is enough. Have some clear water in a little dish, and moisten this same brush of yours in it; and rub it over this ground white lead in the little dish, especially if this is dried up. Then dress it on the back of your hand or your thumb, shaping and squeezing out this brush, and getting it empty, practically draining it. And begin rubbing the brush flat over and into the areas where the high light and relief are to come; and proceed to go over them many times with your brush, and handle it judiciously. Then, for the accents of the reliefs, in the greatest prominence, take a pointed brush, and touch in with white lead with the tip of this brush, and crisp up the tops of these high lights. Then proceed to crisp up with a small brush, with straight ink, marking out the folds, the outlines, noses, eyes, and the divisions in the hairs and beards.

HOW YOU MAY PUT ON LIGHTS WITH WASHES OF
WHITE LEAD JUST AS YOU SHADE WITH
WASHES OF INK.
CHAPTER XXXII

I advise you, furthermore, when you get to be more experienced, to try to put on lights perfectly with a wash, just as you do the wash of

ink. Take white lead ground with water, and temper it with yolk of egg; and it blends like an ink wash, but it is harder for you to handle, and more experience is needed. All this is known as drawing on tinted paper, and it is the path to lead you to the profession of painting. Follow it constantly as much as you can, for it is the essence of your study. Apply yourself to it enthusiastically, and with great enjoyment and pleasure.

HOW TO MAKE GOOD AND PERFECT AND SLENDER COALS FOR DRAWING.
CHAPTER XXXIII

Before going any farther, I want to show you in what fashion you should make the coals for drawing. Take a nice, dry, willow stick; and make some little slips of it the length of the palm of your hand, or, say, four fingers. Then divide these pieces like match sticks; and do them up like a bunch of matches. But first smooth them and sharpen them at each end, like spindles. Then tie them up in bunches this way, in three places to the bunch, that is, in the middle and at each end, with a thin copper or iron wire. Then take a brand-new casserole, and put in enough of them to fill up the casserole. Then get a lid to cover it, ⟨luting it⟩ with clay,[1] so that nothing can evaporate from it in any way.Then go to the baker's in the evening, after he has stopped work, and put this casserole into the oven; and let it stay there until morning; and see whether these coals are well roasted, and good and black. If you find that they are not roasted enough, you must put the casserole back into the oven, for them to get roasted. How are you to tell whether they are all right?—Take one of these coals and draw on some plain or tinted paper, or on a gessoed panel or ancona. And if you find that the charcoal takes, it is all right; and if it is roasted too much, it does not hold together in drawing, but breaks into many pieces. I will also give you another method for making these coals: take a little earthenware baking pan, covered as described above; put it under the fire in the evening, and cover this fire well with ashes; and go to bed. In the morning they will be roasted. And you may

[1] *Crea.* See n. 3, p. 129, below.

make big coals and little ones in the same way; and make them to suit yourself, for there are no better coals anywhere.

ABOUT A STONE WHICH HAS THE CHARACTER OF CHARCOAL FOR DRAWING.
CHAPTER XXXIIII
ENDS THE FIRST SECTION OF THIS BOOK.

Also for drawing, I have come across a certain black stone, which comes from Piedmont; this is a soft stone; and it can be sharpened with a penknife, for it is soft. It is very black. And you can bring it to the same perfection as charcoal. And draw as you want to.

THE SECOND SECTION OF THIS BOOK:
BRINGING YOU TO THE WORKING UP OF THE COLORS.
CHAPTER XXXV

To approach the glory of the profession step by step, let us come to the working up of the colors, informing you which are the choicest colors, and the coarsest, and the most fastidious; which one needs to be worked up or ground but little, which a great deal; which one calls for one tempera, which requires another; and just as they differ in their colors, so do they also in the characters of their temperas and their working up.

THIS SHOWS YOU THE NATURAL COLORS, AND HOW YOU SHOULD GRIND BLACK.
CHAPTER XXXVI

Know that there are seven natural colors,[1] or rather, four actually mineral in character, namely, black, red, yellow, and green; three are

[1] Cennino makes his bow to an old tradition in mentioning the number "seven" here. As Albertus Magnus says, "si quis . . . ad speciem et materiam descendat, erunt amplioris diversitatis." (*Liber de sensu et sensato,* Tract. II, Cap. VII, in ed. A. Borgnet, *Opera Omnia* [Paris, 1890], IX, 60, col. 2.) Albertus explains (*op. cit.,* Tract. II, Cap. V, *ed. cit.,* IX, 53) that colors are divided arbitrarily into seven in order to bring them into harmony with the classifications of "saporum et sonorum et aliorum sensibilium. . . . Una ratio est de omnibus." The number of colors was linked also with the number of planets. (See J. LeBègue, *Tabula etc., s.v.* "color," in Mrs. Mary P. Merrifield, *Original Treatises Dating from the xiith to xviiith Centuries, on the Arts of Painting* . . . [London, 1849], I, 23.) The *De arte illuminandi, ed. cit.,* p. 68, mentions seven colors, "naturales . . . ac necessarii ad illuminandum." The theoretical

natural colors, but need to be helped artificially, as lime white, blues—ultramarine, azurite[2]—giallorino.[3] Let us go no farther, but return to the black color. To work it up properly, take a slab of red porphyry, which is a strong and solid stone; for there are various kinds of slabs for grinding colors, such as porphyry, serpentine, and marble. Serpentine is a soft stone and is not good; marble is still worse, for it is too soft. But porphyry is best of all; and it will be better if you get one of those which are not so very much polished, and a foot[4] or more in width, and square. Then get a stone to hold in your hand, also of porphyry, flat underneath, and rounded on top in the shape of a porringer, and smaller than a porringer, shaped so that your hand may be able to guide it readily, and to move it this way and that, at will. Then take a portion of this black, or of any other color, the size of a nut; and put it on this stone, and with the one which you hold in your hand crush this black up thoroughly. Then take some clear river or fountain or well water, and grind this black for the space of half an hour, or an hour, or as long as you like; but know that if you were to work it up for a year it would be so much the blacker and better a color. Then get a thin wooden slice,[5] three fingers broad; and

arrangement of seven is described as follows by Bartholomaeus Anglicus, *Liber de proprietatibus rerum*, XIX, 5:

"Nigrum et album concurrant equaliter ad compositiones coloris medii, et tunc erit color equedistans inter extremos ut rubedo. Inter album vero et rubeum non possunt esse nisi duo, unus magis appropinquabit albo, et alius rubeo. Inter rubeum vero et nigrum erunt similiter duo."

The distinction between "natural" and "artificial" colors is also an ancient one. Vincent of Beauvais, *Speculum naturale*, VII, 97, points out that "colores . . . quidam ex terra vel in terra nascuntur. . . . Quidam vero finguntur: aut arte, aut permixtione." (Pliny, *Historia naturalis*, XXXV, 6, is his authority. See also Isidore of Seville, *Etym.*, XIX, 17, 2.)

[2] *R:* "ultramarine or azurite." For "azurite" see above, Preface, p. xiii.

[3] See above, Preface, p. xv; also n. 2, p. 28, below.

[4] *Mezzo braccio.* See above, Preface, p. xiii.

[5] *Steccha di legnio.* For the tool "slice," see *NED, s.v.*, II, 5. (Cf. also *idem,* II, 4, a; 4, b, and 7, a.) *Stecca,* "spatula," must be distinguished from *mella,* also a "spatula," for which I reserve that word. In the *stecca,* "slice," the edge of the blade runs at right angles to the axis of the handle, as in a putty knife, or painter's "broad knife." The *mella,* on the other hand, has a blade with its edges parallel with the axis of the handle, like a table knife. The *stecca* is handled in a position roughly vertical; the *mella,* rather horizontal. The use of this word "slice," for the implement in question here, I owe to the designer of this volume, Mr. Carl P. Rollins, who informs me that just such a tool is used by printers to handle ink on the slab. An illustration of a slice, ready for the

it should have an edge like a knife; and scrape over the slab with this edge, and gather the color up neatly; and always keep it liquid, and not too dry, so that it may run well on the stone, and so that you may be able to grind it thoroughly, and gather it up well. Then put it into the little jar, and put enough of the aforesaid clear water in with it to fill up the jar; and always keep it under water in this way, and well covered from dust and all contamination, say in a little chest arranged to hold several jars of liquors.[6]

HOW TO MAKE VARIOUS SORTS OF BLACK.
CHAPTER XXXVII

Know that there are several kinds of black colors. There is a black which is a soft, black stone; it is a fat color.[1] Bearing in mind that every lean color is better than the fat one (except that, for gilding, the fatter the bole or terre-verte which you get for gilding on panel, the better the gold comes out), let us leave this section. Then there is a black which is made from vine twigs; these twigs are to be burned; and when they are burnt, throw water on them, and quench them; and then work them up like the other black. And this is a color both black and lean; and it is one of the perfect colors which we employ; and it is the whole. . . .[2] There is another black which is made from burnt almond shells or peach stones, and this is a perfect black, and fine. There is another black which is made in this manner: take a lamp full of linseed oil, and fill the lamp with this oil, and light the lamp. Then put it, so lighted, underneath a good clean baking dish, and have the little flame of the lamp come about to the bottom of the dish, two or three fingers away, and the smoke which comes out of

color grinder's use, may be found in the *Titelbild* of the first book of Valentin Boltz von Ruffach's *Illuminierbuch, wie man allerley farben bereitte, mischen, schattieren unnd ufftragen soll* . . . (Basel, 1549); in C. J. Benziger's edition in *Sammlung maltechnischer Schriften*, IV (Munich: Callwey, 1913), facing p. 32.

[6] *R*, "several jars of varied colors." I have ordinarily translated *vaselli* as "dishes," and *vasellini* as "little dishes"; but here something in the nature of a jar is surely intended. (Very convenient little wide-mouthed bottles holding an ounce or two, provided with screw caps of non-rusting material, can be obtained nowadays for the purpose.)

[1] See Preface, p. xii.

[2] The conclusion of this sentence has been lost from the text; and there seems to be no evidence for reconstructing it.

the flame will strike on the bottom of the dish, and condense in a mass. Wait a while; take the baking dish, and with some implement sweep this color, that is, this soot, off on to a paper, or into some dish; and it does not have to be worked up or ground, for it is a very fine color. Refill the lamp with the oil in this way several times, and put it back under the dish; and make as much of it in this way as you need.

ON THE CHARACTER OF THE RED COLOR CALLED SINOPER.
CHAPTER XXXVIII

A natural color known as sinoper, or porphyry, is red; and this color is lean and dry in character. It stands working up well; for the more it is worked up, the finer it becomes. It is good for use on panel or anconas, or on the wall, in fresco or in secco. And I will explain this "fresco" and "secco" to you when we discuss working on the wall. And let this do for the first red.

HOW TO MAKE THE RED CALLED CINABRESE, FOR DOING FLESH ON THE WALL; AND ABOUT ITS CHARACTER.
CHAPTER XXXVIIII

A color known as light cinabrese is red, and as far as I know this color is not used anywhere but in Florence; and it is very perfect for doing flesh, or making the flesh colors of figures on a wall; and use it in fresco. This color is made of the handsomest and lightest sinoper obtainable;[1] and it is mixed and worked up with lime white;[2] and this white is made from very white and well-purified lime. And when these two colors are well worked up together, that is, the two parts

[1] There seems to be a distinction intended in this chapter between "cinabrese" and "light cinabrese." The color cinabrese proper seems to have been a reselected light variety of sinoper, perhaps corresponding to Pozzuoli red of modern trade. Two parts of this ground with one of lime white produced the color light cinabrese. Cennino does not make very clear this distinction, which may possibly boil down to a mere slip of the pen: *cinabrese* for *sinopia* in the next sentence. (See I, 23, l. 22.) But "light cinabrese" is specified several times in Chapter LXVII, pp. 42, 47, below.

[2] Literally, "with St. John's white, as it is called in Florence."

cinabrese[3] and the third lime white, make little cakes of it, like halves of nuts, and let them dry. Whenever you need some, take what you think fit; for this color does you great credit in painting countenances, hands, and nudes on the wall, as I have said. And you can make handsome costumes with it sometimes, which, on the wall, will seem to be vermilion.[4]

ON THE CHARACTER OF THE RED CALLED VERMILION; AND HOW IT SHOULD BE WORKED UP.
CHAPTER XL

A color known as vermilion is red; and this color is made by alchemy, prepared in a retort. I am leaving out the system for this, because it would be too tedious to set forth in my discussion all the methods and receipts. Because, if you want to take the trouble, you will find plenty of receipts for it, and especially by asking of the friars. But I advise you rather to get some of that which you find at the druggists' for your money, so as not to lose time in the many variations of procedure. And I will teach you how to buy it, and to recognize the good vermilion. Always buy vermilion unbroken, and not pounded or ground. The reason? Because it is generally adulterated, either with red lead or with pounded brick. Examine the unbroken lump of vermilion; and at the top, where the structure[1] is most spread out and delicate, that is the best. Then put this on the aforesaid slab, and grind it with clear water as much as ever you can; for if you were to grind it every day for twenty years, it would still be better and more perfect. This color calls for various temperas, according to the situations in which you have to use it, which we shall deal with later on; and I will teach you where it is most appropriate. But bear in mind that it is not its nature to be exposed to the air, but it stands up better on panel than on the wall; because, in the course of time, from exposure to the air, it turns black when it is used and laid on the wall.

[3] Read *sinoper?* See n. 1, p. 23, above.

[4] The name of this color, *cinabrese,* suggests its resemblance to vermilion (*cinabro*), for which it was used as a substitute in fresco. (At the end of this chapter XL, Cennino mentions the fact that vermilion should not be used in fresco.)

[1] *Tiglio.* This refers to the crystalline formation. See n. 1, p. 25, and n. 4, p. 82, below.

ON THE CHARACTER OF A RED CALLED RED LEAD.
CHAPTER XLI

A color known as red lead is red, and it is manufactured by alchemy. This color is good only for working on panel, for if you use it on the wall it soon turns black, on exposure to the air, and loses its color.

ON THE CHARACTER OF A RED CALLED HEMATITE.[1]
CHAPTER XLII

A color known as hematite is red. This color is natural, and it is a very strong and solid stone. And it is so solid and perfect that stones and crooks are made of it for burnishing gold on panel;[2] and they acquire a black and perfect color, dark as a diamond.[3] The pure stone is the color of purple or turnsole, and has a structure like vermilion.[4] Pound this stone in a bronze mortar at first, because if you broke it up on your porphyry slab you might crack it. And when you have got it pounded, put on the slab as much of it as you want to work up, and grind it with clear water; and the more you work it up, the better and more perfect color it becomes. This color is good on the wall, for working in fresco; and makes a color for you like a cardinal's,[5] or a

[1] *Amatisto, o ver amatito:* "hematite" >Greek λίθος αἱματίτης, from αἷμα, "blood." This is the stone from which Cennino's burnishers were made. (See Chapter CXXXVI, p. 82, below.) It is still used for making burnishers (though, as far as I know, now only for gold- and silver-smiths), and these appear in trade as "Bloodstone burnishers."

Bloodstone, properly called hematite, consists principally of ferric oxide, Fe_2O_3, substantially pure. It occurs in several well-marked forms in nature: (1) amorphous, as a sort of reddle or sinoper; (2) "kidney ore," which, as the name implies, is reniform in structure; (3) "pencil ore," which has a straight grain; (4) "specular iron-ore," a tabular, crystalline form which corresponds exactly with Cennino's description in Chapter CXXXVI, p. 82, below. It is this crystalline form which Cennino uses for making burnishers; and the same form which he pounds and grinds up for use as a color. This is made certain by his statement in this chapter that it "has a structure like cinnabar," for specular iron ore, like most native cinnabar, crystallizes in the hexagonal system, with rhombohedral symmetry.

[2] See Chapter CXXXVI, p. 82, below. Note that *dentelli,* "crooks," are made from this hematite: these are not to be confused with burnishers made of animals' teeth, *denti.* See n. 2 on Chapter CXXXV, below.

[3] Perhaps "as adamant"? See n. 4, p. 83, below.

[4] See n. 1, above.

[5] See Mrs. Mary P. Merrifield, *Original Treatises* . . . (London, 1849), II, 327. (Cf. also, *ibid.,* p. 453, "Bolognese Manuscript," § 136: "A fare perfecto collore de grana cardinalesco cum verzino. . . .")

purple, or lac color. It is not good to try to use it for other things, or with temperas.

ON THE CHARACTER OF A RED CALLED DRAGONSBLOOD.
CHAPTER XLIII

A color known as dragonsblood is red. This color is used occasionally on parchment, for illuminating. But leave it alone, and do not have too much respect for it; for it is not of a constitution to do you much credit.

ON THE CHARACTER OF A RED CALLED LAC.[1]
CHAPTER XLIIII

A color known as lac is red, and it is an artificial color. And I have various receipts for it; but I advise you, for the sake of your works, to get the color ready-made for your money. But take care to recognize the good kind, because there are several types of it. Some lake[2] is made from the shearings of cloth,[3] and it is very attractive to the eye. Beware of this type, for it always retains some fatness in it, because of the alum,[4] and does not last at all, either with temperas or without temperas, and quickly loses its color. Take good care to avoid this;

[1] *Lacca.* I translate this "lac," rather than "lake," because of the indefinite character of the latter. Cennino meant specifically "lac lake," that is, a lake which is made from the gum *lac*, "the dark-red resinous incrustation produced on certain trees" (resiniferous species of the genera *Schleichera, Butea, Ficus, etc.*) by an insect, *Coccus* or *Carteria lacca.* (See *NED, s.v.* "lac,"[1] 1, 2; also *Merck's Index* [1930], *s.v.* "shellac.") "Lake" originally signified the color made from "lac,"[1] 1, but gradually took on a wider meaning, and the original connection with lac proper is now almost wholly forgotten.

[2] Here *lacca* is used in the general sense of a "lake" color, an organic coloring matter precipitated out on a metallic base, in this case, alumina.

No general classification of medieval receipts for "lakes" can be attempted here, but two rules may be cited: the first, found in Merrifield, *op. cit.,* I, 63, in the *Experimenta de coloribus,* § 37, may serve to represent the manufacture of what Cennino calls "the good kind"; while the second, *ibid.,* p. 53, § 13, "Ad faciendum lacham finissimam," may stand for the type which he condemns.

[3] *Cimatura di drappo, o ver di panno. Drappo* seems to imply a silk material, as *zendado* does; *panno* may refer to wool or linen.

[4] The "Bolognese Manuscript," § 110, in Merrifield, *op. cit.,* II, 433–435, mentions specifically that "quando [*sic*] se fa quella purgationi de lo allumi, tanto e piu bella, piu viva, et melglio."

but get the lac which is made from gum;[5] and it is dry, lean, granular, and looks almost black, and contains a sanguine color. This kind cannot be other than good and perfect. Take this, and work it up on your slab; grind it with clear water. And it is good on panel; and it is also used on the wall with a tempera; but the air is its undoing. There are those who grind it with urine; but it becomes unpleasant, for it promptly goes bad.

ON THE CHARACTER OF A YELLOW COLOR
CALLED OCHER.
CHAPTER XLV

A natural color known as ocher is yellow. This color is found in the earth in the mountains, where there are found certain seams resembling sulphur; and where these seams are, there is found sinoper, and terre-verte and other kinds of color. I found this when I was guided one day by Andrea Cennini, my father, who led me through the territory of Colle di Val d'Elsa, close to the borders of Casole, at the beginning of the forest of the commune of Colle, above a township called Dometaria. And upon reaching a little valley, a very wild steep place, scraping the steep with a spade, I beheld seams of many kinds of color: ocher, dark and light sinoper, blue, and white; and this I held the greatest wonder in the world—that white could exist in a seam of earth; advising you that I made a trial of this white, and found it fat, unfit for flesh color. In this place there was also a seam of black color. And these colors showed up in this earth just the way a wrinkle shows in the face of a man or woman.

To go back to the ocher color, I picked out the "wrinkle" of this color with a penknife; and I do assure you that I never tried a handsomer, more perfect ocher color. It did not come out so light as giallorino; a little bit darker; but for hair, and for costumes, as I shall teach you later, I never found a better color than this. Ocher color is of two sorts, light and dark. Each color calls for the same method of working up with clear water; and work it up thoroughly, for it goes on getting better. And know that this ocher is an all-round color,

[5] See n. 1, p. 26, above.

especially for work in fresco; for it is used, with other mixtures, as I shall explain to you, for flesh colors, for draperies, for painted mountains, and buildings and horses, and in general for many purposes. And this color is coarse by nature.[1]

ON THE CHARACTER OF A YELLOW COLOR CALLED GIALLORINO.[2]
CHAPTER XLVI

A color known as giallorino is yellow, and it is a manufactured one. It is very solid, and heavy as a stone, and hard to break up. This color is used in fresco, and lasts forever, that is, on the wall; and on panel, with temperas. This color is to be ground, like the others aforesaid, with clear water. It does not want to be worked up very much, and, since it is very troublesome to reduce it to powder, you will do well to pound it in a bronze mortar, as you have to do with the hematite, before you work it up. And when you have made use of it, it is a very handsome yellow color; for with this color, with other mixtures, as I will show you, attractive foliage and grass colors are made. And as I understand it, this color is actually a mineral, originating in the neighborhood of great volcanoes; so I tell you that it is a color produced artificially, though not by alchemy.

ON THE CHARACTER OF A YELLOW CALLED ORPIMENT.
CHAPTER XLVII

A color known as orpiment is yellow. This color is an artificial one. It is made by alchemy, and is really poisonous. And in color it is

[1] In choosing between the readings *grasso*, with *R*, and *grosso*, with *L*, it is necessary to weigh several factors. In the neighborhood of Colle, Cennino might well have found the color which we know as "Raw Sienna." This is generically an ocher, and it is characteristically a "fat" color. Against this must be set the insistence of Cennino upon the virtue of "lean" colors (Chapter XXXVII, p. 22, above); his remark just above, that there are "two sorts, light and dark" (well marked in the ochers proper); and the fact that ocher is actually "coarse by nature." I think that the reading *grosso*, with *L*, must be preferred.

[2] The identification of this color must be attempted in a future study. For practical purposes, massicot, a yellow oxide of lead, prepared by roasting white lead, may be employed. Natural massicot, of volcanic origin, is known; but it is not generally available.

a handsome yellow more closely resembling gold than any other color. It is not good for use on a wall, either in fresco or with temperas, because it turns black on exposure to the air. It is very good for painting on shields and lances. A mixture of some of this color with Bagdad indigo gives a green color for grasses and foliage. Its tempera calls for nothing but size. Sparrowhawks are physicked with this color against a certain illness which affects them. And this color is, to start with, the most refractory color to work up that there is in our profession. And so, when you want to work it up, put the amount you want on to your stone; and, with the one which you hold in your hand, proceed to coax it, little by little, so as to squeeze it from one stone to the other, mixing in a little of the glass of a broken goblet, because the powder of the glass attracts the orpiment to the roughness of the stone. When you have got it powdered, put some clear water on it, and work it up as much as you can; for if you were to work it for ten years, it would constantly become more perfect. Beware of soiling your mouth with it, lest you suffer personal injury.

ON THE CHARACTER OF A YELLOW WHICH IS CALLED REALGAR.
CHAPTER XLVIII

A yellow color known as realgar is yellow. This color is really poisonous. We do not use it, except sometimes on panel. There is no keeping company with it. When you want to work it up,[1] adopt those measures which I have taught you for the other colors. It wants to be ground a great deal with clear water. And look out for yourself.

ON THE CHARACTER OF A YELLOW CALLED SAFFRON.
CHAPTER XLVIIII

A color which is made from an herb called saffron is yellow. You should put it on a linen cloth, over a hot stone or brick. Then take half a goblet or glass full of good strong lye. Put this saffron in it; work it up on the slab. This makes a fine color for dyeing linen or cloth. It is good on parchment. And see that it is not exposed to the

[1] I, 28, footnote, "20. L Volendolo . . . macinare": for "20" read "30."

air, for it soon loses its color. And if you want to make the most perfect grass color imaginable, take a little verdigris and some saffron; that is, of the three parts let one be saffron; and it comes out the most perfect grass-green imaginable, tempered with a little size, as I will show you later.

ON THE CHARACTER OF A YELLOW CALLED ARZICA.[1]
CHAPTER L

A color known as arzica is yellow; and this color is made alchemically, and is but little used. Working with this color is chiefly a matter for illuminators; and it is used more in the neighborhood of Florence than anywhere else. This is a very thin color. It fades in the open; it is not good on the wall; it is all right on panel. It makes a lovely green if you mix in a little azurite and giallorino. Like the other choice colors it wants to be ground with clear water.

ON THE CHARACTER OF A GREEN CALLED TERRE–VERTE.
CHAPTER LI

A natural earth color which is called terre-verte is green. This color has several qualities: first, that it is a very fat color. It is good for use in faces, draperies, buildings, in fresco, in secco, on wall, on panel, and wherever you wish. Work it up with clear water, like the other colors mentioned above; and the more you work it up, the better it will be. And, if you temper it as I shall show you ⟨for⟩ the bole for gilding, you may gild with this terre-verte in the same way. And know that the ancients never used to gild on panel except with this green.

[1] The pigment intended here is probably a preparation of weld, "dyers' weed," *Reseda luteola*. A rule "A fare l'arzica bona et bella" occurs in the "Bolognese Manuscript," § 194 (Merrifield, *op. cit.*, II. 483–485), which very likely represents the manufacture of the pigment known to Cennino by the same name. A pound of the chopped plant is soaked in water sufficient to cover it, and boiled down to a half. Then two ounces of finely ground travertine, or an equal weight of white lead, together with a half ounce of rock alum, are added gradually to the hot tincture. The precipitate is allowed to settle, and is then dried off in a hollowed brick, and then on a board. *Reseda luteola* is a common weed in Europe, and has been reported as growing wild on Long Island, N. Y.

ON THE CHARACTER OF A GREEN CALLED MALACHITE.[1]
CHAPTER LII

A half natural color is green; and this is produced artificially, for it is formed out of azurite; and it is called malachite. I will not tell you how it is produced, but buy it ready-made. This color is good in secco, with a tempera of yolk of egg, for making trees and foliage, and for laying in. And put the lights on it with giallorino. This color is rather coarse by nature, and looks like fine sand. For the sake of the color, work it up very, very little, with a light touch; for if you were to grind it too much, it would come out a dingy and ashy color.[2] It should be worked up with clear water; and when you have got it worked up, put it into the dish; put some clear water over the color, and stir the water up well with the color. Then let it stand for the space of one

[1] *Verde azurro:* literally, "blue green." The following chapter serves to identify Cennino's *verde azurro* as malachite, and also Cennino's *azurro della Magna* as azurite. It is curious to note that all translators of this chapter have overlooked the force of the *che* in the opening sentence: ". . . questo si fa artifitialmente, chessi fa d'azurro della Mangnia." (All the Italian editions interpret this correctly as "chè si fa.") Cennino's point is based on the fact that in nature the green hydrated copper carbonate, malachite, $CuCO_3 \cdot Cu(OH)_2$, is formed gradually out of the blue carbonate, azurite, $2CuCO_3 \cdot Cu(OH)_2$, the two being often found blended in a single sample of ore. Just as in the case of giallorino, in Chapter XLVI, p. 28, above, Cennino drew the line at calling any material "natural" which was produced by anything so alchemical in character as a volcano, so here he attempts a subtle distinction: "I cannot say that this green is absolutely a natural color," he implies, *"because* it is formed out of this blue. I regard the blue as natural enough, but I cannot allow that a green formed from it is more than half natural, even though it be found in nature." Mrs. Merrifield and Lady Herringham translate: "There is a green [pigment] which is partly natural, but requires artificial preparation. It is made of azzuro della magna." Ilg translates: "Grün ist auch eine Farbe, welche natürlich ist, die man aber auch künstlich erzeugt, dann macht man sie aus Azzurro della Magna." I think that Cennino was simply quibbling. No artificial preparation is required for malachite, beyond the simple process of grinding and washing which Cennino describes. There are relatively few references to it in the literature; and none, so far as I know, to any method for manufacturing it artificially from the blue.

[2] This caution makes certain the identification of *verde azurro* with malachite. The green color of this pigment practically disappears if the crystals are ground too fine. Malachite green is easily recognized by its blue-green color, and sandy, crusty surface. No other green pigment, known to have been used in the Middle Ages, and possessing the characteristics assigned to *verde azurro* in this chapter, stands in the close relation to a blue pigment which Cennino specifies for this, as malachite does to azurite. I therefore feel justified in translating *verde azurro* as "malachite," and *azurro della Magna,* as "azurite." (See n. 1, p. 35, below.)

hour, or two or three; and pour off the water; and the green will be more beautiful. And wash it this way two or three times, and it will be still more beautiful.

HOW YOU MAKE A GREEN WITH ORPIMENT AND INDIGO.
CHAPTER LIII

A color which is made of orpiment, two parts, and one part indigo, is green; and it is worked up well with clear water. This color is good for painting shields and lances, and is also used for painting rooms in secco. It does not want any tempera except size.

HOW YOU MAKE A GREEN WITH BLUE AND GIALLORINO.
CHAPTER LIIII

A color which is made of azurite and giallorino is green. This is good on wall and on panel. It is tempered with yolk of egg. If you want it to be more beautiful, put in a little arzica. And also it will be a handsome color if you put into the azurite some wild plums,[1] crushing them up; and make a verjuice of them, and put four or six drops of this verjuice on this azurite; and it will be a beautiful green. It will not stand exposure to the air; and in the course of time the juice of the plums will eventually disappear.

[1] *Prungnole salvatiche:* These are not necessarily the fruit of any tree known to modern botany as a *Prunus.* They may be identical with the *pruni meroli* or *prugnameroli,* of the *De arte illuminandi* (ed. de La Marche, *cit. supra,* pp. 71, 83, 84), which the author tells us were found near Rome. Petrus de Sancto Audemaro, § 159 (Merrifield, *op. cit.,* I, 127), speaks of adding some *succum cerosium* to a mixed green, apparently to improve the color. So far, a member of the large family of *Prunus* seems to be suggested: possibly *P. spinosa.*

As far as I have been able to learn, no *Prunus* fruits produce a juice of a strong yellow color (I have every reason to believe that that of *P. spinosa* is a rich red); and it is evident from the use made of them by Cennino that the *prungnole salvatiche* were either very yellow or green. The "Bolognese Manuscript," § 96 (Merrifield, *op. cit.,* II, 423–425), "Affare verde azurro" (not to be confused with the *verde azurro* of Cennino), describes a green made from blue stained with saffron, and mentions as alternatives to the saffron, "quella terra gialla tenta cum lo sugo de spino gerbino et vira verde; o vero cum lo sugo de spino gerbino." This *spino gerbino,* the use of which parallels so closely that of the *prugnole* in Cennino's rule, is a variety of *Rhamnus.* Niccolo Tommaseo, *Dizionario, s.v.* "cervino," states: "Per lo piu è aggiunto d'una

HOW YOU MAKE A GREEN WITH ULTRAMARINE BLUE.
CHAPTER LV

A color which is made of ultramarine blue and orpiment is green. You must combine these colors prudently. Take the orpiment first, and mix the blue with it. If you want it to incline toward light, let the orpiment predominate; if you want it to incline toward dark, let the blue prevail. This color is good on panel, but not on the wall. Temper it with size.

ON THE CHARACTER OF A GREEN CALLED VERDIGRIS.
CHAPTER LVI

A color known as verdigris is green. It is very green by itself. And it is manufactured by alchemy, from copper and vinegar. This color is good on panel, tempered with size. Take care never to get it near any white lead, for they are mortal enemies in every respect. Work it up with vinegar, which it retains in accordance with its nature. And if you wish to make a most perfect green for grass . . .,[1] it is beautiful to the eye, but it does not last. And it is especially good on paper or parchment, tempered with yolk of egg.

HOW YOU MAKE A GREEN WITH WHITE LEAD AND TERRE-VERTE; OR LIME WHITE.
CHAPTER LVII

A sage color which is made by mixing white lead and terre-verte is

specie di Ramno detto Spincervino . . . (*Rhamnus infectorius*, L.) che è pianta delle cui coccole non mature [compare "Paduan Manuscript," § 29, Merrifield, *op. cit.*, II, 663] si fa il Giallo santo, e colle mature [compare "Bolognese Manuscript," § 89, *ibid.*, p. 421] il Verde di vescica." (See also *Vocabolario . . . della Crusca, s.v.* "cervino," § 11.)

The question must be left open for the present, but there is a fair possibility that the *prugnolo* which bore Cennino's *prugnole salvatiche* was a *Rhamnus*, and that its fruits were "plums" only in a popular, unscientific sense. *Rhamnus infectorius* is not the only possibility: *R. alaternus* and *R. catharticus* might easily have been available, or even, perhaps, the superior oriental varieties, *R. saxatilis, R. amygdalinus,* and *R. oleoides.* These are the kinds which until fairly recent years found considerable use under the name of "Persian berries" as yellow dyestuffs. "Yellow berries" was the name applied generally to the whole group, and it is tempting to translate Cennino's *prungnole salvatiche* in that way.

[1] Something seems to have been omitted here: probably a direction to mix the verdigris with saffron. See Chapter XLVIIII, p. 30, above.

green. It is good on panel, tempered with yolk of egg, or on the wall, in fresco, with the terre-verte mixed with lime white, made from white, prepared lime.

ON THE CHARACTER OF LIME WHITE.
CHAPTER LVIII

A natural color, but still artificially prepared, is white, and it is made as follows: take good white air-slaked lime; put it, in the form of powder, into a pail for the space of eight days, adding clear water every day, and stirring up the lime and water thoroughly, so as to get all the fatness out of it. Then make it up into little cakes; put them up on the roofs in the sun; and the older these cakes are, the better the white will be. If you want to make it quickly and well, when the cakes are dry, work them up with water on your stone; and then make it into little cakes and dry them again; and do this twice, and you will see how perfect the white will be. This white is worked up with water, and it wants to be ground thoroughly. And it is good for working in fresco, that is, on a wall without any tempera; and without this you cannot accomplish anything in the way of flesh color and other mixtures of the other colors which you make for a wall, that is, for fresco; and it never wants any tempera whatever.

ON THE CHARACTER OF WHITE LEAD.
CHAPTER LVIIII

A color made alchemically from lead is white, and it is called white lead. This white lead is very brilliant; and it comes in little cakes like goblets or drinking glasses. And if you wish to recognize the choicest sort, always take some of that on the top of the lump, which is shaped like a cup. The more you grind this color, the more perfect it will be. And it is good on panel. It is even used on walls, but avoid it as much as you can, for in the course of time it turns black. It is ground with clear water; it is compatible with any tempera, and it serves you as your whole standard for lightening all colors on panel, just as lime white does on the wall.

ON THE CHARACTER OF AZURITE.
CHAPTER LX

Natural blue is a natural color which exists in and around the vein of silver. It occurs extensively in Germany, and also in that . . .[1] of Siena. It is quite true . . .,[1] or plastic, it wants to be brought to perfection. When you have to lay it in, you must work up some of this

[1] It is hard to estimate the extent or character of these lacunae, and any reconstruction of this passage must be too much a matter of conjecture for inclusion here.

A rule for preparing the pigment from mineral azurite may be found in the "Bolognese Manuscript," § 17, Merrifield, *op. cit.,* II, 365–369. But for practical purposes I may mention here that it is necessary only to crush and grind a piece of the stone, and to wash the resulting powder by decantation. By saving the washings and allowing them to settle separately, numerous grades of pigment, varying in fineness and color, will readily be secured. (See p. 93, below, for the use of a set of these graded blues.) This process is described by Ambrogio di Ser Pietro da Siena in his *Ricepte daffare piu colori,* appended to a Confessional, Siena, MS. I, 11, 19 (dated 1462), fol. 101. A translation of this passage follows:

"When you want to refine azurite (*l'açurro de la Magna*), take three ounces of honey, as light as you can get, and cut it with a little hot lye, not too strong. And then put in a pound of blue, and mix it up. Get it tempered so that you can grind it. Then take a little of this blue; put it on the porphyry, and grind it well. And put all the ground part into a glazed porringer by itself, and put into it some lye as hot as your hand can bear. And get the blue well spread through it, and mix it and stir it up thoroughly with your hand. Then let it settle until all the blue goes to the bottom. Then draw off all the water; and if you find that the water is charged with blue, put it into another porringer, and let it settle thoroughly. And then take some hot water and put it on to the blue, mixing it up with your hand as described above so as to get all the honey out of it. And then divide it up in this way:

"Take some warm water and put some on to the blue, and mix it up with your hand, as stated. Then let it settle for a while, and promptly put this water so tinted into another porringer; and keep all the substance of the coarse blue which stayed in the bottom separate, because that is the first grade, that is, the coarsest. And do the same with the second porringer which has settled for a while. Put that tinted water into another porringer. And this grade will be the best. And treat the second, third and fourth in this way.

"When you have divided the blue by this means, take it out of the porringers, and put it to dry on a clean plate, or a little panel, well cleaned. And know that the second will be sky blue, which is good for pen-flourishing with the addition of a clothlet. The fourth is not good for much, but it is fit for making a green color with arzica when you are working with the brush or pen."

I have translated the isolated word *pastello* here as "plastic," as in Chapter LXII, *passim;* but it is quite possible that it should be read "woad" (French, *pastel*), the herb *Isatis tinctoria,* much used in imitation of indigo. My chief reason for preferring the translation "plastic" lies in the following passage from the *Liber Dedali Philosophi,* Florence, Biblioteca Riccardiana, MS. L.III.13, 19, foll. 195ᵛ, 196ʳ, quoted from ed. J. Wood Brown, in *An Enquiry into the Life and Legend of Michael Scot* (Edinburgh, 1897), Appendix III, § 14, pp. 245, 246:

". . . Invenitur quedam vena terre iuxta venam argenti. Illa terra optime teritur

blue with water, very moderately and lightly, because it is very scornful of the stone.[2] If you want it for working on draperies, or for making greens with it as I have told you above, it ought to be worked up more. This is good on the wall in secco, and on panel. It is compatible with a tempera of egg yolk, and of size, and of whatever you wish.

TO MAKE AN IMITATION OF AZURITE WITH OTHER COLORS.
CHAPTER LXI

A blue which is a sort of sky blue resembling azurite is made in this way: take some Bagdad indigo, and work it up very thoroughly with water; and mix a little white lead with it, on panel; and on the wall, a little lime white. It will look like azurite. It should be tempered with size.[1]

ON THE CHARACTER OF ULTRAMARINE BLUE, AND HOW TO MAKE IT.
CHAPTER LXII

Ultramarine blue is a color illustrious, beautiful, and most perfect, beyond all other colors; one could not say anything about it, or do anything with it, that its quality would not still surpass. And, because of its excellence, I want to discuss it at length, and to show you in detail how it is made. And pay close attention to this, for you will gain great honor and service from it. And let some of that color, combined with gold, which adorns all the works of our profession, whether on wall or on panel, shine forth in every object.

et distemperatur cum aqua calida et ponitur super linteum positum super aliquo vase, et colatur subtiliter. Et quod grassum et feculentum cadit in vase, proice. Quando autem fuerit purum vel iuxta illud, exsiccabitur et recondetur. Si autem non fuerit bene purum, terantur adhuc bene, et ponantur in aqua calida, et accipiatur pix, cera et masticis. Et dissolvatur et ducatur ita cum manu per vas ubi est azurum. Et depurabit eum a superfluitatibus terreis. Et si vena fuerit bona, azurium erit bonum. Si male, azurium erit malum."

[2] See the similar caution, p. 31, above, against grinding malachite too much. As these pigments depend for their color on light transmitted through them, it follows that excessive grinding, by increasing the reflecting surface and resultant scattering of light, will reduce their effectiveness as colors in any medium of low refractive index.

[1] That is, of course, the mixture with white lead, for use on panel.

To begin with, get some lapis lazuli. And if you want to recognize the good stone, choose that which you see is richest in blue color, because it is all mixed like ashes. That which contains least of this ash color is the best. But see that it is not the azurite stone, which looks very lovely to the eye, and resembles an enamel. Pound it in a bronze mortar, covered up, so that it may not go off in dust; then put it on your porphyry slab, and work it up without water. Then take a covered sieve such as the druggists use for sifting drugs; and sift it, and pound it over again as you find necessary. And bear in mind that the more finely you work it up, the finer the blue will come out, but not so beautifully violet[1] in color. It is true that the fine kind is more useful to illuminators, and for making draperies with lights on them.[2] When you have this powder all ready, get six ounces of pine rosin from the druggists, three ounces of gum mastic, and three ounces of new wax, for each pound of lapis lazuli; put all these things into a new pipkin, and melt them up together. Then take a white linen cloth, and strain these things into a glazed washbasin. Then take a pound of this lapis lazuli powder, and mix it all up thoroughly, and make a plastic of it, all incorporated together. And have some linseed oil, and always keep your hands well greased with this oil, so as to be able to handle the plastic. You must keep this plastic for at least three days and three nights, working it over a little every day; and bear in mind that you may keep it in the plastic for two weeks or a month, or as long as you like. When you want to extract the blue from it, adopt this method. Make two sticks out of a stout rod, neither too thick nor too thin; and let them each be a foot long; and have them well

[1] *Non si bello violante.* The translation *violante* as "violet"—or, better, "inclining toward violet"—in this connection is justified by the context. Further evidence that a violet cast was held in general esteem may be seen in the direction given by "Bolognese Manuscript," § 19, in Merrifield, *op. cit.,* II, 371: "Accipe lapis lazuli . . . et sit coloratus colore violatii"; and in many rules similar to Cennino's, on p. —, below, for mixing a crimson color with the blue. (Examples of these may be seen in the *Liber diversarum artium,* Montpellier, École de Médecine, MS 277, in *Catalogue général des manuscrits des bibliothèques publiques des départements,* I [Paris, 1849], 746, and in the "Bolognese Manuscript," § 70, Merrifield, *op. cit.,* II, 411–413.)

[2] See below, p. 93, and Chapter LXXII, pp. 51, 52. These draperies are *biancheggiati,* "modeled *up,*" in contrast to the type of blue drapery described in Chapter LXXXIII, pp. 54, 55, below, in which the only modeling is *darker* than the ground of blue.

rounded at the top and bottom, and nicely smoothed. And then have your plastic in the glazed washbasin where you have been keeping it; and put into it about a porringerful of lye, fairly warm; and with these two sticks, one in each hand, turn over and squeeze and knead this plastic, this way and that, just as you work over bread dough with your hand, in just the same way. When you have done this until you see that the lye is saturated with blue, draw it off into a glazed porringer. Then take as much lye again, and put it on to the plastic, and work it over with these sticks as before. When the lye has turned quite blue, put it into another glazed porringer, and put as much lye again on to the plastic, and press it out again in the usual way. And when the lye is quite blue, put it into another glazed porringer. And go on doing this for several days in the same way, until the plastic will no longer color the lye; and then throw it away, for it is no longer any good. Then arrange all these porringers in front of you on a table, in series: that is, the yields, first, second, third, fourth, arranged in succession; and with your hand stir up in each one the lye with the blue which, on account of the heaviness of this blue, will have gone to the bottom; and then you will learn the yields of the blue. Weigh the question of how many grades of blue you want: whether three or four, or six, or however many you want; bearing in mind that the first yields are the best, just as the first porringer is better than the second. And so, if you have eighteen porringers of the yields, and you wish to make three grades of blue, you take six of the porringers and mix them together, and reduce it to one porringer; and that will be one grade. And in the same way with the others. But bear in mind that if you have good lapis lazuli, the blue from the first two yields will be worth eight ducats an ounce. The last two yields are worse than ashes: therefore be prudent in your observation, so as not to spoil the fine blues for the poor ones. And every day drain off the lye from the porringers, until the blues are dry. When they are perfectly dry, do them up in leather, or in bladders, or in purses, according to the divisions which you have. And know that if that lapis lazuli stone was not so very good, or if you worked the stone up so much that the blue did not come out violet, I will teach you how to give it a little color.[3]

[3] See n. 1, p. 37, above.

Take a bit of pounded kermes[4] and a little brazil;[5] cook them to-
gether; but either grate the brazil or scrape it with glass; and then
cook them together with lye and a little rock alum; and when they
boil you will see that it is a perfect crimson[6] color. Before you take
the blue out of the porringer, but after it is quite dry of the lye, put
a little of this kermes and brazil on it; and stir it all up well with
your finger; and let it stand until it dries, without sun, fire, or wind.
When you find that it is dry, put it in leather, or in a purse, and leave
it alone, for it is good and perfect. And keep it to yourself, for it is an
unusual ability to know how to make it properly. And know that
making it is an occupation for pretty girls rather than for men; for
they are always at home, and reliable, and they have more dainty
hands. Just beware of old women. When you get around to wanting
to use some of this blue, take as much of it as you need. And if you
have draperies with lights on them[7] to execute, it ought to be worked
up a little on the regular stone. And if you want it just for laying in,
it wants to be worked over on the stone very, very lightly, always
using perfectly clear water, and keeping the stone well washed and
clean. And if the blue should get soiled in any way, take a little lye,
or clear water; and put it into the dish, and stir it up well; and you
will do this two or three times, and the blue will be purified entirely.
I am not discussing its temperas for you, because I shall be showing
you about all the temperas for all the colors later on, for panel, wall,
iron, parchment, stone, and glass.

[4] *Grana.* See *NED, s.v.* "grain," III, 10, a; also *ibid., s.v.* "kermes."

[5] *Verzino* appears in medieval Latin manuscripts in various forms, among others:
versinum, berxinum, berxilium, brexilium, brasilicum. I translate as *NED,* "brazil," I,
1, a; though the commonest equivalent in trade is probably "Pernambuco" or "Fernam-
buco." Botanical distinctions among the *Caesalpiniae* which yield the sort of wood
known to Cennino as *verzino* are not very carefully regarded nowadays, and were
probably still less so in Cennino's time. The matter has no great significance, however,
for the coloring principle, *Brazilin,* is common to them all. Any of the group (classifica-
tion attempted by F. Ullmann, *Enzyclopädie der technischen Chemie,* V [1930], 143–
144) will pass as *verzino;* possibly *Caesalpinia echinata,* or *C. cristata,* is, all told, most
likely to be the one Cennino knew.

[6] *Vermiglio.* Not "vermilion," but crimson, the color of kermes, the *"Vermiculus,*
color rubeus . . . qui fit ex frondibus silvestribus . . . et Grece ipsum dicunt coctum,"*
of J. LeBègue's "Tabula de vocabulis sinonimis et equivocis colorum, etc." (Merrifield,
op. cit., I, 38).

[7] See n. 2, p. 37, above.

THE IMPORTANCE OF KNOWING HOW TO MAKE BRUSHES.
CHAPTER LXIII

Now that I have spoken in detail about all the colors which are used with the brush, and about how they are worked up, and these colors ought always to be kept standing in a little chest, well covered up, always soaking and wet, I now want to show you how to use them, with tempera and without tempera. But you still need to know how to work with them: and this you cannot do without brushes. So let us drop everything, and first have you learn how to make these brushes; and you use this method for them.

HOW TO MAKE MINEVER BRUSHES.
CHAPTER LXIIII

In our profession we have to use two kinds of brushes: minever brushes, and hog's-bristle brushes. The minever ones are made as follows. Take minever tails, for no others are suitable; and these tails should be cooked, and not raw: the furriers will tell you that. Take one of these tails: first pull the tip out of it, for those are the long hairs; and put the tips of several tails together, for out of six or eight tips you will get a soft brush good for gilding on panel, that is, wetting down with it, as I will show you later on. Then go back to the tail, and take it in your hand; and take the straightest and firmest hairs out of the middle of the tail; and gradually make up little bunches of them; and wet them in a goblet of clear water, and press them and squeeze them out, bunch by bunch, with your fingers. Then trim them with a little pair of scissors; and when you have made up quite a number of bunches, put enough of them together to make up the size you want your brushes: some to fit in a vulture's quill; some to fit in a goose's quill; some to fit in a quill of a hen's or dove's feather. When you have made these types, putting them together very evenly, with each tip on a line with the other, take thread or waxed silk, and tie them up well with two bights or knots, each type by itself, according to the size you want the brushes. Then take your feather quill which corresponds to the amount of hairs tied up, and have the quill open, or cut off, at the end; and put these tied-up hairs into this tube or quill. Continue

to do this, so that some of the tips stick out, as long as you can press them in from outside, so that the brush will come out fairly stiff; for the stiffer and shorter it is the better and more delicate it will be. Then take a little stick of maple or chestnut, or other good wood; and make it smooth and neat, tapered like a spindle, and large enough to fit tightly in this tube; and have it nine inches long. And there you have an account of how a minever brush ought to be made. It is true that minever brushes of several types are needed: some for gilding; some for working with the flat of the brush, and these should be trimmed off a bit with the scissors, and stropped a little on the porphyry slab to limber them up a little; one brush ought to be pointed, with a perfect tip for outlining; and another ought to be very, very tiny, for special uses and very small figures.

HOW YOU SHOULD MAKE BRISTLE BRUSHES, AND IN WHAT MANNER.
CHAPTER LXV

The bristle brushes are made in this style. First get bristles of a white hog, for they are better than black ones; but see that they come from a domestic hog. And make up with them a large brush into which go a pound of these bristles; and tie it to a good-sized stick with a plowshare bight or knot.[1] And this brush should be limbered up by whitewashing walls, and wetting down walls where you are going to plaster; and limber it up until these bristles become very supple. Then undo this brush, and make the divisions of it as you want, to make a brush of any variety. And make some into those which have the tips of all the bristles quite even—those are called "blunt" brushes; and some into pointed ones of every sort of size. Then make little sticks of the wood mentioned above, and tie up each little bundle with double waxed thread. Put the tip of the little stick into it, and proceed to bind down evenly half the length of this little bundle of bristles, and farther up along the stick; and deal with them all in the same way.

[1] *Con groppo o ver nodo di bomare o ver versuro.* For my translation of *bomare* and *versuro* see W. Meyer-Lübke, *Romanisches etymologisches Wörterbuch* (Heidelberg, 1911), §§ 9447 and 9245.

HOW TO KEEP MINEVER TAILS FROM GETTING
MOTH-EATEN.
CHAPTER LXVI
ENDS THE SECOND SECTION OF THIS BOOK;
BEGINS THE THIRD.

If you wish to keep the minever tails from getting moth-eaten or losing their hairs, dip them in wet earth or chalk. Smear them well with it, and tie them up, and let them stand. When you wish to use them, or make brushes of them, wash them well with clear water.

THE METHOD AND SYSTEM FOR WORKING ON A WALL,
THAT IS, IN FRESCO; AND ON PAINTING AND
DOING FLESH FOR A YOUTHFUL FACE.
CHAPTER LXVII

In the name of the Most Holy Trinity I wish to start you on painting. Begin, in the first place, with working on a wall; and for that I will teach you, step by step, the method which you should follow.

When you want to work on a wall, which is the most agreeable and impressive kind of work, first of all get some lime[1] and some sand, each of them well sifted. And if the lime is very fat and fresh it calls for two parts sand, the third part lime. And wet them up well with water; and wet up enough to last you for two or three weeks. And let it stand for a day or so, until the heat goes out of it: for when it is so hot, the plaster which you put on cracks afterward. When you are ready to plaster, first sweep the wall well, and wet it down thoroughly, for you cannot get it too wet. And take your lime mortar, well worked over, a trowelful at a time; and plaster once or twice, to begin with, to get the plaster flat on the wall. Then, when you want to work, remember first to make this plaster quite uneven and fairly rough. Then when the plaster is dry, take the charcoal, and draw and

[1] *Calcina:* in this case "lime"; but generally to be rendered "lime mortar," or "mortar" for brevity. In this text it is, I think, impossible to render *calcina* always as either "lime" or "mortar." Cennino's plastering terms in general present considerable difficulty: I cannot find precise English equivalents for *calcina, intonaco, smalto,* and *smaltare.* "Plaster" and "mortar" do heavy duty in English. "Parget" (see *NED*) might be pressed into service, but it is scarcely familiar enough in the United States to admit its use here.

compose according to the scene or figures which you have to do; and take all your measurements carefully, snapping lines first, getting the centers of the spaces.[2] Then snap some, and take the levels from them. And this line which you snap through the center to get the level must have a plumb bob at the foot. And then put one point of the big compasses on this line,[3] and give the compasses a half turn on the under side. Then put the point of the compasses on the middle intersection of one line with the other,[4] and swing the other semicircle on the upper side. And you will find that you make a little slanted cross on the right side, formed by the intersection of the lines. From the left side apply the line to be snapped, in such a way that it lies right over both the little crosses; and you will find that your line is horizontal by a level.[5] Then compose the scenes or figures with charcoal, as I have described. And always keep your areas in scale, and regular.[6] Then take a small, pointed bristle brush, and a little ocher without tempera, as thin as water; and proceed to copy and draw in your fig-

[2] Diagonal lines from corner to corner would, of course, intersect at the center of the whole area. If the composition were a large one, plumb lines might be dropped, other sets of diagonals snapped, and the "centers of the spaces" determined *ad lib*. See n. 3, below.

[3] The construction which follows is perfectly general. The arcs may be swung from any center on any plumb line, according to where the horizontal is wanted: near the edges, for borders, or well up in the composition for a horizon. Short horizontals might be required across a subdivision of the total area, as for an architectural subject (see pp. 56, 57, below), and these would be constructed on the vertical axis of that subdivision. It should be remembered that very large areas might be involved, and that the size of compasses is somewhat limited in practice. Even with a two-foot radius, which would be cumbersome, the points on the horizontal would be only about three and a half feet apart; so for a horizontal border thirty or forty feet long it would be wise to repeat the construction on lines snapped plumb through several sections.

The space to be decorated may readily be "squared up" in this way, for enlarging a drawing; but Cennino does not seem to have had this in mind.

[4] That is, the intersection of the arc with the vertical axis, as I understand it.

[5] Modern practice would probably rely on a long spirit level to determine points on the horizontal to be snapped; but failing that instrument, Cennino's geometry might be trusted safely.

[6] Literally, "And arrange your areas always even and equal." Cennino was not always successful in theoretical expression, and I have taken some liberty in interpreting this precept. I do not wish, however, to minimize the difficulty of conveying the idea.

In painting of the sort which Cennino describes, form is indicated conventionally in terms of modeling, light and dark, applied over clearly marked areas of local color. Each of these areas, besides being a unit in the whole design, possesses in itself a separate entity. The edges of these areas, the shapes and sizes of the areas themselves, are con-

ures, shading as you did with washes when you were learning to draw. Then take a bunch of feathers, and sweep the drawing free of the charcoal.

Then take a little sinoper without tempera, and with a fine pointed brush proceed to mark out noses, eyes, the hair, and all the accents and outlines of the figures; and see to it that these figures are properly adjusted in all their dimensions, for these[7] give you a chance to know and allow for[8] the figures which you have to paint. Then start making your ornaments, or whatever you want to do, around the outside; and when you are ready, take some of the aforesaid lime mortar, well worked over with spade and trowel, successively, so that it seems like an ointment. Then consider in your own mind how much work you can do in a day; for whatever you plaster you ought to finish up. It is true that sometimes in winter, in damp weather, working on a stone wall, the plaster will occasionally keep fresh until the next day; but do not delay if you can help it, because working on the fresh plaster,[9] that is, that day's, is the strongest tempera and the best and most delightful kind of work. So then, plaster a section with plaster, fairly thin, but not excessively, and quite even; first wetting down the old plaster. Then take your large bristle brush in your hand; dip it in clear water; beat it, and sprinkle over your plaster. And with a little block the size of the palm of your hand, proceed to rub with a circular motion over the surface of the well-moistened plaster, so that the little block may succeed in removing mortar wherever there is too much, and supplying it wherever there is not enough, and in evening up your plaster nicely. Then wet the plaster with that brush, if you need to; and rub over the plaster with the point of your trowel, very straight and clean. Then snap your lines in the same system and dimensions which you adopted previously on the plaster underneath.

And let us suppose that in a day you have just one head to do, a

spicuous; and they must be designed for perfection in themselves as well as in relation to the whole. The idea of "scale," achieved through the repetition of a uniform measure throughout the composition, has been brought out by Cennino in Chapter XXX, p. 17, above.

[7] That is, the preliminary layout on the rough plaster, over which the finish plaster and final painting are applied.

[8] Or "foresee." [9] Il lavorare in frescho.

youthful saint's, like Our Most Holy Lady's. When you have got the mortar of your plaster all smoothed down, take a little dish, a glazed one, for all your dishes should be glazed and tapered like a goblet or drinking glass, and they should have a good heavy base at the foot, to keep them steady so as not to spill the colors; take as much as a bean of well-ground ocher, the dark kind, for there are two kinds of ocher, light and dark: and if you have none of the dark, take some of the light. Put it into your little dish; take a little black, the size of a lentil; mix it with this ocher; take a little lime white, as much as a third of a bean; take as much light cinabrese[10] as the tip of a penknife will hold; mix it up with the aforesaid colors all together in order,[11] and get this color dripping wet with clear water, without any tempera. Make a fine pointed brush out of flexible, thin bristles, to fit into the quill of a goose feather; and with this brush indicate the face which you wish to do, remembering to divide the face into three parts, that is, the forehead, the nose, and the chin counting the mouth. And with your brush almost dry, gradually apply this color, known in Florence as verdaccio, and in Siena, as bazzèo. When you have got the shape of the face drawn in, and if it seems not to have come out the way you want it, in its proportions or in any other respect, you can undo it and repair it by rubbing over the plaster with the big bristle brush dipped in water.

Then take a little terre-verte in another dish, well thinned out; and with a bristle brush, half squeezed out between the thumb and forefinger of your left hand, start shading under the chin, and mostly on the side where the face is to be darkest; and go on by shaping up the under side of the mouth; and the sides of the mouth; under the nose, and on the side under the eyebrows, especially in toward the nose; a little in the end of the eye toward the ear; and in this way you pick out the whole of the face and the hands, wherever flesh color is to come.

Then take a pointed minever brush, and crisp up neatly all the outlines, nose, eyes, lips, and ears, with this verdaccio.

There are some masters who, at this point, when the face is in this

[10] See Chapter XXXVIIII, p. 23, above, and *ibid.*, n. 1.

[11] *L, per ragioni,* might be interpreted as "by values." *R* has *per ragione.*

stage, take a little lime white, thinned with water; and very systematically pick out the prominences and reliefs of the countenance; then they put a little pink on the lips, and some "little apples" on the cheeks. Next they go over it with a little wash of thin flesh color; and it is all painted, except for touching in the reliefs afterward with a little white. It is a good system.

Some[12] begin by laying in the face with flesh color; then they shape it up with a little verdaccio and flesh color, touching it in with some high lights: and it is finished. This is a method of those who know little about the profession.

But you follow this method in everything which I shall teach you about painting: for Giotto, the great master, followed it. He had Taddeo Gaddi of Florence as his pupil for twenty-four years; and he was his godson. Taddeo had Agnolo, his son. Agnolo had me for twelve years: and so he started me on this method, by means of which Agnolo painted much more handsomely and freshly than Taddeo, his father, did.

First take a little dish; put a little lime white into it, a little bit will do, and a little light cinabrese, about equal parts. Temper them quite thin with clear water. With the aforesaid bristle brush, soft, and well squeezed with your fingers, go over the face, when you have got it indicated with terre-verte; and with this pink touch in the lips, and the "apples" of the cheeks. My master used to put these "apples" more toward the ear than toward the nose, because they help to give relief to the face. And soften these "apples" at the edges. Then take three little dishes, which you divide into three sections of flesh color; have the darkest half again as light as the pink color, and the other two, each one degree lighter. Now take the little dish of the lightest one; and with a very soft, rather blunt, bristle brush take some of this flesh color, squeezing the brush with your fingers; and shape up all the reliefs of this face. Then take the little dish of the intermediate flesh color, and proceed to pick out all the half tones of the face, and of the hands and feet, and of the body when you are doing a nude. Then take the dish of the third flesh color, and start into the accents of the shadows, always contriving that, in the accents, the terre-verte

12 I, 43, l. 12: read with R, Alcuni campeggiano.

may not fail to tell. And go on blending one flesh color into another in this way many times, until it is well laid in, as nature promises. And take great care, if you want your work to come out very fresh: contrive not to let your brush leave its course with any given flesh color, except to blend one delicately with another, with skilful handling. But if you attend to working and getting your hand in practice, it will be clearer to you than seeing it in writing. When you have applied your flesh colors, make another much lighter one, almost white; and go over the eyebrows with it, over the relief of the nose, over the top of the chin and of the eyelid. Then take a sharp minever brush; and do the whites of the eyes with pure white, and the tip of the nose, and a tiny bit on the side of the mouth; and touch in all such slight reliefs. Then take a little black in another little dish, and with the same brush mark out the outline of the eyes over the pupils of the eyes; and do the nostrils in the nose, and the openings in the ears. Then take a little dark sinoper in a little dish; mark out under the eyes, and around the nose, the eyebrows, the mouth; and do a little shading under the upper lip, for that wants to come out a little bit darker than the under lip. Before you mark out the outlines in this way, take this brush; touch up the hair with verdaccio; then with this brush shape up this hair with white. Then take a wash of light ocher; and with a blunt-bristle brush work back over this hair as if you were doing flesh. Then with the same brush shape up the accents with some dark ocher. Then with a sharp little minever brush and light ocher and lime white shape up the reliefs of the hair. Then, by marking out with sinoper, shape up the outlines and the accents of the hair as you did the face as a whole. And let this suffice you for a youthful face.

THE METHOD FOR PAINTING AN AGED FACE IN FRESCO.
CHAPTER LXVIII

When you want to do the head of an old man, you should follow the same system as for the youthful one; except that your verdaccio wants to be a little darker, and the flesh colors, too; adopting the system and practice which you did for the youthful one; and the hands

and feet and the body in the same way. Now, assuming that your old man's hair and beard are hoary, when you have got it shaped up with verdaccio and white with your sharp minever brush, take some lime white mixed with a small amount of black in a little dish, liquid; and with a blunt and soft bristle brush, well squeezed out, lay in the beards and hairs; and then make some of this mixture a little bit darker, and shape up the darks. Then take a small, sharp, minever brush, and stripe delicately over the reliefs of these hairs and beards. And you may do minever ⟨fur⟩ with this same color.

THE METHOD FOR PAINTING VARIOUS KINDS OF BEARDS AND HAIR IN FRESCO.
CHAPTER LXVIIII

Whenever you wish to make different hair and beards, ruddy, or russet, or black, or any kind you please, do them with verdaccio still, or shaped up with white,[1] and then lay them in in the regular way as described above. Just consider what color you want them; and thus the experience of seeing some of them finished will teach you this.

THE PROPORTIONS WHICH A PERFECTLY FORMED MAN'S BODY SHOULD POSSESS.
CHAPTER LXX

Take note that, before going any farther, I will give you the exact proportions of a man. Those of a woman I will disregard, for she does not have any set proportion. First, as I have said above, the face is divided into three parts, namely: the forehead, one; the nose, another; and from the nose to the chin, another. From the side of the nose through the whole length of the eye, one of these measures. From the end of the eye up to the ear, one of these measures. From one ear to the other, a face lengthwise, one face. From the chin under the jaw to the base of the throat, one of the three measures. The throat, one measure long. From the pit of the throat to the top of the shoulder,

[1] The reading of R may be preferred: "Just make them with verdaccio and shaped up with white, at first." This corresponds more closely to the practice described in the previous chapters.

one face; and so for the other shoulder. From the shoulder to the elbow, one face. From the elbow to the joint of the hand, one face and one of the three measures. The whole hand, lengthwise, one face. From the pit of the throat to that of the chest, or stomach, one face. From the stomach to the navel, one face. From the navel to the thigh joint, one face. From the thigh to the knee, two faces. From the knee to the heel of the leg, two faces. From the heel to the sole of the foot, one of the three measures. The foot, one face long.

A man is as long as his arms crosswise. The arms, including the hands, reach to the middle of the thigh. The whole man is eight faces and two of the three measures in length. A man has one breast rib less than a woman, on the left side. A man has . . .[1] bones in all. The handsome man must be swarthy, and the woman fair, etc. I will not tell you about the irrational animals, because you will never discover any system of proportion in them. Copy them and draw as much as you can from nature, and you will achieve a good style in this respect.

THE WAY TO PAINT A DRAPERY IN FRESCO.
CHAPTER LXXI

Now let us get right back to our fresco-painting. And, on the wall,[2] if you wish to paint a drapery, any color you please, you should first draw it carefully with your verdaccio; and do not have your drawing show too much, but moderately. Then, whether you want a white drapery or a red one, or yellow, or green, or whatever you want, get three little dishes. Take one of them, and put into it whatever color you choose, we will say red: take some cinabrese and a little lime white; and let this be one color, well diluted with water. Make one of the other two colors light, putting a great deal of lime white into it. Now take some out of the first dish, and some of this light, and make an intermediate color; and you will have three of them. Now take some of the first one, that is, the dark one; and with a rather large and fairly pointed bristle brush go over the folds of your figure in the darkest areas; and do not go past the middle of the thickness of your figure. Then take the intermediate color; lay it in from one dark strip

[1] A numeral is omitted here: the omission is marked in *L*.
[2] I, 47, l. 8, read: "fresco. E, in muro, ⟨s⟩e."

to the next one, and work them in together, and blend your folds into the accents of the darks. Then, just using these intermediate colors, shape up the dark parts where the relief of the figure is to come, but always following out the shape of the nude. Then take the third, lightest color, and just exactly as you have shaped up and laid in the course of the folds in the dark, so you do now in the relief, adjusting the folds ably, with good draftsmanship and judgment. When you have laid in two or three times with each color, never abandoning the sequence of the colors by yielding or invading the location of one color for another, except where they come into conjunction, blend them and work them well in together. Then in another dish take still another color, lighter than the lightest of these three; and shape up the tops of the folds, and put on lights. Then take some pure white in another dish, and shape up definitively all the areas of relief. Then go over the dark parts, and around some of the outlines, with straight cinabrese; and you will have your drapery, systematically carried out. But you will learn far better by seeing it done than by reading. When you have finished your figure or scene, let it dry until the mortar and the colors have dried out well all over. And if you still have any drapery to do in secco, you will follow this method.

THE WAY TO PAINT ON A WALL IN SECCO; AND THE TEMPERAS FOR IT.
CHAPTER LXXII

You may use any of those colors which you used in fresco, in secco as well; but there are colors which cannot be used in fresco, such as orpiment, vermilion, azurite, red lead, white lead, verdigris, and lac. Those which can be used in fresco are giallorino, lime white, black, ocher, cinabrese, sinoper, terre-verte, hematite. The ones which are used in fresco call for lime white as an adjunct, to make them lighter; and the greens, when you want to keep them as greens, call for giallorino: when you want to leave them as sage greens, use white. Those colors which cannot be used in fresco require white lead and giallorino as adjuncts, to make them lighter, and sometimes orpiment: but orpiment very seldom. Now if you are to execute a blue with lights on it,[1]

[1] See n. 2, p. 37, above.

follow that three-dish system which I taught you for the flesh color
and the cinabrese; and the system will be the same for this, except that
where you took lime white before, you now take white lead; and you
temper everything. There are two good kinds of tempera for you, one
better than the other. The first tempera: take the white and yolk of
the egg; put in a few clippings of fig shoots; and beat it up well. Then
put some of this tempera into the little dishes, a moderate amount,
neither too much nor not enough, just about as a wine might be half
diluted with water. And then use your colors, white or green or red,
just as I showed you for fresco; and carry out your draperies the same
way you did in fresco, handling it with restraint, allowing time for it
to dry out. Know that if you put in too much tempera the color will
soon crack and peel away from the wall. Be reasonable and judicious.
I advise you first, before you begin to paint, if you want to make a
drapery of lac or any other color, before you do anything else, take a
well-washed sponge; and have a yolk and white of egg together, and
put them into two porringerfuls of clear water, mixing it up thor-
oughly; and go evenly over the whole work which you have to paint
in secco and also to embellish with gold, with your sponge half
squeezed out in this tempera; and then proceed to paint freely, as you
please. The second tempera is simply yolk of egg; and know that this
tempera is a universal one, for wall, for panels, or for iron; and you
cannot use too much, but be reasonable, and choose a middle course.
Before you go any farther with this tempera, I want you to carry out
a drapery in secco. Just as I had you do with cinabrese in fresco, I now
want you to do with ultramarine. Take three dishes as usual; put the
two parts of blue and the third of white lead into the first one; and
into the third dish, the two parts white lead and the third blue; and
mix and temper them as I have told you. Then take the empty dish,
that is, the second; take as much out of one dish as out of the other,
and make up a mixture, stirring it thoroughly.[2] With a bristle brush,
or a firm, blunt minever one, and the first color[3] that is, the darkest, go
over the accents, shaping up the darkest folds. Then take the medium
color, and lay in some of those dark folds, and shape up the light folds
in the relief of the figure. Then take the third color, and lay it in, and

[2] I, 49, l. 26, read: "rimenata. Con." [3] *Ibid.*, l. 27, read: "sodo, ecchol."

make the folds which come on top of the relief; and work one well into the other, blending and laying in, as I taught you for fresco. Then take the lightest color, and put some white lead into it, with some tempera; and shape up the tops of the folds in the relief. Then take a little straight white lead, and go over certain strong reliefs as the nude of the figure requires. Then shape up the limits of the darkest folds and outlines with some straight ultramarine; and in this way stroke over the drapery the colors corresponding to each area, without mixing or contaminating one color with another, except delicately. And work with lac in the same way, and with every color which you use in secco, etc.

HOW TO MAKE A VIOLET COLOR.
CHAPTER LXXIII

If you wish to make a pretty violet color, take fine lac and ultramarine blue, in equal parts. Then, when it is tempered, take three dishes as before; and leave some of this violet color in its little dish, for touching up the darks. Then, with what you take out of it, make up three values of color for laying in the drapery, each stepped up lighter than the others, as described above.

TO EXECUTE A VIOLET COLOR IN FRESCO.
CHAPTER LXXIIII

If you want to make a violet for use in fresco, take indigo and hematite, and make a mixture like the previous one, without tempera; and make four values of it in all. Then execute your drapery.

TO TRY TO IMITATE AN ULTRAMARINE BLUE
FOR USE IN FRESCO.
CHAPTER LXXV

If you want to make a drapery in fresco which will look like ultramarine blue, take indigo and lime white, and step your colors up together; and then, in secco, touch it in with ultramarine blue in the accents.

TO PAINT A PURPLE OR TURNSOLE DRAPERY
IN FRESCO.
CHAPTER LXXVI

If you want to do a purple drapery in fresco which will look like lac, take hematite and lime white, and step up your colors as described. And blend them and work them well together. Then, in secco, touch it in with pure lac, tempered, in the accents.

TO PAINT A SHOT[1] GREEN DRAPERY IN FRESCO.
CHAPTER LXXVII

If you want to make a shot drapery for an angel in fresco, lay in the drapery in two values of flesh color, one darker and one lighter, blending them well at the middle of the figure. Then, on the dark side, shade the darks with ultramarine blue; and shade with terre-verte on the lighter flesh color, touching it up afterward in secco. And know that everything which you execute in fresco needs to be brought to completion, and touched up, in secco with tempera. Make the lights on this drapery in fresco just as I have told you for the rest.

TO PAINT IN FRESCO A DRAPERY SHOT WITH
ASH GRAY.
CHAPTER LXXVIII

If you want to make a shot drapery in fresco, take lime white and black, and make a minever color which is known as ash gray. Lay it in; put the lights on it, using giallorino for some and lime white for others, as you please. Apply the darks with black or with violet or with dark green.

TO PAINT ONE IN SECCO SHOT WITH LAC.
CHAPTER LXXVIIII

If you want to make a shot one in secco, lay it in with lac; put on the lights with flesh color, or with giallorino; shade the darks either with straight lac or with violet, with tempera.

[1] *NED, s.v.* "shot," 5, c; Cennino's word is *cangiante*. See DuCange, *Glossarium, s.v.* "cangium." J. Karabacek, "Neue Quellen zur Papiergeschichte," in *Mitteilungen aus*

TO PAINT ONE IN FRESCO OR IN SECCO SHOT
WITH OCHER.
CHAPTER LXXX

If you wish to make a shot one either in fresco or in secco, lay it in with ocher; put on the lights with white; and shade it with green in the light; and in the dark, with black and sinoper, or else with hematite.

TO PAINT A GREENISH–GRAY COSTUME IN FRESCO
OR IN SECCO.
CHAPTER LXXXI

If you wish to make a greenish-gray drapery, take black and ocher, that is, the two parts ocher and the third black; and step up the colors as I have taught you before, both in fresco and in secco.

TO PAINT A COSTUME, IN FRESCO AND IN SECCO,
OF A GREENISH–GRAY COLOR LIKE THE
COLOR OF WOOD.
CHAPTER LXXXII

If you want to make a wood color, take ocher, black, and sinoper; but the two parts ocher, and black and red to the amount of half the ocher. Step up your colors with this in fresco, in secco, and in tempera.

TO MAKE A DRAPERY, OR A MANTLE FOR OUR LADY,
WITH AZURITE OR ULTRAMARINE BLUE.
CHAPTER LXXXIII

If you wish to make a mantle for Our Lady with azurite, or any other drapery which you want to make solid blue, begin by laying in the mantle or drapery in fresco with sinoper and black, the two parts sinoper,[1] and the third black. But first scratch in the plan of the folds with some little pointed iron, or with a needle. Then, in secco, take some azurite, well washed either with lye or with clear water, and worked over a little bit on the grinding slab. Then, if the blue is good

der Sammlung der Papyrus Erzherzog Rainer, IV (1888), 119, offers ingenious arguments for deriving this word from the name of the "durch ihre satinirten Stoffe berühmten chinesischen Stadt Chanfâ (arab.)."

[1] I, 53, l. 6, read: "di nero, [mal]le due."

and deep in color, put into it a little size, tempered neither too strong nor too weak (and I will tell you about that later on). Likewise put an egg yolk into the blue; and if the blue is pale, the yolk should come from one of these country eggs, for they are quite red. Mix it up well. Apply three or four coats to the drapery, with a soft bristle brush. When you have got it well laid in, and after it is dry, take a little indigo and black, and proceed to shade the folds of the mantle as much as you can, going back into the shadows time and again, with just the tip of the brush. If you want to get a little light on the tops of the knees or other reliefs, scratch the pure blue with the point of the brush handle.[2]

If you want to put ultramarine blue on a ground or on a drapery, temper it as described for the azurite, and apply two or three coats of it over the latter. If you wish to shade the folds, take a little fine lac, and a little black, tempered with yolk of egg; and shade it as delicately and as neatly as you can, first with a little wash, and then with the point ⟨of the brush⟩; and make as few folds as possible, because ultramarine wants little association with any other mixture.

TO MAKE A BLACK DRAPERY FOR A MONK'S OR FRIAR'S ROBE, IN FRESCO AND IN SECCO.
CHAPTER LXXXIIII

If you want to make a black drapery, for a friar's or monk's robe, take pure black, stepping it up in several values, as I have already told you above, for fresco; for secco, mixed with a tempera.

ON THE WAY TO PAINT A MOUNTAIN, IN FRESCO OR IN SECCO.
CHAPTER LXXXV

If you want to do mountains in fresco or in secco, make a verdaccio color, one part of black, the two parts of ocher. Step up the colors, for fresco, with lime white and without tempera; and for secco, with

[2] This roughing of the surface gives a lighter value without the use of white. It is, as Cennino suggests, of limited application, even in secco; in panel-painting it is not to be practiced, for varnish nullifies the optical effect upon which the lighter value depends. The point of this ingenious trick is to keep the blue at its maximum intensity in the lights, in contrast to the technique described in Chapter LXXII, pp. 50–52,

white lead and with tempera. And apply to them the same system of shadow and relief that you apply to a figure. And the farther away you have to make the mountains look, the darker you make your colors; and the nearer you are making them seem, the lighter you make the colors.

THE WAY TO PAINT TREES AND PLANTS AND FOLIAGE, IN FRESCO AND IN SECCO.
CHAPTER LXXXVI

If you wish to embellish these mountains with groves of trees or with plants, first lay in the trunk of the tree with pure black, tempered, for they can hardly be done in fresco; and then make a range of leaves with dark green, but using malachite, because terre-verte is not good; and see to it that you make them quite close. Then make up a green with giallorino, so that it is a little lighter, and do a smaller number of leaves, starting to go back to shape up some of the ridges. Then touch in the high lights on the ridges with straight giallorino, and you will see the reliefs of the trees and of the foliage. But before this, when you have got the trees laid in, do the base and some of the branches of the trees with black; and scatter the leaves upon them, and then the fruits; and scatter occasional flowers and little birds over the foliage.

HOW BUILDINGS ARE TO BE PAINTED, IN FRESCO AND IN SECCO.
CHAPTER LXXXVII

If you want to do buildings, get them into your drawing in the scale you wish; and snap the lines.[1] Then lay them in with verdaccio, and with terre-verte, quite thin in fresco or in secco. And you may do some with violet, some with ash gray, some with green, some

above. There, the maximum intensity is found only in the deep shadows; the lights are neutralized progressively, by the addition of white. Here, all is to be pure blue except such portions as are neutralized, in the direction of black, by the thin surface modeling of the shadows. The only light modeling regarded as consistent with the display of this fair field of valuable color is achieved by the optical trick described. A clear understanding of this distinction is necessary to grasp the significance of the *vestiri biancheg-giati* mentioned in Chapter LXXII. See n. 2, p. 37, above.

[1] See Chapter LXVII, p. 43, above.

with greenish gray, and likewise with any color you wish. Then make a long ruler, straight and fine; and have it chamfered on one edge, so that it will not touch the wall, so that if you rub on it, or run along it with the brush and color, it will not smudge things for you; and you will execute those little moldings with great pleasure and delight; and in the same way bases, columns, capitals, façades, fleurons, canopies, and the whole range of the mason's craft, for it is a fine branch of our profession, and should be executed with great delight. And bear in mind that they must follow the same system of lights and darks that you have in the figures. And put in the buildings by this uniform system: that the moldings which you make at the top of the building should slant downward from the edge next to the roof; the molding in the middle of the building, halfway up the face, must be quite level and even; the molding at the base of the building underneath must slant upward, in the opposite sense to the upper molding, which slants downward.

THE WAY TO COPY A MOUNTAIN FROM NATURE.
CHAPTER LXXXVIII
ENDS THE THIRD SECTION OF THIS BOOK.

If you want to acquire a good style for mountains, and to have them look natural, get some large stones, rugged, and not cleaned up; and copy them from nature, applying the lights and the dark as your system requires.

HOW TO PAINT IN OIL ON A WALL, ON PANEL, ON
IRON, AND WHERE YOU PLEASE.
CHAPTER LXXXVIIII

Before I go any farther, I want to teach you to work with oil on wall or panel, as the Germans are much given to do; and likewise on iron and on stone. But we will begin by discussing the wall.

HOW YOU SHOULD START FOR WORKING IN
OIL ON A WALL.
CHAPTER LXXXX

Plaster the wall the way you do for fresco; except that where you do the plastering little by little, here you are to plaster the whole job

all at once. Then draw your scene with charcoal, and fix it either with ink or with tempered verdaccio. Then take a little well-diluted size. A still better tempera is the whole egg beaten up in a porringer with fig-tree latex; and pour a goblet of clear water over this egg. Then, either with a sponge or with the soft, rather blunt brush, apply one coat of it all over the ground which you have to execute; and let it dry for at least one day.

HOW YOU ARE TO MAKE OIL, GOOD FOR A TEMPERA, AND ALSO FOR MORDANTS, BY BOILING WITH FIRE.
CHAPTER LXXXXI

You ought to know how to make this oil, since it is one of the useful things which you need to understand; for it is used for mordants, and for many purposes. And therefore take one pound, or two, or three, or four, of linseed oil, and put it into a new casserole; and if it is a glazed one, so much the better. Make a little stove; and make a round opening so that this casserole will fit into it exactly, so that the flame cannot come up past it; because the flame would be glad to get to it, and you would jeopardize the oil, and also risk burning down the house. When you have made your stove, start up a moderate fire: for the more gently you make it boil, the better and more perfect it will be. And make it boil down to a half,[1] and it will do. But to make mordants, when it is reduced to a half,[2] put into it one ounce of liquid

[1] *Bollire per mezo:* Dr. A. P. Laurie, *The Painter's Methods and Materials* (Philadelphia: Lippincott, 1926), pp. 31, 32, and 41, in discussing the related passage in Chapter LXXXXII, *se v'el tieni tanto che torni per mezo,* brands the translation "reduced to one-half" as "nonsense." Dr. Laurie suggests the alternative translation of mezzo as "bleached." A simpler explanation will serve: the total volume of oil does not diminish, it is true, but upon exposure to sun and air a pellicle of "dried" oil forms, and as the drying process advances the volume of oil available for painting purposes is reduced. In this sense, a quantity of oil may be "reduced to a half" by exposure to the sun. Similarly, in boiling, waste takes place, and a quantity of oil may be "boiled down to a half." If any doubt remained, the unequivocal order, "Fac bullire tam diu donec medietas olei sit consumpta," from the *Secreta magistri Johannis ortulani vera et probata,* should remove it. (See Ludwig Rockinger, "Zum baierischen Schriftwesen im Mittelalter," *Abhandlungen der historischen Classe der königlichen bayerischen Akademie der Wissenschaften,* XII [1872], 1te Abteilung, p. 47. See also I, 65, l. 12; and p. 66, l. 10, *bollire chettorni per terzo,* and compare with this p. 67, l. 23.)

[2] *Quando ettornato per mezo:* see n. 1, above.

varnish which is bright and clear for each pound of oil; and this sort of oil is good for mordants.

HOW GOOD AND PERFECT OIL IS MADE BY COOKING IN THE SUN.
CHAPTER LXXXXII

When you have made this oil, some may be cooked in another way besides; and it is more perfect for painting, but for mordants it has to be cooked with fire. Take your linseed oil, and during the summer put it into a bronze or copper pan, or a basin, and keep it in the sun when August comes. If you keep it there until it is reduced to a half,[1] this will be most perfect for painting. And know that I have found it in Florence as good and choice as it could be.

HOW YOU SHOULD WORK UP THE COLORS WITH OIL, AND EMPLOY THEM ON THE WALL.
CHAPTER LXXXXIII

Go back to working up or grinding, color by color, as you did for work in fresco; except that where you worked them up with water you now work them up with this oil. And when you have got them worked up, that is, some of every color, for all the colors will stand oil except lime white, get little lead or tin dishes into which to put these colors. And if you cannot find those, get glazed ones. And put in these ground-up colors; and put them into a little box to keep clean. Then when you wish to make a drapery in three values, as I have told you, mark them out and set them in their places with minever brushes, working one color well into another, keeping the colors quite stiff. Then wait a day or so, and go back, and see how they are covered, and lay them in again as necessary. And do the same for flesh-painting, and for doing any sort of work which you may care to carry out; and mountains, trees, and every other subject in the same way. Then have a plate of tin or lead which is one finger deep all around, like a lamp; and keep it half full of oil, and keep your brushes in it when idle, so that they will not dry up.

[1] See n. 1, p. 58.

HOW YOU SHOULD WORK IN OIL ON IRON, ON PANEL, ON STONE.
CHAPTER LXXXXIIII

And work on iron in the same way, and on stone; and on panel, always sizing first; and on glass likewise,[1] or wherever you wish to work.

THE WAY TO EMBELLISH WITH GOLD OR WITH TIN ON A WALL.
CHAPTER LXXXXV

Now, since I have taught you the method of working in secco, in fresco, and in oil, I wish to show you how you should embellish the wall with tin, golden and white,[2] and with fine gold. And know that above all you are to work with as little silver as you can, because it does not last; and it turns black, both on wall and on wood, but it fails sooner on a wall. Use beaten tin or tin foil instead of it henceforth. Also beware of alloyed gold, for it soon turns black.

HOW YOU SHOULD ALWAYS MAKE A PRACTICE OF WORKING WITH FINE GOLD AND WITH GOOD COLORS.
CHAPTER LXXXXVI

Most people make a practice of embellishing a wall with golden tin,[3] because it is less costly. But I give you this urgent advice, to make an effort always to embellish with fine gold, and with good colors, especially in the figure of Our Lady. And if you wish to reply that a poor person cannot make the outlay, I answer that if you do your work well, and spend time on your jobs, and good colors, you will get such a reputation that a wealthy person will come to compensate you for the poor one; and your standing will be so good for using good colors that if a master is getting one ducat for a figure, you will be offered two; and you will end by gaining your ambition. As the old saying goes, good work, good pay. And even if you were

[1] See p. 113, below.

[2] So *R*: *dorato e bianco*. *L* has *dorato in bianco*, which might be interpreted as "white made golden." See n. 1, pp. 61 ff., below.

[3] See n. 3, pp. 61 ff., below.

not adequately paid, God and Our Lady will reward you for it, body and soul.

HOW YOU SHOULD CUT THE GOLDEN TIN, AND EMBELLISH.
CHAPTER LXXXXVII

When you are embellishing with tin, either white or golden,[1] so that you have to cut it with a penknife, first get a good, smooth board of nut or pear or plum wood, not too thin, the size of a royal folio in each dimension. Then get some liquid varnish; smear this board well; put your piece of tin on it, spreading it out and smoothing it down nicely. Then proceed to cut it with a penknife, well sharpened and . . .[2] at the point. And with a ruler cut the little strips of whatever width you wish to make the ornaments, whether just of tin, or wide enough for you to embellish them afterward with black or other colors.

HOW TO MAKE GREEN TIN FOR EMBELLISHING.
CHAPTER LXXXXVIII

Again, to embellish these ornaments, take some verdigris ground with linseed oil; and spread some all over a sheet of white tin, so that it will be a fine green. Let it dry well in the sun; then spread it out on the board with varnish. Then cut it with a penknife; or first make little rosettes, or any pretty trifles, with dies; and smear the board with liquid varnish, and set those rosettes out on it: then fasten them to the wall. Furthermore, if you wish to make stars with fine gold, or to apply the diadems of the saints, or to embellish with the knife as I have told you, you should first lay the fine gold on the golden tin.

HOW TO MAKE THE GOLDEN TIN, AND HOW TO LAY FINE GOLD WITH THIS VERMEIL.[3]
CHAPTER LXXXXVIIII

Golden tin is made as follows. Set up a nice, smooth board, six

[1] See n. 3, below.

[2] A word seems to be missing here: perhaps "thin." In the apparatus, I, 59, for "23" read "24."

[3] *Doratura,* that is, *deauratura;* see *NED, s.v.* "vermeil," 4, a. The ancient and widespread tradition represented here must be made the subject of a separate study; but

or eight feet long; and have it smeared with fat or tallow. Some of this white tin is laid out on it; then a liquid known as vermeil is put on the tin, in three or four places, a little in each place; and you pat over this tin with the palm of your hand, so as to get this vermeil as even in one part as in another. Let it dry well in the sun. When it is almost dry, so that it is just a little bit tacky, take your fine gold, and systematically overlay and cover the tin with this fine gold. Then clean it up with some very clean cotton; separate the tin from the board. When you want to use it, work with liquid varnish; and make those stars with it, or any devices you wish, just as you do with the golden tin.

some instances are cited below in support of my translation of *dorato* as "golden," and also to indicate the general character of the material, *doratura*.

Two rules in the *Compositiones ad tingenda . . .*, "De tinctio petalorum," and "De inductio exorationis" (ed. Muratori, *Antiquitates* [Milan, 1739], II, 385, B–C, and 381, D; ed. also, with translation, in J. M. Burnam, *A Classical Technology Edited from Codex Lucensis, 490* [Boston, 1920], pp. 67, 68, and 129; 58 and 120, 121), reappear with variants in the *Mappae clavicula*. (See ed. T. Phillipps, *Archaeologia*, XXXII [1847], 212, § cxvi; 227, § ccviii; 211, § cxv.) Theophilus' *Schedula*, MSS L^2 and P (see my article, "The *Schedula* of Theophilus Presbyter," *Speculum*, VII [1932], 203), outlines the use of gold leaf laid over varnished tin for use on walls. (See ed. A. Ilg, in *Quellenschriften*, VII [Vienna, 1874], 55.) The *Schedula* gives also (*ed. cit.*, pp. 57–59) a rule of somewhat different character for coloring "tabulas stagneas tenuatas ut tanquam deauratae videantur" to be used "loco auri quando aurum non habetur," allied to Cap. XIII, "De deauratura petulae stagni," in Heraclius, *De coloribus et artibus Romanorum*. (See Merrifield, *op. cit.*, I, 221.) (In this chapter Heraclius describes as *deauratura* an amalgam of tin with mercury; and in Cap. XIV the term seems to be applied to an amalgam of gold with mercury; but neither of these is the *doratura* of Cennino.)

Petrus de Sancto Audemaro, *Liber de coloribus*, devotes five sections to the subject (§§ 205–209 in Merrifield, *op. cit.*, I, 161–165): "De modo attenuandi [*read* tinguendi?] laminas stanni ut auratae videantur, ex carentia auri utendas in operibus" —the very argument discounted by Cennino in Chapter LXXXXVI; "De modo deaurandi folia seu laminas stanni attenuatas," etc. The recipe "Ad ponendum aurum finum super stagno aurato" in J. LeBègue's *Experimenta de coloribus*, § 105 (Merrifield, *op. cit.*, I, 95), involves still a different type of procedure, but confirms the distinction between "golden" and "gilded" tin.

Cennino's *doratura* was evidently a sort of transparent yellow oil-gold-size, which could be used as a lacquer on tin, to produce a golden effect; or, alternatively, as a mordant for gilding with leaf over tin foil, either plain or previously lacquered with *doratura*. Montpellier, *École de Médecine*, MS 277, approximately contemporary with the *Libro dell'Arte*, contains (No. 17) a *Liber diversarum artium* (published in *Catalogue général des manuscrits des bibliothèques publiques des départements*, I [Paris, 1849], 739–811), which preserves (II, 8; fol. 96ʳ, col. 1; *ed. cit.*, p. 789) a rule, "De confectione dorature," which probably represents the sort of compound which Cennino knew under this name:

"*Doratura* is made in this way. Take hepatic aloes, one ounce; linseed oil, **two**

HOW TO FASHION OR CUT OUT THE STARS, AND PUT THEM ON THE WALL.
CHAPTER C

First you have to cut out all the stars with the ruler; and wherever you have to put them on, first put a little lump of wax on the blue, wherever the star comes; and shape the star on it, ray by ray, just as you cut it on the board. And know that much more work can be done with less fine gold than can be done by mordant gilding.

HOW YOU CAN MAKE THE DIADEMS OF THE SAINTS ON THE WALL WITH THIS TIN GILDED WITH FINE GOLD.
CHAPTER CI

Likewise, if you want to make the diadems of the saints without mordants, after you have painted the figure in fresco, take a needle, and scratch around the outline of the head. Then after it is dry smear the diadem with varnish, put your tin on it, either golden or gilded with fine gold; put it over this varnish, pat it down well with the palm of your hand; and you will see the marks which you made with the needle. Take a well-sharpened knife point, and trim the gold up carefully; and put the surplus aside for your other jobs.

HOW YOU SHOULD MODEL UP A DIADEM IN LIME MORTAR ON A WALL.
CHAPTER CII

Know that the diadem wants to be modeled up with a small trowel on the fresh plaster, as follows. When you have drawn the head of the

pounds; a little saffron; and boil them all up in a pot until the aloes are well dissolved; then strain them through a cloth into another dish, and vermeil (*deaura*) thinly with your hand two or three times with this *doratura;* and gold will be improved, and tin most of all, and silver. But that color is applied only once, thinly, over gold."

(For the composition and use of a similar preparation in the eighteenth century, see articles "Vermeil" and "Vermeillionner" in Sieur Watin, *L'art du peintre, doreur, vernisseur* . . . [2d ed., Paris, 1773], pp. 144, 159. It is recommended to "reléver l'éclat de l'or et lui donner un plus beau lustre," as in the rule just quoted.)

A similar rule in the same chapter of the *Liber diversarum artium* may be noted, though it is not specifically labeled *doratura.* Fol. 98ʳ, col. 2 (*ed. cit.*, p. 798), II, 5, states that "cum doratura pictorum potest vas stagneum deaurari."

Instances might be multiplied, but the above should suffice to demonstrate the justice of translating *doratura* as "vermeil," and *stagno dorato* as "golden tin."

figure, take the compasses, and swing the halo. Then take a little very fat lime mortar, made into a sort of ointment or dough, and plaster this lime mortar rather thick around the outside of the circle, and thin in toward the head. Then when you have got the lime mortar quite smooth, take the compasses again, and with the penknife[1] cut away the mortar along the path of the compasses; and it will come out in relief. Then take a little slice[2] of strong wood, and indent the radiating beams of the diadem. And this wants to be the system for the wall.

HOW FROM THE WALL YOU ENTER UPON PANEL–PAINTING.
CHAPTER CIII
ENDS THE FOURTH SECTION OF THIS BOOK.

When you do not want to embellish your figures with tin, you may embellish them with mordants, which I shall discuss thoroughly in due course, later on: which ones you may use for wall, for panel, for glass, for iron, and for every kind of material; and the ones which are strong, and adequate to stay outside in the wind and wet; and the ones which are to be varnished, and the ones which are not. But still I must get back to our painting, and from the wall go on to panels or anconas, the nicest and the neatest occupation which we have in our profession. And bear this well in mind, that anyone who learns to work on the wall first, and then on panel, will not get such perfect mastery by his bargain as one who starts learning on panel first, and then on the wall.

THE SYSTEM BY WHICH YOU SHOULD PREPARE TO ACQUIRE THE SKILL TO WORK ON PANEL.
CHAPTER CIIII

Know that there ought not to be less time spent in learning than this: to begin as a shopboy studying for one year, to get practice in drawing on the little panel; next, to serve in a shop under some master to learn how to work at all the branches which pertain to our

[1] *Sc.,* "fastened to one beam." [2] See n. 5, p. 21, above.

profession; and to stay and begin the working up of colors; and to learn to boil the sizes, and grind the gessos; and to get experience in gessoing anconas, and modeling and scraping them; gilding and stamping; for the space of a good six years. Then to get experience in painting, embellishing with mordants, making cloths of gold, getting practice in working on the wall, for six more years; drawing all the time, never leaving off, either on holidays or on workdays.[1] And in this way your talent, through much practice, will develop into real ability. Otherwise, if you follow other systems, you need never hope that they will reach any high degree of perfection. For there are many who say that they have mastered the profession without having served under masters. Do not believe it, for I give you the example of this book: even if you study it by day and by night, if you do not see some practice under some master you will never amount to anything, nor will you ever be able to hold your head up in the company of masters.

Beginning to work on panel, in the name of the Most Holy Trinity: always invoking that name and that of the Glorious Virgin Mary.

HOW YOU MAKE BATTER OR FLOUR PASTE.
CHAPTER CV

To begin with we have to make . . . ,[2] that is; and they are known as various sorts of size. There is one size which is made of cooked batter, and it is good for parchment workers and masters who make books; and it is good for pasting parchments together, and also for fastening tin to parchment. We sometimes need it for pasting up parchments to make stencils. This size is made as follows. Take a pipkin almost full of clear water; get it quite hot. When it is about to boil, take some well-sifted flour; put it into the pipkin little by little, stirring constantly with a stick or a spoon. Let it boil, and do not get it too thick. Take it out; put it into a porringer. If you want to keep it from going bad, put in some salt; and so use it when you need it.

[1] Cf. Othloh, *Liber de Temptatione* . . ., in Pertz, *Monumenta germaniae historiae scriptorum*, XI, 392: ". . . raro nisi in festivis diebus aut in aliis horis incompetentibus ab hoc opere cessaret."

[2] We can only guess at the words omitted here: perhaps "the necessary adhesive materials" might be supplied.

HOW YOU SHOULD MAKE CEMENT FOR
MENDING STONES.
CHAPTER CVI

There is a cement which is good for mending stones: and this one is made of mastic, fresh wax, sifted pounded stone; and then all melted up thoroughly together on the fire. Take your broken stone, and warm it well; put some of this cement on it. It will last forever, in the wind; and in water if you were to mend sharpening or grinding wheels, or millstones, with it.

HOW TO MAKE CEMENT FOR MENDING
DISHES OF GLASS.
CHAPTER CVII

And there is a cement which is good for mending glasses, or hourglasses, or any other fine dishes of Damascus or Majorca which might be broken. To make this cement, take liquid varnish, a little white lead and verdigris. Put into them some of the same color as the glass: if it is blue, put in a little indigo; if it is green, let the verdigris predominate, and *sic de singulis*. And then work these ingredients up together very finely. Take the pieces of your broken dishes or goblets, and, even if they are in a thousand fragments, fit them together, putting this cement on them thinly. Let it dry for a few months in the sun and wind; and you will find these dishes stronger, and more fit to stand water,[1] where they are broken than where they are whole.

HOW FISH GLUE IS USED, AND HOW IT IS TEMPERED.
CHAPTER CVIII

There is a glue which is known as fish glue. This glue is made from various kinds of fish. If you put the little piece, or leaf, in your mouth, just as it is, until it gets a little wet, and rub it on sheep parchments or other parchments, this fastens them together very securely. To dissolve it, . . .[2] It is good and excellent for mending lutes and other

[1] *Meglio da difendersi dall'aqua.* Lady Herringham follows Mrs. Merrifield in translating, "better able to keep out the water." The commoner function of a glass dish, as I conceive it, is to keep the water *in!*

[2] We may supply "you must put it on the fire," or something of that sort; or pos-

fine paper, wooden, or bone objects. When you put it on the fire, put
in half a goblet of clear water for each leaf.

HOW GOAT GLUE IS MADE, AND HOW IT IS TEMPERED; AND HOW MANY PURPOSES IT WILL SERVE.
CHAPTER CVIIII

And there is a glue which is known as leaf glue; this is made out
of clippings of goats' muzzles, feet, sinews, and many clippings of
skins. This glue is made in March or January, during those strong
frosts or winds; and it is boiled with clear water until it is reduced
to less than a half.[1] Then put it into certain flat dishes, like jelly molds
or basins, straining it thoroughly. Let it stand overnight. Then, in the
morning, cut it with a knife into slices like bread; put it on a mat to
dry in the wind, out of the sunlight; and an ideal glue will result.
This glue is used by painters, by saddlers, and by ever so many mas-
ters, as I shall show you later on. And it is a good glue for wood, and
for many things. We shall discuss it thoroughly, showing what it
may be used for, and how, for gessos, for tempering colors, making
lutes, tarsias, fastening pieces of wood and foliage ornament together,
tempering gessos, doing raised gessos; and it is good for many things.

A PERFECT SIZE FOR TEMPERING GESSOS FOR ANCONAS OR PANELS.
CHAPTER CX

And there is a size which is made of the necks[2] of goat and sheep
parchments, and clippings of these parchments; these are washed

sibly the whole sentence should be recast: *A struggierla e buna. E perfettissima . . .*:
and translated, "It is good if you dissolve it. It is the best thing for mending. . . ."

For similar and fuller instructions see Rockinger, *art. cit.* p. 4 *supra*, 1te Abt., 27;
and among many others, the parallel account in the *De arte illuminandi*, § 15 (ed. A.
Lecoy de La Marche, p. 95).

[1] *Torna men che per mezzo.* See note on p. 58, above.

[2] Finished parchment represents only a fairly small proportion of the total area of
the skin from which it is made. This rule utilizes the waste produced by trimming out
the rectangular sheets of parchment from the skin, as the next one, Chapter CXI, em-
ploys the scrapings taken off by the parchment maker's knife. Mrs. Merrifield translates
colli as "shavings"; Lady Herringham amends this to "waste"; I see no reason to avoid
the literal translation, "necks."

thoroughly, and put to soak a day before you put them on to boil. Boil it with clear water until the three parts are reduced to one. And when you have no leaf glue, I want you just to use this size for gessoing panels or anconas; for you cannot get any better one anywhere.

A SIZE WHICH IS GOOD FOR TEMPERING BLUES
AND OTHER COLORS.
CHAPTER CXI

And there is a size which is made from the scrapings of goat or sheep parchment. Boil them with clear water until it is reduced to a third.[1] Know that it is a very clear[2] size, which looks like crystal. It is good for tempering dark blues. And apply a coat of this size in any place where you have happened to lay in colors which were not tempered sufficiently, and it will retemper the colors, and reinforce them, so that you may varnish them at will, if they are on panel; and blues on a wall the same way. And it would be good for tempering gessos, too; but it is lean in character, and it ought to be rather fat for any gesso which has to take gilding.[3]

TO MAKE A GLUE OUT OF LIME AND CHEESE.
CHAPTER CXII
ENDS THE FIFTH[4] SECTION OF THIS BOOK.

There is a glue used by workers in wood; this is made of cheese. After putting it to soak in water, work it over with a little quicklime, using a little board with both hands. Put it between the boards; it joins them and fastens them together well. And let this suffice you for the making of various kinds of glue.

[1] *Chettorni per terzo.* See note on p. 58, above.

[2] Or "light colored" (*chiarissima*).

[3] "Lean" (*magra*), and "rather fat" (*grassetta*), are literal translations which require a word of comment here. The pure gelatine which results from the present rule has practically no *adhesive* properties, such as glue made as directed in Chapter CVIIII possesses. That more tenacious and adhesive size may be described as "fatter," more substantial, more full bodied; and the present one as "lean" in contrast.

[4] For MSS *quarta,* I, 66, l. 19, read *quinta.* The fourth section ends with Chapter CIII, p. 64, above.

HOW YOU SHOULD START TO WORK ON
PANEL OR ANCONAS.
CHAPTER CXIII

Now we come to the business of working on anconas or on panel. To begin with, the ancona should be made of a wood which is known as whitewood or poplar, of good quality, or of linden, or willow. And first take the body of the ancona, that is, the flats, and see whether there are any rotten knots; or, if the board is greasy at all, have the board planed down until the greasiness disappears; for I could never give you any other cure.

See that the wood is thoroughly dry; and if it were wooden figures, or leaves, so that you could boil them with clear water in kettles, that wood would never give you any trouble with cracks.

Let us just go back to the knots or nodes, or other defects which the flat of the panel may display. Take some strong leaf glue; heat up as much as a goblet or glass of water; and boil two leaves of glue, in a pipkin free from grease. Then have some sawdust wet down with this glue in a porringer. Fill the flaws of the nodes with it, and smooth down with a wooden slice, and let it stand. Then scrape with a knife point until it is even with the surrounding level. Look it over again; if there is a bud, or nail, or nail end, sticking through the surface, beat it well down into the board. Then take small pieces of tin foil, like little coins, and some glue, and cover over carefully wherever any iron comes; and this is done so that the rust from the iron may never come to the surface of the gessos. And the flat of the ancona must never be too much smoothed down. First take a size made of clippings of sheep parchments, boiled until one part remains out of three. Test it with the palms of your hands; and when you find that one palm sticks to the other, it will be right. Strain it two or three times. Then take a casserole half full of this size, and the third ⟨part⟩[1] water, and get it boiling hot. Then apply this size to your ancona, over foliage ornaments, canopies, little columns, or any sort of work which you have to gesso, using a large soft bristle brush. Then let it dry.

[1] The original is ambiguous here. I understand it to mean: "Add half as much water as you have size," as Cennino's rules usually call for a total of three "parts." The point has little practical significance in this case.

Next take some of your original strong size, and put two coats over this work with your brush; and always let it dry between one coat and the next; and it will come out perfectly sized. And do you know what the first size, with water, accomplishes? Not being so strong, it is just as if you were fasting, and ate a handful of sweetmeats, and drank a glass of good wine, which is an inducement for you to eat your dinner. So it is with this size: it is a means of giving the wood a taste for receiving the coats of size and gesso.

HOW YOU SHOULD PUT CLOTH ON A PANEL.
CHAPTER CXIIII

When you have done the sizing, take some canvas, that is, some old thin linen cloth, white threaded, without a spot of any grease. Take your best size; cut or tear large or small strips of this canvas; sop them in this size; spread them out over the flats of these anconas with your hands; and first remove the seams; and flatten them out well with the palms of your hands; and let them dry for two days. And know that this sizing and gessoing call for dry and windy weather. Size wants to be stronger in summer than in winter. Gilding calls for damp and rainy weather.

HOW THE FLAT OF A PANEL SHOULD BE GESSOED
WITH THE SLICE WITH GESSO GROSSO.
CHAPTER CXV

When the ancona is quite dry, take a tip of a knife shaped like a spatula, so that it will scrape well; and go over the flat. If you find any little lump, or seam of any sort, remove it. Then take some gesso grosso, that is, plaster of Paris,[1] which has been purified[2] and sifted

[1] *Giesso grosso, cioe Volteriano:* That is, "coarse plaster, of Volterra." Perhaps Cennino's plaster was no more *Volteriano* than ours is Parisian!

[2] The phrase, *che e purghato,* may be introduced in L through error, or through confusion by the scribe of gesso grosso with gesso sottile, anticipating the directions of Chapter CXVI. R gives quite a different reading: ". . . gesso grosso . . . which is purified like flour; and, when sifted, put a little porringerful. . . ."

It might be argued that *purgare* actually means "to slake," and that the gesso grosso was intended to be slaked in some way less than the gesso sottile. This, however, seems to me as improbable in theory as I know it to be unnecessary, and even undesirable, in practice.

like flour. Put a little porringerful on the porphyry slab, and grind it with this size very vigorously, as if it were a color. Then scrape it up with a slice; put it on the flat of the ancona, and proceed to cover all the flats with it, with a very even and rather broad slice; and wherever you can lay it with this slice you do so. Then take some of this same ground-up gesso; warm it; and take a small soft bristle brush, and lay some of this gesso over the moldings and over the leaves, and likewise over the flats gessoed with the slice. You lay three or four coats of it on the other parts and moldings; but you cannot lay too much on the flats. Let it dry for two or three days. Then take this iron spatula and scrape over the flat. Have some little tools made which are called "little hooks,"[3] such as you will see at the painters' made up in various styles. Shape up the moldings and foliage ornaments nicely, so that they do not stay choked up; get them even; and contrive to get every flaw in the flats and gap in the moldings repaired by this gessoing.

HOW TO MAKE THE GESSO SOTTILE FOR GESSOING PANELS.
CHAPTER CXVI

Now you have to have a gesso which is called gesso sottile; and it is some of this same gesso, but it is purified for a whole month by being soaked in a bucket. Stir up the water every day, so that it practically rots away, and every ray of heat goes out of it, and it will come out as soft as silk. Then the water is poured off, and it is made up into loaves, and allowed to dry; and then this gesso is sold to us painters by the apothecaries. And this gesso is used for gessoing, for gilding, for doing reliefs, and making handsome things.

[3] *Raffietti*: These are made nowadays in Italy under the name of *raschiaii*. The so-called "plaster tools" of the sculptors, made of bronze or steel, may be pressed into service, but a set of *raschiaii*, with blades shaped to meet the requirements of moldings, carvings, *pastiglia*, etc., mounted at right angles to shafts and handles of convenient shape, will lighten and expedite the work enormously. The modern practice of "drawing up" the gesso as it is applied, with cut pumice templets, and smoothing off after the gesso is dry with the same templets and water, produces a rather mechanical perfection, and is not applicable to carved ornaments.

HOW TO GESSO AN ANCONA WITH GESSO SOTTILE; AND HOW TO TEMPER IT.
CHAPTER CXVII

When you have done the gessoing with gesso grosso, and scraped it nice and smooth, and evened it up well and carefully, take some of this gesso sottile. Put it, loaf by loaf, into a washbasin of clear water; let it soak up as much water as it will. Then put it on the porphyry slab, a little at a time, and without putting any more water in with it, grind it very thoroughly. Then place it neatly on a piece of strong white linen cloth; and keep on doing this until you have taken out one loaf of it. Then fold it up in this cloth, and squeeze it out thoroughly, so as to get as much water out of it as possible. When you have ground as much of it as you are going to need, which you must consider carefully, so as not to have to make gessos tempered in two ways, which would not be a good system, take some of that same size with which you tempered the gesso grosso. Enough of it wants to be made at one time for you to temper the gesso sottile and the grosso. And the gesso sottile wants to be tempered less than the gesso grosso. The reason?—Because the gesso grosso is your foundation for everything. Nevertheless, you will naturally realize that you cannot squeeze the gesso out so much that there will not still be some little water left in it. And for this reason, make the same size, confidently.

Take a new casserole, which is not greasy; and if it is glazed, so much the better. Take the loaf of this gesso, and with a penknife cut it thin, as if you were cutting cheese; and put it into this casserole. Then pour some of the size over it; and proceed to break up this gesso with your hand, as if you were making a batter for pancakes, smoothly and deftly, so that you do not get it frothy. Then have a kettle of water, and get it quite hot, and place this casserole of tempered gesso over it. And this keeps the gesso warm for you; and do not let it boil, for if it boiled it would be ruined. When it is warm, take your ancona; and dip into this pipkin with a good-sized and quite soft bristle brush, and pick up a reasonable amount of it, neither lavish nor skimpy; and lay a coat of it all over the flats and moldings and foliage ornaments. It is true that for this first coat, as you are applying it, you smooth out and rub over the gesso, wher-

ever you lay it, using your fingers and the palm of your hand, with a rotary motion; and this makes the gesso sottile unite well with the grosso. When you have got this done, begin over again, and apply a brush coat of it all over, without rubbing it with your hand any more. Then let it stand a while, not long enough for it to dry out altogether; and put on another coat, in the other direction, still with the brush; and let it stand as usual. Then give it another coat in the other direction. And in this way, always keeping your gesso warm, you lay at least eight coats of it on the flats. You may do with less on the foliage ornaments and other reliefs; but you cannot put too much of it on the flats. This is because of the scraping which comes next.

HOW YOU MAY GESSO WITH GESSO SOTTILE WITHOUT HAVING GESSOED WITH GESSO GROSSO FIRST.
CHAPTER CXVIII

Furthermore, it is all right to give any small-sized and choice bits of work two or three coats of size, as I told you before; and simply put on as many coats of gesso sottile as you find by experience are needed.

HOW YOU SHOULD TEMPER AND GRIND GESSO SOTTILE FOR MODELING.
CHAPTER CXVIIII

There are many, too, who just grind the gesso sottile with size, and not with water. This is all right for gessoing anything which has not been gessoed with gesso grosso, for it ought to be more strongly tempered.

This same gesso is very good for modeling up leaves and other productions, as you often need to do. But when you make this gesso for modeling, put in a little Armenian bole, just enough to give it a little color.[1]

[1] Modeling executed on the gesso surface with gesso applied with a brush is now generally called *pastiglia*. (See Chapter CXXIIII, p. 76, below.) The addition of a little coloring matter makes it easier to see the effect of the work as it progresses. The modern trade equivalent for "Armenian bole" is "Gilders' Red Clay," or "Red Burnish Gold-Size."

HOW YOU SHOULD START TO SCRAPE DOWN AN ANCONA FLAT GESSOED WITH GESSO SOTTILE.
CHAPTER CXX

When you have finished the gessoing, which must be finished in one day (and, if necessary, put in part of the night at it, just so you allow your required intervals), let it dry without sun for at least two days and two nights: the longer you let it dry, the better it is. Take a rag and some ground-up charcoal, done up like a little ball, and dust over the gesso of this ancona. Then with a bunch of hen or goose feathers sweep and spread out this black powder over the gesso. This is because the flat cannot be scraped down too perfectly; and, since the tool with which you scrape the gesso has a straight edge, wherever you take any off it will be as white as milk. Then you will see clearly where it is still necessary to scrape it down.

HOW THE GESSO SOTTILE ON THE FLATS SHOULD BE SCRAPED DOWN, AND WHAT THESE SCRAP-INGS ARE GOOD FOR.
CHAPTER CXXI

First take a "little hook"[1] with a straight edge, one finger wide, and go lightly all around the flat, scraping the molding once. Then take your spatula, ground to as straight an edge as possible; and with a light touch, not holding the point tightly at all, you rub it over the flat of your ancona, sweeping the gesso ahead of you with these feathers. And know that these sweepings are excellent for taking the oil out of the parchments of books. And in the same way scrape down the moldings and foliage ornaments with your little tools; and smooth it up as if it were an ivory. And sometimes, if you are hurried and have several jobs on hand, you may just smooth up the moldings and foliage ornaments with a linen rag, soaked and wrung out, rubbing it well over these moldings and foliage ornaments.

[1] *Raffietto.* See n. 3, p. 71, above.

HOW TO DRAW ON PANEL WITH CHARCOAL, TO BEGIN WITH, AND TO FIX IT WITH INK.
CHAPTER CXXII

When the gesso has all been scraped down, and come out like ivory, the first thing for you to do is to draw in your ancona or panel with those willow coals which I taught you to make before. But the charcoal wants to be tied to a little cane or stick, so that it comes some distance from the figures; for it is a great help to you in composing. And keep a feather handy; so that, if you are not satisfied with any stroke, you may erase it with the barbs of the feather, and draw it over again. And draw with a light touch. And then shade the folds and the faces, as you did with the brush, or as you did with the pen; for you draw as if you were working with a pen. When you have finished drawing your figure, especially if it is in a very valuable ancona, so that you are counting on profit and reputation from it, leave it alone for a few days, going back to it now and then to look it over and improve it wherever it still needs something. When it seems to you about right[1] (and bear in mind that you may copy and examine things done by other good masters; that it is no shame to you), when the figure is satisfactory, take the feather and rub it over the drawing very lightly, until the drawing is practically effaced; though not so much but that you may still make out your strokes. And take a little dish half full of fresh water, and a few drops of ink; and reinforce your whole drawing, with a small pointed minever brush. Then take a little bunch of feathers, and sweep the whole drawing free of charcoal. Then take a wash of this ink, and, with a rather blunt minever brush, shade in some of the folds, and some of the shadow on the face. And you come out with such a handsome drawing, in this way, that you will make everyone fall in love with your productions.

[1] In editing the Italian text, I, 73, l. 13, I indicated my belief that a lacuna exists here. By re-punctuating the text to read, *loc. cit.*, ll. 13–15: ". . . *presso di bene, (e sappi, . . . vergongnia), staendo la figura bene* . . ." it may be construed as complete, though awkward, as I have translated it here.

HOW YOU SHOULD MARK OUT THE OUTLINES OF THE FIGURES FOR GILDING THE GROUNDS.
CHAPTER CXXIII

When you have got your whole ancona drawn in, take a needle mounted in a little stick; and scratch over the outlines of the figure against the grounds which you have to gild, and the ornaments which are to be made for the figures, and any special draperies which are to be made of cloth of gold.

HOW TO MODEL ON A PANEL WITH GESSO SOTTILE, AND HOW TO MOUNT PRECIOUS STONES.
CHAPTER CXXIIII

After this, take some of that gesso for modeling,[1] if you want to model any ornament or foliage ornament, or to mount any precious stones in any special ornaments in front of God the Father or Our Lady, or any other special embellishments, for they add greatly to the beauty of your work. And there are glass gems of various colors. Arrange them systematically, and have your gesso in a little dish over a pot of hot ashes, and a little dish of hot clear water, for you have to wash the brush out often; and this brush is to be of minever, quite fine, and rather long; taking up some of the warm gesso neatly on the tip of this brush; and briskly set to modeling whatever you please. And if you are modeling any little leaves, draw them in first, as you do the figure. And do not try to model many of them, or too many complicated objects; for the clearer you make your foliage ornaments, the better they respond to the stamping with the rosette,[2] and they can be burnished better with the stone. There are some masters who, after they have modeled what they want, apply one or two coats of the gesso with which they gessoed the ancona, just the gesso sottile, with a soft bristle brush. But if you model lightly, in my opinion you get a finer, stronger, surer result by not putting any on, by the system which I stated earlier—of not putting on several types of gesso temperas.

[1] See Chapter CXVIIII, p. 73, above.　　　[2] See n. 6, p. 88, below.

HOW YOU SHOULD CAST A RELIEF FOR EMBELLISHING AREAS OF ANCONAS.
CHAPTER CXXV

Since we are on the subject of modeling, I will tell you something about it. With this same gesso, or some stronger of size, you may cast a lion's head, or any other impressions taken in earth or in clay.[1] Oil this impression with lamp oil;[2] put in some of this gesso, well tempered; and let it get quite cold; and then lift up the gesso at the side of the impression, with the point of a penknife, and blow hard. It will come out clean. Let it dry. Then apply some in embellishments in this way. With a brush, smear some of the same gesso with which you do the gessoing, or some of that with which you model, wherever you want to put this head; press it down with your finger, and it will stay in place neatly. Then take some of this gesso, and lay a coat or two of it, with the minever brush, over the part which you are modeling, and rub over this casting with your finger; and let it stand. Then feel over it with a knife point, to see whether there are any little lumps on it, and remove them.

HOW TO PLASTER RELIEFS ON A WALL.
CHAPTER CXXVI

I will also tell you about modeling on a wall. In the first place, there are certain wall jobs involving curves or leaves which cannot be plastered with the trowel. Take some well-sifted lime, and well-sifted sand; put them into a pan, and temper them well to a batter, with a large bristle brush and clear water; and apply several coats of it with this brush to the places in question. Then smooth it with the trowel, and it will come out neatly plastered. And execute it, wet and dry,[3] as you were taught for work in fresco.

[1] *R* has *cera,* "wax." See notes on pp. 129 and 130, below.
[2] *Olio da bruciare:* a vegetable oil, probably olive oil, of inferior quality.
[3] *Ellavorala frescha e seccha.* That is, in fresco and in secco.

HOW TO MODEL WITH MORTAR ON A WALL THE WAY YOU MODEL WITH GESSO ON PANEL.
CHAPTER CXXVII

Furthermore, with the aforesaid mortar, worked up a little on the stone, you can model whatever you want on a wall, just the way I taught you for panel, right in the mortar and fresh plaster.

HOW TO TAKE RELIEFS FROM A STONE MOLD, AND HOW THEY ARE GOOD ON WALL AND ON PANEL.
CHAPTER CXXVIII

You may also get a stone, carved with devices of any style you wish; and grease this stone with bacon fat or lard. Then get some tin foil; and, laying some fairly moist tow on the tin which lies over the mold, and beating it as hard as you can, with a willow mallet, you then take gesso grosso ground with size, and fill up this impression with the slice. You may embellish with these on a wall, on chests, on stone, on anything you please, afterward putting some mordant over the tin; and when it is a little tacky, gild it with fine gold. Then, when it is dry, fasten it to the wall with ship pitch.

HOW YOU MAY MODEL ON A WALL WITH VARNISH.
CHAPTER CXXVIIII

You may also model on a wall ⟨in this way⟩. Take some liquid varnish mixed with flour, well worked up together; and model it with a pointed minever brush.

HOW YOU MAY MODEL ON A WALL WITH WAX.
CHAPTER CXXX

Furthermore, you may model on a wall with melted wax and ship pitch mixed together: the two parts wax, the third, pitch. Model with a brush. Have it hot.

To get back to our previous discussion:

HOW TO LAY BOLE ON PANEL, AND HOW
TO TEMPER IT.
CHAPTER CXXXI

When you have finished modeling your ancona, get some Armenian bole,[1] and choose a good grade. Touch it to your lower lip: if you find that it sticks, that is excellent. Now you will need to know how to make the perfect tempera for gilding. Take the white of an egg in a very clean glazed porringer. Take a whisk with several branches cut even; and you beat this white as if you were beating up spinach, or a *purée,* until the whole porringer is full of a solid foam which looks like snow. Then take an ordinary drinking glass, not too large, not quite full of good clear water; and pour it over the white in the porringer. Let it stand and distil from evening to morning. Then grind the bole with this tempera, as long as ever you can. Take a soft sponge; wash it well, and dip it in good clear water; squeeze it out; then rub lightly with this sponge, not too wet, wherever you want to gild. Then, with a good-sized minever brush, temper some of this bole, as thin as water for the first coat; and wherever you want to gild, and where you have damped down with the sponge, lay this bole all over, watching out for the breaks which the brush sometimes makes. Then wait a while; put some more of this bole into your little dish, and have the second coat stronger of color. And you lay the second coat of it in the same way. Again you let it stand for a while; then you put some more bole into the little dish, and put on the third coat as before, watching out for the breaks. Then put some more bole into the little dish, and lay the fourth coat in the same way: and in this way it gets covered with bole. Now the job should be covered up with a cloth, to shield it as far as you can from dust and sun and water.

ANOTHER WAY TO TEMPER BOLE ON PANEL,
FOR GILDING.
CHAPTER CXXXII

This tempera can also be made in another way, in grinding the bole. Take the egg white and put it on the porphyry slab, whole, as it is.

[1] See n. 1, p. 73, above.

Then have the bole powdered; wet it up in this egg white. Then grind it well and finely; and as it dries under your hands, add good clear clean water on the slab. Then when it is well ground, temper it with plain clear water, so that it runs from the brush; and lay four coats of it on your work in the same way described above. And this method will be surer for you than the other tempera as long as you have not had much experience. Cover up your ancona carefully, and protect it from dust, as I have said.

HOW YOU MAY GILD ON PANEL WITH TERRE–VERTE. CHAPTER CXXXIII

You may do also as our forefathers used to, that is, apply canvas all over the whole ancona before you gesso; and then gild with terre-verte, grinding this terre-verte with whichever of these two kinds of tempera, which I have just taught you, you prefer.

HOW TO GILD ON PANEL. CHAPTER CXXXIIII

When some mild damp weather comes along, and you want to do some gilding, have this ancona laid out on two trestles. Take your feathers; sweep it off thoroughly. Take a little hook;[1] feel over the ground of the bole with a light touch. If there should be any foreign matter, or any little lump or grit, get rid of it. Take a piece of a strip of linen cloth, and burnish the bole briskly. Burnishing it also with a crook[2] would be sure to help. When you have got it burnished and cleaned up in this way, take a goblet almost full of good clean clear water, and put a little of that white-of-egg tempera into it. And if it were a trifle stale, so much the better. Mix it up thoroughly with the water in the goblet. Take a good-sized minever brush made out of the tips of the tails as I told you before; take your fine gold, and pick up the leaf carefully with a pair of tweezers or small pincers. Have a card cut in a square larger than the leaf of gold, trimmed off at each

[1] See n. 3, p. 71, above.

[2] That is, a stone burnisher with a curved point. (See n. 2, p. 25, above.) This operation—burnishing directly on the bole ground—wears out the burnisher, so Cennino hesitates to advise it.

corner. Hold it in your left hand; and, using the brush with your right hand, wet down as much of the bole as is to receive the leaf of gold which you have in your hand. And wet it down evenly, so that there will not be any more water in one place than in another. Then carefully bring the gold up to the water on the bole; but have the gold extend a little bit beyond the card, just so that the little tip[3] of the card will not get wet. Now, as soon as you have brought the gold into contact with the water, instantly and quickly draw your hand and the little tip toward you. And if you observe that the gold is not all in contact with the water, take a bit of fresh cotton-wool, and tamp the gold down, as lightly as ever you can. And lay some more leaves in the same way. And when you are wetting down for the second leaf, take care to run the brush along the edge of the leaf just laid so accurately that the water will not run over it. And see to it that you lap the one which you are laying a little bit over the one which has been laid; first breathing upon the latter, so that the gold will adhere to the part where it overlaps. When you have laid about three pieces, go back and tamp the first one down with the cotton, breathing on it, and that will show you whether it requires any faulting.[4] Then fix yourself up a cushion, the size of a brick or tile, that is, a good flat board, with some nice soft white leather stretched over it, not greasy, but the kind that calfskins make. Tack it on, nicely spread out, and fill in between the wood and the leather with shearings. Then lay a leaf of gold out flat on this cushion; and with a good straight spatula cut this gold into such little pieces as you require for the faults which remain. Take a small pointed minever brush, and wet these faults with the usual tempera. And thus, if you moisten the handle of the brush with your lips a little cupped, it will be adequate to pick up

[3] *Tanto chella paletta della charta non si bangni.* A *paletta* is literally a "little shovel"; here, the "tip" of the card formed by trimming off its corners. This method is not suitable for handling the ordinary gold leaf of modern commerce. The thin modern leaf is best applied with a "gilder's tip," a flat thin brush made of long hairs mounted between cards. This is called regularly in French, and not uncommonly in English, a "palette." It may be noted that the cards in which the hairs are mounted almost invariably have their back corners trimmed off, and thus preserve something of the form of Cennino's *paletta,* though the card itself no longer carries the gold.

[4] "Faulting" is the workshop expression used by modern gilders to signify patching up with small pieces of leaf.

the little scrap of gold and lay it on the fault. When you have finished the flats, though you ought to lay it so that you can burnish it the same day, as I shall show you when you have to gild moldings or leaves, take pains to gather up the scraps, as the master does who wishes to pave his way; so that you may always be as thrifty with the gold as you can, and make economies with it; and cover up the gold which you have laid, with white napkins.

WHAT STONES ARE GOOD FOR BURNISHING THIS GILDING.
CHAPTER CXXXV

When you judge that the gold is ready to be burnished, take a stone known as hematite;[1] and I will teach you how to prepare it; and, failing this stone, and even better for anyone who can make the outlay, sapphires, emeralds, balas rubies, topazes, rubies, and garnets: the choicer the stone, the better it is. A dog's tooth is also good, or a lion's, a wolf's, a cat's, and in general that of any animal which feeds decently upon flesh.[2]

HOW TO PREPARE THE STONE FOR BURNISHING GOLD.
CHAPTER CXXXVI

Take a piece of hematite, and be careful to choose a good sound one, without any grain,[3] with its whole structure[4] continuous from

[1] See Chapter XLII, and n. 1, p. 25, above. Amorphous hematite, and kidney ore are, of course, unsuitable for burnishers; the best, as Cennino specifies, is the specular iron ore, the crystalline form.

[2] Teeth of herbivorous animals were also employed. Rockinger, *art. cit.* p. 4, *supra,* 1^te Abt., p. 49, n., quotes from Munich, Staatsbibliothek, Cod. germ. 821, *Liber illuministarum pro fundamentis auri et coloribus ac consimilibus,* foll. 209^r–209^v, the following directions, given by "Johannes Purger, caplan ze Trienndt," for preparing a horse's tooth for use as a burnisher:

"Schleiff jn mit dem weczstain am ersten, das er gleich werd. hüet dich das du das jnner vnder dem weissen auff dem zand nit beruerst, anders ist er nichts werd. vnd leym jn wol ein in ein holcz, das du jn [in] der hant haben mügst zu pollieren, vnd lasz in dür werden. darnach nym ein linds locz, als eschen alber linden oder ander, vnd mach als ein linial, doch pasz dicker, vnd nym puluer von kesselprawn, vnd see es auff das hölczli, vnd pollier den zand als lang bisz er glat vnd vein glancz wirt als ein spiegel."

[3] *Vena:* as in pencil hematite. (See n. 1, p. 25, above.)

[4] That *tiglio* actually means "structure" in the sense of "crystal structure" may be seen from the comment in Chapter XLII, already noted, that hematite has a *tiglio* like that of cinnabar. (See n. 1, p. 25, above.)

top to bottom. Then betake yourself to the millstone, and grind it; and get it all straight across, and smooth, two fingers wide, or as much as you can. Then take some emery powder,[3] and shape it up, not so that it gets a sharp edge, but just a little ridge. Round it off nicely at the corners. Then mount it in a wooden handle, with a brass or copper ferrule; and have the handle all round and smooth at the end, so that the palm of your hand will rest on it well. Then polish it in this way. Take a good flat porphyry; put some powdered charcoal on it; and burnish over the porphyry with this stone, gripping it tightly with your hand, as if you were burnishing. And the result is that your stone gets dense, and turns quite black, and so shiny that it looks like a diamond.[4] Then you must take great care of it, so that it does not get chipped or come in contact with iron. And when you want to use it for burnishing gold or silver, first keep it in your bosom, so that there will not be any dampness about it, for the gold is very fastidious.

HOW YOU SHOULD BURNISH THE GOLD, OR MEND MATTERS IN CASE IT COULD NOT GET BURNISHED.
CHAPTER CXXXVII

Now the gold has to be burnished, because the time for that has arrived. It is true that in winter you may gild as much as you please, when the weather is damp and mild. In summer, lay your gold one hour, and burnish it the next. Now if it is too fresh, and some reason comes up why it has to be burnished, keep it in a place which gets some breath of heat, or breezes. Now if it is too dry, keep it in a moist place, always covered up; and when you want to burnish it, uncover it gently, with caution, for the slightest rubbing will injure it. If you put it in a cellar, at the foot of the casks or wine vats, it will become fit to burnish. Now if for some reason it has been impossible to get it burnished for a week or ten days or a month, take a good white napkin or towel; lay it over your gold, in the cellar or wherever it may

[3] *Polvere di smeriglio:* Mottez, Ilg, and Verkade translate this correctly; but Lady Herringham follows Mrs. Merrifield's romantic but inaccurate example in translating it "emerald dust." (Mrs. Merrifield's reading is "dust of emeralds.")

[4] Here, as in Chapter XLII, it is possible that we should read for *diamante, adamante,* "adamant."

be. Then take another napkin; soak it in clear water; wring it out, and squeeze it thoroughly. Open it up, and spread it on top of the first napkin which you laid over the gold; and the gold will soon come back so that it can be burnished. Now I have recounted the circumstances of the case, when the gold is fit to stand being burnished.

NOW I WILL SHOW YOU HOW TO BURNISH, AND IN WHAT DIRECTION, ESPECIALLY A FLAT.
CHAPTER CXXXVIII

Take your ancona, or whatever has been gilded; spread it out flat on two trestles, or on a bench. Take your burnishing stone, and rub it on your breast, or wherever you have any better clothing that is not greasy. Get it nice and warm; then sound out the gold, to see whether it is ready to be burnished; sound it out cautiously, always with hesitation. If you feel any dust under the stone, or feel it grit at all, like dust between your teeth, take a minever tail, and sweep lightly over the gold. And so burnish up a flat gradually, first in one direction, then, holding the stone quite flat, in the other direction. And if, while rubbing with the stone, it ever strikes you that the gold is not as even as a mirror, then take some gold, and put it on, by the leaf or the half leaf, at the same time blowing with your breath to begin with; and immediately burnish it with the stone. And if you ever find that even the flat of the gold is obstinate, and will not come out just to suit you, then again you lay it over once more in the same way. And, if you could stand the expense, it would be ideal, and good for your reputation, to lay the whole ground over again that way. When shall you know that it is burnished properly?—The gold then becomes almost dark from its own brilliance.

WHAT GOLD IS GOOD FOR BURNISH AND FOR MORDANT GILDING, AND WHAT THICKNESS.
CHAPTER CXXXVIIII

Let me tell you that for the gold which is laid on flats they ought not to get more than a hundred leaves out of a ducat, whereas they do get a hundred and forty-five;[1] because the gold for the flat wants to be

[1] Modern leaf is considerably thinner than this. The Venetian ducat weighed fifty-

rather dull. If you want to be sure of the gold, when you buy it, get it from someone who is a good goldbeater; and examine the gold; and if you find it rippling and mat, like goat parchment, then consider it good. On moldings or foliage ornaments you will make out better with thinner gold; but for the delicate ornaments of the embellishment with mordants it ought to be very thin gold, and cobweb-like.

HOW YOU SHOULD BEGIN SWINGING THE DIADEMS AND DO STAMPING ON THE GOLD, AND MARK OUT[1] THE OUTLINES OF THE FIGURES.
CHAPTER CXL

When you have burnished and finished your ancona, you must start by taking the compasses; swinging your crowns or diadems; engraving them; tapping in a few ornaments; stamping them with tiny punches, so that they sparkle like millet grains; embellish with other punches; and do stamping if there are any foliage ornaments. You

four troy grains, so Cennino's best leaf weighed something like half a grain, and his thin leaf, about a third. The best trade leaf nowadays seldom weighs over a fifth of a grain, though most goldbeaters will furnish double-weight leaf without extra cost, and heavier gold can be procured from dealers in dentists' supplies.

Borghesi and Branchi, *Nuovi documenti per la storia dell'arte Senese* (Siena, 1898), p. 10, print the contract for Pietro Lorenzetti's Arezzo ancona, in which he agrees to use "the finest gold leaf, 100 leaves to a florin." The florin was equivalent to the ducat, so a leaf weighing half a grain, or thereabouts, may be considered the best fourteenth-century Italian standard. The size of the leaf does not seem to have been inflexibly determined; but from measurements made at Assisi, I judge that the leaves used by Pietro there were about 8.5 cm. square, almost exactly the size of the average modern leaf.

Precise comparisons are not possible, and I will not enter into a long discussion here. For the present purpose, it will be enough to say that our ordinary commercial leaf is good for mordant gilding; double-weight leaf would have suited Cennino for "moldings and foliage ornaments"; and for flats, quadruple gold is desirable, if it can be obtained. It should be observed, however, that perfect gilding can be done with thin leaf: the advantage of heavier leaf lies not in any inferiority of the effect produced but in the greater ease of manipulation and freedom from blemishes which require faulting.

[1] *Ritagliare.* This corresponds exactly to the modern sign painters' expression "cut in," in the sense of establishing an outer edge. I find to my regret that this term is not generally understood, and suggests rather some such process of incision as described in Chapter CXXIII, p. 76, above. Lady Herringham misunderstood the Italian in this sense, translating it here, "indent." Verkade's translation, "beschneiden," is the best, for it cannot be misconstrued, yet does convey the idea of "cutting in"—figuratively —the sharp outline.

will need to get some practice at this. When you have shaped up the diadems and ornaments in this way, take a bit of white lead in a little dish, thoroughly ground with a little diluted size; and with a smallish minever brush cover and mark out[2] the figures from the ground, just as you see those little marks which you scratched in with the needle before you laid the bole. Again, if you want to do without marking out[2] with white lead and the brush, take your little tools, and scrape off all the gold which is superfluous, or which laps over the figure: and this is better practice.

This stamping which I am telling you about is one of our most delightful branches. And you may do all-over stamping, as I have described; and you may model in the stamping,[3] so that, with imaginative feeling and a delicate touch, you may work out foliage ornaments on a gold ground, and make little angels and other figures so that they show up in the gold; that is, in the folds and in the shadows do not do any stamping; not much in the half tone; in the reliefs, a great deal; because stamping amounts to making the gold lighter; because by itself it is dark wherever it is burnished.[4] But before you stamp a figure or foliage ornament, draw on the gold ground whatever you want to do, with a style of silver or brass.[5]

HOW TO DESIGN GOLD BROCADES IN VARIOUS COLORS.[1]

Before you get started on painting, I want to show you how to make a cloth of gold. If you want to make a mantle, or a gown, or a little cushion, out of cloth of gold, lay the gold with bole; and scratch in the folds of the drapery, just the way I taught you for gilding a ground. Then, if you want to make the cloth red, lay in with vermilion over this burnished gold. If you need to put any dark on it, put it on with lac; if you need to put on lights, put them on with red

[2] See n. 1, p. 85.

[3] Literally, "stamp in relief." The process is made clear by what follows.

[4] See p. 84, above.

[5] This paragraph, not found in *L,* is supplied from *R.* (See I, 84, n. 1.) From this point on, neither of the basic MSS has any original chapter headings or numbers; the headings printed here in italics are of my own composing, introduced purely for the convenience of the reader. (See above, Preface, p. xviii.)

[1] T., M., CXLI.

lead; all tempered with yolk of egg; but not rubbing your brush too hard, nor too many times. Let it dry; and put on at least two coats of it. And in the same way, if you want to make them green, black, or any way you like. But if you should want to do them with a handsome ultramarine blue, begin by laying in over the gold with white lead tempered with yolk of egg. When it is dry, temper your ultramarine blue with a little size and a little yolk, perhaps two drops; and lay in two or three coats of it over this white lead; and let it dry. Then you prepare your pounce patterns according to the cloths which you want to make; that is, first draw them on parchment;[2] and then prick them carefully with a needle, holding a piece of canvas or cloth under the paper. Or do the pricking over a poplar or linden board; this is better than the canvas. When you have got them pricked, take dry colors according to the colors of the cloths upon which you have to pounce. If it is a white cloth, pounce with charcoal dust wrapped up in a bit of rag; if the cloth is black, pounce it with white lead, with the powder done up in a rag; and *sic de singulis*. Make your repeats so that they register well on each side.

HOW TO EXECUTE GOLD OR SILVER BROCADES.[1]

When you have pounced your cloth, take a little style of birch, or hard wood, or bone; with a point, like a regular style for drawing, at one end; and a little edge at the other, for scraping. And with the point of this style, sketch in and shape up all your cloths; and with the other end of the style, scrape and remove the color from them, nicely, so as not to scratch the gold. And scrape whichever you please, either the ground or the pattern,[3] and whatever you uncover, you

[2] *Carta:* this might equally well mean paper, but practice will make it clear that parchment is intended. (See n. 1, p. 6, above.)

[1] T., M., CXLII.

[3] *L'alacciato* <*laccio* <Latin *lăqueus* "hole," "opening"> "net," "mesh." (See W. Meyer-Lübke, *Romanisches etymologisches Wörterbuch* [Heidelberg, 1911], § 4909.) When a layer of color is "opened up" by scraping through to reveal the metal ground below it, the root meaning is sufficiently descriptive, and *laccio* is translated as "opening." When, however, the pattern is conceived figuratively as made of *lacci* in a uniform ground, or, as here, when ground and pattern are regarded as interchangeable, *laccio* and its derivatives must be translated in their secondary sense, as "pattern."

stamp afterward with the rosette.[6] And if you cannot get the rosette into the little strokes, take a single little iron punch with a point like a drawing style. And in this way you begin learning how to make cloths of gold. If you want to make a cloth of silver, you must use the same system and method for laying silver as for laying gold. And, indeed, I advise you, if you want to teach boys or children how to do gilding, have them lay silver, so as to get some experience with it; for it is less expensive.

SEVERAL RULES FOR CLOTHS OF GOLD AND SILVER.[1]

Again, when you want to make a rich cloth of gold, the drapery which you wish to do may be modeled up with leaves and mounted jewels of various colors; then lay fine gold all over it; and then stamp it after it is burnished.

Item. Gild the whole ground; burnish it; draw upon it the cloth which you wish to make, animal forms, or other subjects. Then stamp either the ground or the pattern,[2] that is, the subjects drawn upon it.

Item. Gild the ground; burnish it; and model it in the stamping.[3]

Item. Gild the ground; draw on it the subject which you want; lay in the grounds with verdigris in oil, shading some folds twice; then lay some uniformly all over the grounds and the subjects evenly.

Item. Lay the drapery in silver; after you have burnished, for that is always understood, design your cloth; lay in the ground or the pattern[4] with vermilion, just tempered with yolk of egg; then lay a coat or two of fine lac in oil over each subject, like a pattern on a ground.[5]

[6] By "rosette" must be understood a stamping tool which produces a cluster of small points. In medieval gold stamping these are generally seen to be grouped on a rectangular surface. The number of points engraved on the rosette varied greatly, as did the size of the stamping surface. I hope that medieval stamping tools and their application will soon be made the objects of detailed study; for I believe that this aspect of technique offers a fertile field for critical investigation.

[1] T., M., CXLIII. [2] *Lacci.* See n. 2, p. 87, above.

[3] *Granare arrilievo.* See n. 3, p. 86, above. [4] *Lacci.* See n. 2, p. 87, above.

[5] *Si chome laccio in canpo.* It is tempting to read: *si in laccio come in campo:* that is, "on the pattern as well as the ground." I strongly suspect that the finished product was intended to show a pattern of silver glazed with lac on a ground of vermilion also glazed with lac, and not, as the text suggests, a combination of vermilion and silver both with and without glazes; but I will not venture to modify the reading. *R* has *laccio e campo:* "such as pattern and ground."

Item. If you want to make a handsome cloth with ultramarine blue, lay your drapery in burnished silver; design your cloth; set out either the grounds or the patterns[6] with this blue, tempering it with size. Then lay some evenly all over the grounds and the patterns; and it will be a velvety cloth.

Item. Lay in and clothe the figure with any color you wish; shade it. Then take a fine minever brush, and some of the mordants. When you have got it pounced, work with the mordants, as I shall explain to you later on, according to the way you want to make the cloths and patterns.[6] And you may lay these mordants with gold or with silver; and they will come out lovely cloths if you sweep them off and burnish them with cotton.

Item. When you have worked with any color you wish, as I said a little way back, and you want to get a shot effect, work over the gold with any oil color you please, provided it differs from the ground.

Item. For a wall, put in the drapery with golden tin; lay it in with any ground you please; pounce it; execute and scrape the cloth with the wooden style, with the colors still tempered with yolk of egg. And it will be a very lovely cloth, as walls go. But you can work with mordants on a wall, as well as on panel.

HOW TO DO VELVET, WOOL, AND SILK.[1]

If you want to get the effect of a velvet, do the drapery with any color you wish, tempered with yolk of egg. Then make the cut threads, as the velvet requires,[2] with a minever brush, in a color tem-

[6] *Lacci:* see n. 3, p. 87, above. [1] T., M., CXLIV.

[2] *Va' facciendo i peluzi; chome ista il velluto.* Velvets were something of a rarity in fourteenth-century Italy, and figured velvets still more so. Some figured velvets were woven in Venice early in the fifteenth century, and Cennino doubtless saw examples of those or their imported prototypes during his residence in Padua. The phrase, *chome ista il velluto,* seems to point to a figured, that is, "voided," velvet.

In weaving velvet by hand, threads from one or more extra warps are formed into loops by the insertion of grooved rods into the weaving shed. In so-called "terry velvets" the rods are withdrawn and the loops left as such. In "cut velvets" a blade separates the loops of pile warp into vertical threads, seated in the ground of the fabric much as the hairs of a fur are seated in the skin. These cut loops are the *peluzi,* the "little hairs." Taken together they form the "pile" (Italian *pelo:* both this and the English term are descended from the Latin *pilus,* "a hair"; so probably also the late Latin *villus* > Italian *velluto*), but Cennino evidently intends that the velvet should be painted

pered with oil; and make the cut threads rather coarse. And you may make black velvets in this way, and red ones, and any colored ones, tempering in this way.

Sometimes on a wall a lining has to be simulated, or a drapery which shall really look like woolen cloth. And for this, when you have plastered, smoothed down, and done the painting, put off whatever you want to do until afterward. And take a little block, not much bigger than a checker[3] and, sprinkling clear water into or over this part with the brush, work over it, around and around, with this little block. The mortar gets rough and poor surfaced. Let it stay so, and paint it as it is, without smoothing down. And it will really look like woolen stuff or cloth.[4]

Item. If you want to make a silk cloth, either on panel or wall, lay it in with vermilion, and hatch or sprig it[5] with red lead. Or hatch with dark sinoper; or hatch with vermilion or with giallorino on the

like a fur, to some extent hair by hair. Since that would be, of course, impossible, he amends his direction: *effa' i pelucci grossetti*—"and make the little hairs rather coarse."

Lady Herringham's translation, "Make the pile with thick paint," seems to me to miss the point, through confusion of the "pile" (*pelo*) with the "little hairs" (*peluzi*) of which it is made up. This passage is cited by A. P. Laurie, *op. cit.*, p. 41: "Shape the pile with thick paint." (In Dr. Laurie's quotation a typographical error should be corrected: for "a minever brush tempered with oil," read, "a minever brush and color tempered with oil.")

[3] *Tavola da giuchare:* this is a rather indefinite term at best, but we may understand it as a round piece, probably something like an inch in diameter. A "checker," or "draught," or even a "poker chip" is perhaps a little more graphic than Lady Herringham's literal translation, "play-tablet."

[4] *Panno o ver drappo di lana.* See n. 3, p. 26, above.

[5] *Palia o ver viticha. Viticare* is known only from this text. It has been regarded by Tambroni, the Milanesi, Tommaseo and others as synonymous with *paliare*, owing to the association of the terms here. Cennino's *paliare*, furthermore, has been identified with *palliare* "to cover" <Latin *pallium* "cloak," and understood as *velare* "to glaze." So Tambroni, *Trattato*, pp. 159, 160, defines both *palliare* and *viticare* by *velare;* Tommaseo, *Dizionario, s.v.* "palliare," suggests that the imperative *vitica* may be a scribal error for *vernica* or *vernicia.*

I do not believe that *viticare* is a by-form (by scribal error) of *vernicare* "to varnish," but that it represents an independent verb based on Latin *viticŭla*>Italian *viticcio* "tendril," or "sprig"; the history of the derived Italian verb would then correspond almost exactly to the English "sprig" (*NED* v[2]) as in the phrase, "sprigged muslin" (see *NED*, "sprigged," pple.).

In printing *pallia* for MSS *palia*, the Milanesi, and Simi as well, have disguised the possibility that a verb *paliare*, elsewhere unrecorded, and distinct from *palliare*, might be intended. This I believe to be the case: that Cennino's *paliare* looks back, not to Latin *pallium*, but to Latin *pălĕa* "chaff"> Italian *paglia* "straw," and that the phrase

wall, and on panel, with orpiment.[6] Or lay in dark with green or any color you please, and hatch it light.

Item. On a wall, in fresco, lay in with indigo; and hatch with indigo and lime white mixed together. And if you wish to work with this color on panel, or on shields, mix the indigo with white lead tempered with size. And in this way you may make many cloths of various kinds, according to your understanding and to how much you enjoy it.

HOW TO PAINT ON PANEL.[1]

I believe that by yourself you will have enough understanding, with your experience, to train yourself, by following this method, to understand working neatly with various kinds of cloth. And by the grace of God it is time for us to come to painting on panel. And let me tell you that doing a panel is really a gentleman's job, for you may do anything you want to with velvets on your back.[2] And it is true that the painting of the panel is carried out just as I taught you to work in fresco, except that you vary it in three[3] respects. The first, that you always want to work on draperies and buildings before faces. The second is that you must always temper your colors with yolk of egg, and get them tempered thoroughly—always as much yolk as the color which you are tempering. The third is that the colors want to be more choice, and well worked up, like water. And for your great pleasure, always start by doing draperies with lac[4] by the same system which I showed you for fresco; that is, leave the first value in its own color; and take the two parts of lac color, the third of white lead; and when this is tempered, step up three values from it, which vary slightly

palia o ver viticha means, accordingly, "make straw-like or tendril-like markings," hence, "hatch or sprig."

The context above demands some such explanation of both verbs.

[6] We might venture to read: "O vo' *campeggiare* . . . e palia . . ." That is, "Or *lay in* with dark sinoper, *and* hatch with vermilion or with giallorino."

The punctuation of the text, I, 87, ll. 3, 4, should be modified as follows: "giallorino in muro, e in tavola, d'orpimento. O di verde . . ."

[1] T., M., CXLV.

[2] The height of elegance! See n. 2, p. 89, above.

[3] MSS, "two." Perhaps the copyists' error; or perhaps the third "variation" was an afterthought of the author's.

[4] *NED, s.v.* "Lac"[1] 2. See n. 1, p. 26, above.

from each other: tempered well, as I have told you, and always made lighter with white lead well worked up. Then set your ancona up in front of you; and mind you always keep it covered with a sheet, for the sake of the gold and the gessos, so that they may not be injured by dust, and that your jobs may quit your hands very clean.[4a] Then take a rather blunt minever brush, and and start to apply the dark color, shaping up the folds where the dark part of the figure is to come. And in the usual way take the middle color and lay in the backs and the reliefs of the dark folds, and begin with this color to shape up the folds of the relief, and around toward the light part of the figure. And shape it up once more in this way. Then take the light color, and lay in the reliefs and the backs of the light part of the figure. And in this way go back once again to the first dark folds of the figure with the dark color. And carry on as you began, with these colors, over and over again, first one and then the other, laying them in afresh and blending them skilfully, softening delicately. And with this[5] you have enough time so that you can get up from your work and rest yourself for a while, and reflect upon this work of yours. Work on panel wants to be done with much enjoyment.

When you have got it well laid in and these three colors blended, make another lighter one out of the lightest, always washing the brush between one color and the next; and out of this lighter one make another lighter still; and have the variations among them very slight. Then touch in with pure white lead, tempered as has been said; and touch in with it over the strongest reliefs. And make the darks, gradually, in the same way, until you finally touch in the strongest darks with pure lac. And bear this in mind: just as you prepared your colors value by value, so you put them into your little dishes value by value, so as not to take one of them for another by mistake.

And use this same system, likewise, for any color which you want to paint, whether reds, or whites, or yellows, or greens. But if you want to make a lovely violet color, take good choice lac, and good choice fine ultramarine blue; and with this mixture and white lead

[4a] So *R; L* has, "that your jobs may touch . . ."
[5] *Sc.,* "As opposed to fresco."

make up your colors, value by value, always tempering them. If you wish to do a drapery with blue with lights on it, make it lighter in this way with white lead; and execute it in the way described above.

HOW TO MAKE DRAPERIES IN BLUE AND PURPLE.[1]

If you want to do a blue, that is, for a drapery, neither wholly modeled with lights nor all just laid in flat,[2] take some of three or four divisions of ultramarine blue:[3] for you will find various grades of it, one lighter than another. And paint according to the lighting of the figure, as I have shown you above. And you can work in this way on a wall with the tempera mentioned above, in secco. And if you do not want to make the outlay for these divisions, you will find grades of azurite.[4] And if you want to brocade[5] them with gold, you may do that too; and touch them in afterward with a little violet in the darks of the folds, and a little in the lights, shaping them up nicely, shaping up the folds over the gold. And draperies like these will please you very much, and particularly for draperies of the Lord God.

And if you wish to clothe Our Lady with a purple,[6] make the drapery white, shaded with a little violet so very light that it is just off white. Brocade it[7] with fine gold, and then touch it up, and shape up the folds over the gold, with a little darker violet; and it is a very handsome drapery.

HOW TO PAINT FACES.[8]

When you have done the draperies, trees, buildings, and mountains, and got them painted, you must come to painting the faces; and those you should begin in this way. Take a little terre-verte and a little white lead, well tempered; and lay two coats all over the face, over the hands, over the feet, and over the nudes. But for faces of young people with cool flesh color this couch should be tempered,

[1] T., M., CXLVI. [2] See n. 2, p. 37, above.

[3] See Chapter LXII, p. 38, above. [4] See n. 1, p. 35, above.

[5] *Drapparli.*

[6] *D'una porpora. Porpora* may mean "purple," as I have translated it, conservatively; it may also mean "a pourpoint"; and it may even apply to the golden ornamentation of the drapery which Cennino goes on to describe (cf. *porporina,* p. 101, below).

[7] *Drappeggiallo.* [8] T., M., CXLVII.

the couch, and the flesh colors too, with yolk of a town hen's egg, because those are whiter yolks than the ones which country or farm hens produce; those are good, because of their redness, for tempering flesh colors for aged and swarthy persons. And whereas on a wall you make your pinks with cinabrese, bear in mind that on panel they should be made with vermilion. And when you are putting on the first pinks, do not have it straight vermilion—have a little white lead in it. And also put a little white lead into the verdaccio with which you shade at first. Just exactly a ou work and paint on a wall, in just that same method, make three values of flesh color, each lighter than the other; laying each flesh color in its place on the areas of the face; still do not work up so close to the verdaccio shadows as to cover them entirely; but work them out with the darkest flesh color, fusing and softening them like a puff of smoke. And bear in mind that the panel needs to be laid in more times than a wall; but still not so much as not to need to have the green, which lies under the flesh colors, always show through a little. When you have got your flesh colors down so that the face is about right, make a flesh color a little bit lighter, and pick out the forms[2] of the face, making it gradually lighter, in a careful way, until you finally come to touch in with pure white lead any little relief more pronounced than the rest, such as there would be over the eyebrow, or on the tip of the nose, etc. Then outline the upper edge of the eyes with an outline of black, with a few lashes[3] as the eye requires, and the nostrils of the nose. Then take a little dark sinoper and a trace of black; and outline all the accents of nose, eyes, brows, the hair, hands, feet, and everything in general, as I showed you for a wall; always using that yolk-of-egg tempera.

HOW TO PAINT A DEAD MAN.[1]

We shall next speak about the way to paint a dead man, that is, the face, the breast, and wherever in any part the nude may show.

[2] *I dossi.* Literally, "the backs," as translated on p. 92, above. It is very tempting to interpret *i dossi* as "reflected lights," as Lady Herringham occasionally does; but that would imply a degree of sophistication in the treatment of light and shade which Cennino probably did not possess.

[3] *Peluzo*: literally, "little hair." See n. 2, p. 89, above.

[1] T., M., CXLVIII.

It is the same on panel as on wall: except that on a wall it is not necessary to lay in all over with terre-verte; it is enough if it is laid in the transition between the shadows and the flesh colors. But on a panel lay it in as usual, as you were taught for a colored or live face; and shade it with the same verdaccio, as usual. And do not apply any pink at all, because a dead person has no color; but take a little light ocher, and step up three values of flesh color with it, just with white lead, and tempered as usual; laying each of these flesh colors in its place, blending them nicely into each other, both on the face and on the body. And likewise, when you have got them almost covered, make another still lighter flesh color from this light one, until you get the major accents of the reliefs up to straight white lead. And mark out all the outlines with dark sinoper and a little black, tempered; and this will be called "sanguine." And manage the hair in the same way, but not so that it looks alive, but dead, with several grades of verdaccio. And just as I showed you various types and styles for beards on the wall, so on panel you do them in the same way; and so do every bone of a Christian, or of rational creatures; do them with these flesh colors aforesaid.

HOW TO PAINT WOUNDS.[1]

To do, that is, to paint, a wounded man, or rather a wound, take straight vermilion; get it laid in wherever you want to do blood. Then take a little fine lac, well tempered in the usual way, and shade all over this blood, either drops or wounds, or whatever it happens to be.

HOW TO PAINT WATER.[2]

Whenever you want to do a stream, a river, or any body of water you please, either with fish or without, on wall or on panel; on a wall, take that same verdaccio which you used for shading the faces on the mortar; do the fish, shading with this verdaccio the shadows always on their backs; bearing in mind that fish, and in general all irrational animals, ought to have the dark part on top and the light underneath. Then when you have shaded with verdaccio, put on lights under-

[1] T., M., CXLIX. [2] T., M., CL.

neath, with lime white on the wall; and with white lead on panel. And make a few shadows over the fish, and all over the background, with the same verdaccio. And if you care to make any outstanding fish, lace it with a few spines of gold. Then, in secco, lay verdigris in oil uniformly over the whole ground; and work this way also on panel. And if you do not want to work in oil, take some terre-verte, or malachite, and cover evenly all over; but not so much that the fish and waves of water do not still show through; and, if they need it, put a few lights on the waves, with lime white on the wall, and tempered white lead on panel. And let this suffice you for the business of painting; and let us get on to the study of embellishing. But let us first discuss the mordants.

A SHORT SECTION ON MORDANT GILDING. HOW TO MAKE A STANDARD MORDANT, AND HOW TO GILD WITH IT.[1]

There is a mordant which is perfect for wall, for panel, for glass, for iron, and for any location; and it is made in this way. You take your oil, cooked on the fire or in the sun, cooked as I have shown you before; and work up with this oil a little white lead and verdigris; and when you have got it worked up like water, put a little varnish into it, and let it all boil together for a while. Then take one of your little glazed dishes, and put this into it, and let it stand. And when you want to use any of it, either for flats or for embellishments, take a bit of it in a little dish, and a minever brush made up in the quill of a dove's or chicken's feather, and make it quite firm and pointed, and have the point extend just a little bit outside the quill. Then dip the point part way into the mordant, and carry out your embellishments and your ornaments. And, as I tell you, never get the brush too full. The reason is, that your works will come out for you as fine as hairs, and that is the handsomest work. Then do not do any more for a while;[2] then wait from day to day. Then sound out these productions with the ring finger of your right hand, that is, with the finger tip;

[1] T., M., CLI.

[2] Perhaps read *sentare* with L: "Endeavor to learn more about doing them"; but I think that the reading of R, *stentare*, is to be preferred.

and if you find it a little bit tacky or adhesive, then take the pincers; cut a half leaf of fine gold; or alloyed gold, or silver, though these do not last; and lay it over this mordant. Press it down with cotton, and then, with this finger, gradually stroke up some of this gold, and lay it over the mordant which has none. And do not do it with any other finger tip, for that is the most sensitive one you have. And see that your hands are always clean. And remember that the gold which you lay upon mordants, particularly in these delicate works, wants to be the most thoroughly beaten gold, and the most fragile, that you can secure; for if it is at all stiff you cannot use it so well.[3] When you have got it all gilded, you may leave it, if you like, until the next day. And then take a feather, and sweep it all over; and if you want to gather up the gold which comes off, that is, the "skewings," keep it, for it is useful to goldsmiths, or for your own affairs. Then take some cotton, all clean and new, and burnish your gilded ornament to perfection.

HOW TO CONTROL THE DRYING OF THE MORDANT.[1]

If you want to have this mordant just described keep for a week before it has to be gilded, do not put any verdigris in it. If you want it to keep for four days, put in a little verdigris. If you want the mordant to be good from one evening to the next, put in a lot of verdigris, and also a little bit of bole. And if you find that anyone protests to you against the verdigris, on the ground that it might eventually corrupt the gold, just listen patiently; for I have found by experience that the gold lasts well.

HOW TO MAKE A MORDANT OUT OF GARLIC.[2]

There is another mordant, which is made in this way. Take clean garlic bulbs, to the volume of two or three porringers, or one; pound them in a mortar, squeeze them through a linen cloth two or three times. Take this juice, and work up a little white lead and bole with

[3] So R. L has, *si bene che,* which suggests that something which followed was omitted: ". . . you cannot use it so well as *when it is good and thin";* or, ". . . you cannot use it so well because *the heavier the leaf the more likely it is to leave a ragged edge, or to refuse entirely to stick to the very fine lines of the ornament";* or something of that sort.

[1] T., M., CLII. [2] T., M., CLIII.

it, as fine as ever you can. Then scrape it up; put it into a little dish; cover it, and keep it; for the older and more seasoned it is, the better it will be. Do not take small garlic bulbs, nor young ones; get them about half grown. And when you want to use any of this mordant, put a little of it into a little glazed dish with a small amount of urine, and stir it up thoroughly with a straw, according to your judgment, so that your brush will run freely enough to permit of handling it dexterously and in the way described above.[2] You may gild with it after half an hour, in the way described above. And this mordant possesses this quality, that it will wait for half an hour for you to gild, or for an hour, a day, a week, a month, a year, or as long as you want. Just keep it well covered up, and protect it from dust. This kind of mordant would never withstand the water or moisture in churches, even if there were brick copings on the wall; but it is quite in place on panel or iron, or on anything at all which is going to have to be varnished with liquid varnish. And these methods, with these two types of mordant, must suffice you.

INTRODUCTION TO A SHORT SECTION ON VARNISHING.[1]

It seems to me that I have had enough to say about the system of painting, on wall, in fresco and secco, and on panel. Now we are going to get on to the system of painting and gilding and illuminating on parchment. But first I should like to look into the process of varnishing a panel or ancona, and any other sort of job, except on a wall.

WHEN TO VARNISH.[3]

Know that the secret of the best and most beautiful kind of varnishing is this: that the longer you delay after the painting of the panel, the better it is. I say emphatically: if you wait for several years, and at the very least for one, your work will come out the fresher. The reason is that the painting will automatically achieve the character which gold displays, which does not want companionship with other metals, and colors certainly display, for when they are in the

[2] The punctuation of the Italian text, I, 93, l. 28, should be changed to: *lavorare et per lo sopradetto modo. Passando* . . .

[1] T., M., CLIV. [3] T., M., CLV.

company of their own temperas they do not want any other admixture of any other temperas. Varnish is a powerful liquid, and it is revealing, and it wants to be obeyed in everything, and it cancels any other tempera. And immediately, as you spread it out on your work, every color immediately loses some of its resistance, and is obliged to yield to the varnish, and never again has the power to go on refreshing itself with its own tempera. And so it is a good plan to wait as long as you can before varnishing; for if you varnish after the colors and their temperas have run their course, they then become very fresh and beautiful, and remain in pristine state forever.

HOW TO APPLY THE VARNISH.[1]

So then, take your varnish, as liquid and light and clear as you can get it. Place your ancona in the sun, and sweep it off; wipe it as clean as you can of dust and dirt of any kind. And see to it that the weather be not windy, because dust is light, and if ever the wind should blow it on to your work you could not get it clean again even by skilful treatment. You would be well off in certain fields of grass, or at sea, so that dust could not cause you any trouble. When you have warmed the panel in the sun, and the varnish too, lay the panel out level, and spread this varnish thinly and thoroughly all over it with your hand. But take care not to run over on to the gold, for it does not want to be associated with varnish or with other liquids. Again, if you do not want to work with your hand, take a little piece of nice soft sponge dipped in this varnish; and by rolling it over the ancona with your hand, varnish methodically; and take away and add as proves necessary. If you want to have the varnish dry without sun, cook it thoroughly in the first place; for the panel will be very well off not to be strained by the sun too severely.

HOW TO MAKE A PAINTING LOOK AS IF IT WERE VARNISHED.[2]

In order to give one of your works the appearance of being varnished within a short time,[3] without actually being so, take some

[1] Included in T., M., CLV. [2] T., M., CLVI.
[3] That is, soon after it is painted.

white of egg, beaten as thoroughly as possible with the whisk, so that
it comes out a good solid foam; let it distil for a night. Take the part
that has distilled, in a little new dish, and lay it all over your works
with a minever brush; and they will look as if they were varnished,
and likewise they are stronger. This sort of "varnishing" is well
adapted to carved figures, either of wood or of stone; and varnish their
faces, hands, and their flesh colors in this way. And this will have to
be enough comment upon varnishing; and we will talk about paint-
ing and illuminating on parchment.

A SHORT SECTION ON ILLUMINATING: FIRST, HOW TO GILD ON PARCHMENT.[1]

If you want to do illuminating, you must start by drawing the fig-
ures, foliage ornaments, letters, or whatever you want, with a little
lead on parchment, that is, in books; then you must crisp up your
drawing carefully with a pen. Then you will need to have some of a
color, or rather, a gesso, which is called size, and is made as follows:
take a little gesso sottile, and a small amount of white lead, less than
a third as much as of the gesso; then take a little sugar candy,[2] less
than the white lead. Grind these things very fine with clear water.
Then scrape it up; and let it dry without sun. When you want to use
some for gilding, take a little of it, as much as you need; and temper
it with white of egg, well beaten as I taught you before. And temper
this mixture with it. Let it dry. Then take your gold: and you may lay
it either with breathing or without breathing. And as you lay the gold
on it, take your crook[3] and burnishing stone, and burnish it at once;
and put[4] a solid little panel of good wood, nicely smoothed, under the
parchment; and do the burnishing on that. And know that with this
size you can write letters with a quill, ⟨and do⟩ grounds, or whatever
you please; for it is most perfect. And before you gild it, see whether
you need to scrape it, or level it, or clean it up at all, with a knife

[1] T., M., CLVII. [2] See *NED*, *v*. 1.

[3] See n. 2, p. 25, above. Both the curved and pointed crook and the straight-edged
burnishing stone are useful for gilding on parchment: the former, for getting into the
angle of the relief, the latter, for burnishing flat over the surface.

[4] Italian text, I, 96, l. 9, read: *"e ⟨tieni⟩ socto. . . ."*

point; because your little brush sometimes lays more in one place than in another. Always look out for this.

ANOTHER KIND OF SIZE: FOR GROUNDS ONLY.[1]

If you want another kind of size—but it is not so perfect, though it is good for gilding a ground, but not for writing—take gesso sottile,[2] and the third, white lead, and the fourth, Armenian bole, and a little sugar. Grind all these things very fine with white of egg. Then lay it in as usual. Let it dry. Then scrape and clean up your "gesso" with the point of a penknife. Put the little panel, or a good flat stone, under the parchment, and burnish it. And if, by chance, it does not take a good burnish, wet the gesso when you are gilding, with clear water on a little minever brush; and when it is dry, burnish it.

HOW TO MAKE AND USE MOSAIC GOLD.[3]

I want to show you about a color of these illuminators, similar to gold, which is good on parchment; and it might be used on panel too, but be as careful as of fire in using it. Do not let any of this color, which is known as mosaic gold, come anywhere near any gold ground; for I warn you that if it were on a ground of gilding which stretched from here to Rome, and there were as much as half a millet seed of quicksilver in it, and this came in contact with that gold ground, it would be enough to ruin the whole thing. The best antidote which you can apply quickly is to make a scratch on the gold with the point of a penknife, or a needle; and it will not creep any farther. This mosaic gold is made as follows. Take sal ammoniac, tin, sulphur, quicksilver, in equal parts; except less of the quicksilver. Put

[1] T., M., CLVIII. [2] *Sc.,* as usual, "two parts."

[3] T., M., CLIX. The color which Cennino calls *porporina* is more commonly known in medieval writings as *oro musivo* <Latin *aurum musaicum,* or *a. musicum*> French, *or mussif.* For the translation "mosaic gold," see *NED, v.* 2. That this is the modern trade equivalent may be seen from the rule for "Mosaic gold" in *The Scientific American Cyclopedia of Formulas* (New York: Munn & Co., 1928), pp. 624, 625. An attempt was made by A. Ilg, in his elaborate "Untersuchung über die ursprüngliche Bedeutung des Wortes 'Mosaik,' " in *Mitteilungen des k.k. Oesterreichischen Museums für Kunst und Industrie,* N.F., V (1890), 161 ff., reprinted in his *Beiträge zur Geschichte der Kunst und der Kunsttechnik aus mittelhochdeutschen Dichtungen* (Vienna, 1896), "Excurs," pp. 168–187, to solve the mystery of the name; but the manufacture, use, and nomenclature of this pigment must receive much further study.

these ingredients into a flask of iron, copper, or glass. Melt it all on the fire, and it is done. Then temper it with white of egg and gum, and work with it as you wish. If you do draperies with it, shade either with lac or with blue, or with violet,[2] always tempering your colors with gum arabic for use on parchment.

HOW TO GRIND GOLD AND SILVER FOR USE AS COLORS.[1]

If you want to work with gold on panel, or on parchment, or on wall, or anywhere else, but not all solid like a gold ground; or if you want to make a tree to look like one of the trees of Paradise, take a number of leaves of fine gold according to the work which you want to do, or to write, with it; say ten or twenty leaves. Put them on your porphyry slab, and work this gold up well with some well-beaten white of egg; and then put it into a little glazed dish. Put in enough tempera to make it flow from the quill or the brush; and you may do any work you want to with it. You may likewise grind it with gum arabic, for use on parchment. And if you are doing leaves of trees, mix with this gold a little very finely ground green, for the dark leaves. And in this way, by mixing it with other colors, you may make shot effects to suit yourself.

By the use of this ground gold, or silver, or alloyed gold, you may also lace draperies in the antique style, and make certain embellishments which are not much practiced by others and do you credit. But you yourself must use judgment in learning how to make good use of all that I am showing you.

COLORS FOR USE ON PARCHMENT.[3]

It is true that you may use on parchment any of the colors which you use on panel; but they must be ground very fine. It is likewise true that there are certain colors which have no body, known as

[2] *Biffo:* a mixture of lac and blue. See Chapter LXXIII, p. 52, above.

[1] T., M., CLX. (T., CLX, is made up of this chapter coupled with another, M., CLXXVIII. See I, 97, n. 1.)

[3] M., CLXI. From here on, as far as "well washed and squeezed out," p. 105, below, *R* is the only source for the text. As *R* was not consulted by Tambroni, these chapters do not appear in his edition, or in translations made from it. (See my edition of the Italian text, I, 97, n. 1. An edition of Victor Mottez' translation was issued with this material added by M. Henry Mottez: *Le livre de l'art* . . . [Paris, 1911].)

clothlets, and they are made in every color; and it is only necessary to take a bit of this clothlet, of any color it may be dyed or colored, put it into a little glazed dish, or into a drinking cup; put in some gum; and it is ready for use.

There is also a color made of brazil boiled with lye and rock alum; and then, when it is cold, it is ground with quicklime, and makes a very lovely pink, and develops a little body.

A SECTION DEALING WITH WORK ON CLOTH: FIRST, PAINTING AND GILDING.[1]

Now let us speak about how to work on cloth, that is, on linen or on silk.[2] And you will adopt this method for cloth: in the first place, stretch it taut on a frame, and begin by nailing down the lines of the seams. Then go around and around with tacks, to get it stretched out evenly and systematically, so that it all has every thread perfectly arranged. When you have done this, take gesso sottile and a little starch, or a little sugar, and grind these things with the kind of size with which you tempered the gesso on panel; grinding them good and fine; but first put on an all-over coat of this size without any gesso. And it would not matter if the size were not as strong as for gesso. Keep it as hot as you can; and, with a blunt soft bristle brush, lay some on both sides, if you are going to do painting on each side. Then, when it is dry, take the cloth; take a knife blade which is even on the edge, and as straight as a ruler; and lay some of this gesso on the canvas with this edge, putting it on and taking it off evenly, as if you were scraping it down. And the less gesso you leave on, the better it is; just so you fill up the interstices between the threads. It will be amply sufficient to put on one coat of gesso. When it is dry, take a penknife which scrapes well, and look over the cloth to see whether there is any node or knot on it, and get rid of it; and then take your charcoal. Draw on cloth just the way you draw on panel; and fix it with a wash of ink. Then I will teach you, if you wish, how to lay the diadems or grounds in gold, burnished as on panel, which, on any cloth or silk, are ordinarily laid with a mordant, that is, with the lin-

[1] M., CLXII. [2] *Zendado.*

seed one. But, because this method is a source of wonder among the others, since much ⟨. . .⟩³ done, I will tell you about it. And you may roll up and fold the cloth without hurting the gold and the colors. First take some of this gesso sottile, and a little bole: and temper this gesso with a little white of egg and size, and lay a coat on the part which you want to gild. When it is dry, scrape it a little bit; then take bole, ground and tempered, just like what you lay on panel, and in the same way put on five or six coats of it. Let it stand for a day or so. Lay your gold just as you do on panel, and burnish it, holding a very smooth and solid board underneath this cloth, keeping a cushion between the cloth and the board. And in this way stamp and punch these diadems, and they will be just the same as on panel. But you must ⟨varnish them⟩ afterward; because sometimes these banners, which are made for churches, get carried outdoors in the rain; and therefore you must take care to get a good clear varnish, and when you varnish the painting, varnish these diadems and gold grounds a little, too.

In the same way as for anconas you should paint, step by step, on this cloth; and it is more pleasant to work on it than on panel, because the cloth holds the moisture a little; and it is just as if you were working in fresco, that is, on a wall. And I will also inform you that, in painting, the colors must be laid in many, many times, far more than on panel, because the cloth has no body as the ancona has, and it does not show up well under varnishing when it is poorly laid in. Temper the colors the same as for panel. And I will not enlarge upon this any more.

VARIOUS WAYS TO DO HANGINGS.¹

If you have to work on black or blue cloth, as for hangings, stretch your cloth as described above. You do not have to apply gesso; you cannot draw with charcoal. Take tailors' chalk, and make little pieces of it neatly, just as you do with charcoal; and put them into a goose-feather quill, of whatever size is required. Put a little stick into this

³ *Sc.,* perhaps, "cloth has to be gilded, and most people do not know how it should be."

¹ M., CLXIII.

quill, and draw lightly. Then fix with tempered white lead. Next, lay a coat of that size with which you temper the gessos on anconas or on panel. Then lay in as thoroughly as you can, and paint costumes, faces, mountains, buildings, and whatever appeals to you; and temper in the usual way.

Also, for painting hangings, you may cut white cloth, and put it on top of the blue cloth, fastening it on with pastes, like glue; and lay it on according to the figures which you wish to distribute over the ground; and you may paint with washes of colors, without varnishing afterward. And you get more done, and cheaply, and they are handsome enough at the price.

Also, on hangings, you may do some foliage decorations with a brush, and indigo and pure white lead, on the ground, tempering with size; and leave a few pretty areas, among these foliage decorations, to carry out some little designs in gold done with oil mordants.

HOW TO DRAW FOR EMBROIDERERS.[1]

Again, you sometimes have to supply embroiderers with designs of various sorts. And, for this, get these masters to put cloth or fine silk on stretchers for you, good and taut. And if it is white cloth, take your regular charcoals, and draw whatever you please. Then take your pen and your pure ink, and reinforce it, just as you do on panel with a brush. Then sweep off your charcoal. Then take a sponge, well washed and[2] squeezed out in water. Then rub the cloth with it, on the reverse, where it has not been drawn on; and go on working the sponge until the cloth is damp as far as the figure extends. Then take a small, rather blunt, minever brush; dip it in the ink; and after squeezing it out well you begin to shade with it in the darkest places, coming back and softening gradually. You will find that there will not be any cloth so coarse but that, by this method, you will get your shadows so soft that it will seem to you miraculous.[3] And if the cloth

[1] M., CLXIV.

[2] L begins again at this point. See n. 3, p. 102, above.

[3] Designs for *gros-point* embroidery are still worked out in this way on coarse, open-grain canvas, with the colors as even and well blended as on the fine canvas used as a foundation for *petit-point*.

gets dry before you have finished shading, go back with the sponge and wet it again as usual. And let this suffice you for work on cloth.

HOW TO WORK ON SILK, ON BOTH SIDES.[1]

If you have to do palls or other jobs on silk, first spread them out on a stretcher as I taught you for the cloth. And, according to what the ground is, take crayons,[2] either black or white. Do your drawing, and fix it either with ink or with tempered color; and if the same scene or figure has to be executed on both sides, put the stretcher in the sun, with the drawing turned toward the sun, so that it shines through it. Stand on the reverse side. With your tempered color, with your fine minever brush, go over the shadow which you see made by the drawing. If you have to draw at night, take a large lamp on the side toward your design, and a small lamp on the side which you are drawing, that is, on the right side;[3] thus there might be a lighted taper on the side which is drawn on, and a candle on the side which you are drawing, if there is no sun. And if you have to draw by day, contrive to have light from two windows on the side with the drawing, and have the light from one little window shine on what you have to draw.

Then size with the usual size wherever you have to paint or gild; and mix a little white of egg with this size, say one white of egg to four goblets or glasses of size. And when you have got it sized, if you want to lay any diadem or ground in burnished gold, to bring you great honor and reputation, take gesso sottile and a little Armenian bole, ground very fine together, and a little bit of sugar. Then, with the usual size and a very little white of egg, mixed with a small amount of white lead, you put on two coats of it thinly wherever you wish to gild. Then apply your bole just as you apply it on panel. Then lay your gold with clear water, mixing with it a little of the tempera

[1] M., CLXV. [2] *Charboni:* literally, "coals."

[3] *Cioe all'avenante.* The Milanesi follow R, and read: *Ciò è a lavorare;* but *all'avenante,* with L, should be preferred. *Avenante* (modern Italian, *avvenente*) means "neat," "sightly"; and makes clear an important point in Cennino's procedure. When both sides of a cloth are to be decorated, the drawing is worked out first on the "wrong" side, and traced through to the "neat" side, the *avenante,* the "right" side, all uncertainty being thus eliminated from its execution.

for the bole; and burnish it over a good smooth slab, or a good sound, smooth board. And stamp and punch it likewise over this board.

Furthermore, you may paint any subject in the usual way, tempering the colors with yolk of egg, laying the colors in six or eight times, or ten, out of regard for the varnishing; and then you may gild the diadems or grounds with oil mordants; and the embellishments with garlic mordants, varnishing afterward, but preferably with oil mordants. And let this serve for ensigns, banners and all.

HOW TO PAINT AND GILD ON VELVET.[1]

If you have to work on velvets, or to design for embroiderers, draw your works with a pen, with either ink or tempered white lead. If you have to paint or gild anything, take size as usual, and an equal amount of white of egg, and a little white lead; and with a bristle brush put it on the pile,[2] and beat it down hard, and press it down thoroughly flat. Paint and lay gold in the way described, but just mordant gilding. But it will be less trouble for you to work each thing out on white silk, cutting out the figures or whatever else you do, and have the embroiderers fasten them on your velvet.[3]

HOW TO LAY GOLD AND SILVER ON WOOLEN CLOTH.[4]

If you happen to have to work on woolen cloth, on account of tourneys or jousts, for gentlemen or great lords sometimes teem with desire for distinctive things, and want their arms in gold or silver on this sort of cloth: first, according to the color of the stuff or cloth, select the crayon[5] which it requires for drawing; and fix it with a pen, just as you did on the velvet. Then take white of egg, well beaten as I taught you before, and an equal amount of size, in the usual way;

[1] M., CLXVI. [2] *Pelo.* See n. 2, p. 89, above.

[3] Another practice for gilding on velvet may be noted here, though I have no evidence as to its antiquity. Finely powdered gamboge may be dusted over the velvet, a leaf of gold applied, and the elements of the pattern pressed in with metal dies sufficiently heated to fuse the resin, much as leather is gilded with albumen. This is in many ways superior to Cennino's process, when gold alone is to be applied. If both gilding and painting are called for, however, the velvet should be prepared uniformly for both, as Cennino describes.

[4] M., CLXVII. [5] *Charbone.* See n. 2, p. 106, above.

and put it on the nap[3] of this cloth, on the part where you have to do gilding. Then when it is dry take a crook, and burnish over this cloth; then apply two more coats of this tempera. When it is quite dry, apply your mordant so as not to go outside the tempered part, and lay whatever gold or silver you think fit.

HOW TO MAKE DEVICES OUT OF GILDED PAPER.[1]

Now and then, for these tourneys and jousts, devices are made on the covered horses and on the uniforms, modeled, and sewn on these productions. So I will show you how to make them out of paper. And these papers are laid first, the whole sheet of paper, either with burnished gold or silver. And it is done in this way: grind a little ocher, some tailors' chalk, and a bit of Armenian bole as fine as ever you can. Temper them together with size which is practically plain water, so that it is not at all strong, but has little substance or worth; and, with a soft bristle brush, or with a minever brush, lay one coat of it all over the sheets of paper, fit for writing, but not written on. And when they are dry, go back, and wet a section with a minever brush, and gild that section in the same way and system as you lay gold on the bole on panel; and when you have got the whole sheet laid, watch for the time to burnish it. Take a good flat slab, or a good smooth, hard board, and burnish your sheets over that; and set them aside. And out of these sheets you may make animals, flowers, roses, and devices of many sorts, and it will win you much renown; and you do it quickly and well. And you may embellish them with a little coloring in oil.

HOW TO MODEL CRESTS OR HELMETS.[2]

Whenever you have occasion to make a crest or helmet for a tourney, or for rulers who have to march in state, you must first get some white leather which is not dressed except with myrtle or *ciefalonia;*[4] stretch it, and draw your crest the way you want it made. And draw

[3] *Pelo.* See n. 2, p. 89, above. Here probably the "nap" which results from shearing, rather than "pile" proper.

[1] M., CLXVIII. [2] M., CLXIX.

[4] This material cannot yet be identified certainly. A. Ilg, *Das Buch von der Kunst* (Vienna, 1871), p. 177, suggests "die sogenannten Eckerdoppen," known also as "Valonia, welcher aus Ciefalonia erkürzt scheint."

two of them, and sew them together; but leave it open enough on one side so that you can put sand into it; and press it with a little stick until it is all quite full. When you have done this, put it in the sun for several days. When it is quite dry, take the sand out of it. Then take some of the regular size for gessoing, and size it two or three times. Then take some gesso grosso ground with size, and mix in some beaten tow, and get it stiff, like a batter; and put on this gesso, and rough it in, giving it any shape of man, or beast, or bird, which you may have to make, getting it as like as you can. This done, take some gesso grosso ground with size, liquid and flowing, on a brush, and you lay it three or four times over this crest with a brush. Then, when it is quite dry, scrape it and smooth it down, just as you do when you work on panel. Then, in the same way, as I showed you how to gesso with gesso sottile on panel, in that same way gesso this crest. When it is dry, scrape it and smooth it down; and then if it is necessary to make the eyes of glass, put them in with the gesso for modeling;[3] do modeling if it is called for. Then, if it is to be gold or silver, lay some bole, just as on panel; and follow the same method in every detail, and the same for the painting, varnishing it in the usual way.

HOW TO DO CASKETS OR CHESTS.[1]

In executing caskets or chests, if you want to do them royally, gesso them, and follow all the methods which you follow in working on panel, for gilding and for painting and for stamping, embellishing and for varnishing, without obliging me to tell you about each step.

If you want to execute other caskets of less worth, size them first, and lay cloth over the cracks, and you do that with the previous ones as well. But you may just gesso these at first with the slice and brush with well-sifted ashes and the usual size. When they are gessoed and dry, smooth them down; and, if you care to, gesso them afterward with gesso sottile, if you wish. If you want to embellish them with any figures or other devices made of tin, follow this method:[2]

Get a soft stone, flat and fine grained, and engrave the surface of

[3] See Chapter CXVIIII, p. 73, above. [1] M., CLXX.

[2] It is the ingenious method which follows here, rather than the mere substitution of ashes for gesso, that makes these caskets less costly. Tin, white or golden, takes the

this stone, or get it engraved for you; and the slightest hollow is enough. Have engraved upon it figures, animals, devices—flowers, stars, roses, and any kind your mind desires. Then take some tin foil, either yellow or white, in several thicknesses; and lay it over the impression which you wish to take. Then have a sort of wad of soaked tow, well squeezed out; and lay it over this tin. And in your other hand take a willow mallet, not too heavy, and pound this tow, shifting it and turning it about with your other hand. And when you have pounded it thoroughly, so that you see every incision show up clearly, take gesso grosso ground rather stiff with size, and put some of it over this tin foil with a slice. When you have done this, take a penknife, and, with the tip of it, pick out the top piece of tin, and pry it loose, and lift it off. Then come back with your gesso and your slice, as before: pick out and separate this piece of tin in the same way. Make enough of them in this fashion to give you an abundant supply, and set them out to dry. When they are dry, take a good sharp knife point, and put this tin on a good flat board of nut wood, piece by piece, and cut away all the tin which comes outside the outline of your figure. And in this way make any amount you wish.

When you have got your caskets gessoed systematically and laid in with any color you wish, take some of the usual size, and even stronger, and moisten the gesso of your figures or devices thoroughly, and immediately stick them on; and arrange them on the ground of your casket, and outline and apply a little coloring with a minever brush. Then varnish this ground. When it is dry, take a beaten white of egg, and rub over the varnished part with a sponge moistened in this white; and then, with other colors, hatch and embellish the ground, using any color you wish which differs distinctly from the ground. And I will not stop to say any more about this, for, if you are really expert and accomplished in great things, you will be able to manage small ones all right. Showing you, in the next place, how to work on glass.

place of silver or gold, and its use obviates the necessity of putting on a fine gesso surface, and permits the omission of several operations required for the application of leaf metal.

A SHORT SECTION ON OPERATIONS WITH GLASS:
FIRST, FOR WINDOWS.[1]

There are two processes for working on glass: that is, windows, and pieces of glass which are set in little anconas, or in embellishments for reliquaries. But we shall first discuss the method for windows. It is true that this occupation is not much practiced by our profession, and is practiced more by those who make a business of it. And ordinarily those masters who do the work possess more skill than draftsmanship, and they are almost forced to turn, for help on the drawing, to someone who possesses finished craftsmanship, that is, to one of all-round, good ability. And therefore, when they turn to you, you will adopt this method. He will come to you with the measurements of his window, the width and length: you will take as many sheets of paper glued together as you need for your window; and you will draw your figure first with charcoal, then fix it with ink, with your figure completely shaded, exactly as you draw on panel. Then your glass master takes this drawing, and spreads it out on a large flat bench or table; and proceeds to cut his glasses, a section at a time, according to the way he wants the costumes of the figure painted. And he gives you a color which he makes from well-ground copper filings; and with this color, on the point of a minever brush, you shape up your shadows gradually, matching up the arrangement of the folds and the other details of the figure, on one piece of glass after another, just as the master has cut them and put them together; and you may shade any glass, indifferently, with this color. Then the master, before he fastens one piece to another, according to their practice, fires it moderately in iron cases with his ashes; and then he fastens them together.

You may execute silk stuffs, upon these glasses, sprig and hatch and do lettering, that is, by laying in with this color, and then scraping through, just as you do on panel.[2] You have one advantage: that you do not need to lay any other ground, because you can get glass in all colors.

And if you happen to have any very small figures to do, or arms or

devices so tiny that the glasses could not be cut to shape, after you have shaded with the aforesaid color you may paint any costumes, and mark out with oil paint. And this need not be fired again, nor should that be done, for you would not accomplish anything. Just let it dry in the sun, as it will.

HOW TO GILD GLASS FOR RELIQUARY ORNAMENTS.[1]

There is another process for working on glass, indescribably attractive, fine and unusual, and this is a branch of great piety, for the embellishment of holy reliquaries; and it calls for sure and ready draftsmanship. This process is carried out as follows. Take a piece of white glass, with no green cast, very clean, free from bubbles; and wash it, rubbing it down with lye and charcoal. And rinse it with good clear water, and let it dry by itself. But before you wash it, cut it to the size you want. Then take the white of a fresh egg; beat it with a good clean whisk just as you do that for gilding, so that it is thoroughly beaten; and let it distil overnight. Then take a minever brush, and with this brush wet the back of the glass with this glair; and when it is thoroughly wet all over, take a leaf of the gold, which should be quite heavy gold, that is, dull;[2] put it on the paper tip, and lay it deftly on the glass where you have wet it; and press it down with a little very clean cotton, gently, so that the glair does not get on top of the gold; and lay the whole glass in this way. Let it dry without sun for the space of some days.

ARRANGEMENTS FOR DRAWING ON THIS GLASS.[3]

When it is all dry, get a nice flat little panel, covered with black cloth or silk; and have a little study of your own, where no one will cause you any sort of interruption, and which has just one cloth-covered window; and you will put your table in this window, as if for writing, so arranged that the window shines over your head when you have your face turned toward this window. With your glass laid out on this black cloth:

[1] M., CLXXII. [2] See Chapter CXXXVIIII, pp. 84, 85, above.
[3] Included in M., CLXXII.

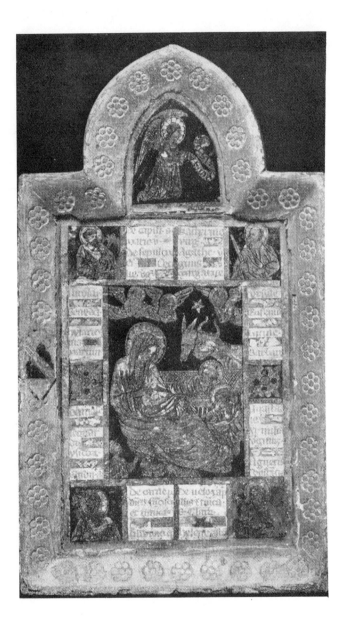

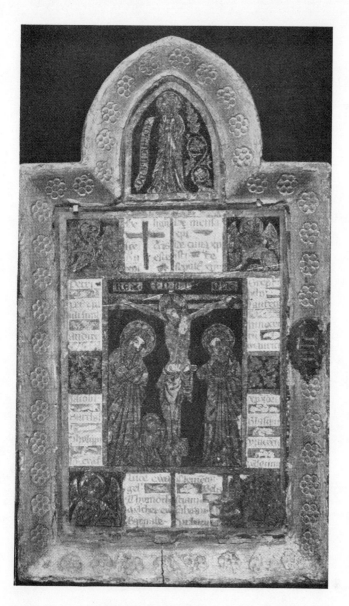

A Diptych with Panels of Gilded and Painted Glass.
From the collection of Henry Oppenheimer, Esq., London.
20.3 × 24.1 cmm. See pp. 112–114.

HOW TO DRAW ON THE GILDED GLASS.[1]

Take a needle, fastened in a little stick as if it were a little brush, and have it quite sharp pointed. And, with the name of God, begin to draw lightly with this needle whatever figure you wish to make. And have this first drawing show very little, for it can never be erased; and therefore work lightly until you get your drawing settled; then proceed to work as if you were sketching with a pen, for this work has to be done freehand. And do you want to be convinced that you need to have a light hand, and that it should not be tired?—⟨Know⟩ that the strongest shadow you can make consists in penetrating to the glass with the point of the needle, and no more; that the intermediate shadow consists in not piercing through the gold all over; that it is as delicate as that, and you must not work with haste— rather with great enjoyment and pleasure. And I give you this advice, that the day before the day you want to work at this job, you hold your hand to your neck, or in your bosom, so as to get it all unburdened of blood and weariness.

HOW TO SCRAPE THE GOLD OFF THE BACKGROUNDS.[2]

When you have got your drawing finished, and you want to scrape away certain grounds, which generally want to be put in with ultramarine blue in oil, take a leaden style, and rub the gold, which it takes off for you neatly; and work carefully around the outlines of the figure. When you have done this:

HOW TO BACK UP THE DRAWING WITH COLORS.[3]

Take various colors ground in oil, such as ultramarine blue, black, verdigris, and lac; and if you want any drapery or lining to glisten ⟨in lines of gold⟩ on green,[4] apply green; if you want it on lac, apply

[1] Included in M., CLXXII. [2] Included in M., CLXXII.
[3] Included in M., CLXXII.

[4] In this system of modeling, the lights are formed uniformly by the gold; the darks, by the backing-up color; and the half tones, as Cennino implies in the paragraph on drawing, by lines of gold left to glisten on the colored ground. The survival of this practice, in window lettering, mirror ornaments, etc., is familiar to everyone. Indeed, few processes in the arts have a longer history of usefulness than this of gilding on glass and scratching in designs.

lac; if you want it on black, apply black. But the black is the most striking of all, for it shows up the figures better than any other color.

PART OF A SECTION DEALING WITH MOSAIC: FIRST, A FRAGMENT FROM THE END OF A CHAPTER OTHERWISE LOST.[1]

. . . your little figures, and tamp them down with something flat, and press them into the gesso, so that the work comes out quite flat. And execute your work in this way.

MOSAIC OF QUILL CUTTINGS.[2]

For this same work quills of feathers are very nice, cut up very small, and stained as I have related.[3]

[1] Included in M., CLXXII. Part of the text is clearly missing here: how much, or of what nature, we can only surmise.

The directions which follow suggest that a number of small objects were involved, requiring care to keep the surface flat. This is borne out by the next paragraph, which recommends stained cuttings of quills "for this same work"; and the next, which calls for crushed eggshells, "per lavorare *del detto musaicho,*" suggests that these small objects may have been tesserae for mosaic. A little later, Cennino speaks of laying in with gilded or silvered paper, or gold or silver foil, "to lay in these figures as you do on a wall"; from which we may conclude that the *Libro dell'Arte* originally dealt with monumental mosaic and the use of gilded tesserae. Altogether the internal evidence of these passages points to the loss of a section on mosaic techniques to which the brief articles here preserved were merely supplementary. Externally, Vasari, in his life of Agnolo Gaddi, states that Cennino's work included an account of painting in mosaic.

The occurrence of these isolated sentences on mosaic at the end of the chapters on gilded glass deceived the Milanesi. Not recognizing their fragmentary nature, they identified them with the preceding material, and headed their chapter, CLXXII, "Come si lavora in opera musaica per adornamento di reliquie. . . ." This error—for the work on gilded glass is nowhere called "mosaic" by Cennino—later misled Albert Ilg, in spite of his own close acquaintance with Cennino's work. Ilg saw, as he supposed, in that chapter, but actually only in the Milanesi's heading, support for his theory that the word "mosaic" "a priori mit unserem heutigen Begriff 'Mosaik' (Zusammenset-zung) gar nichts zu tun hatte, sondern lediglich jene eigentümliche Art Vergoldung bedeutete, welche zur Herstellung der kunstgeschichtlich wichtigsten Gattung Mosai-ken erforderlich ist, wie sie vorher schon zur Anfertigung der altchristlichen Glasge-fässe diente." (See his "Untersuchung über . . . 'Mosaik,'" *art. cit.* p. 101, *supra,* p. 174.) He states further (*id.,* p. 178), with unconscious irony, that "Cennino . . . nennt opera musaica höchst interessanter Weise eine Technik, welche mit unserem 'Mosaik' ausser der Anbringung des Goldes auf's Glas absolut nichts gemein hat." It was, as we have seen, the Milanesi, and not Cennino at all, who called this process "opera musaica."

[2] Included in M., CLXXII.

[3] In one of the missing chapters, of course.

MOSAIC OF CRUSHED EGGSHELLS, PAINTED.[1]

You may likewise work at this mosaic in this way. Take your plain white crushed eggshells, and lay them in over the figure which you have drawn; fill in and work as if they were colored. And then, when you have laid in your figure, you set to painting it, section by section, with the regular colors from the little chest,[2] and tempered with a little white of egg, just as you would do on the regular gessoed one,[3] just using a wash of the colors. And then, when it is dry, varnish, just as you varnish the other things on panel.

MOSAIC OF PAPER OR FOIL.[4]

To lay in these figures as you do on a wall,[5] you must adopt this expedient: take little leaves of gilded or silvered paper, or thick gold or silver foil. Cut it up very small, and lay in with these tweezers, the way you laid in your crushed shells, wherever the ground calls for gold.[6]

MOSAIC OF EGGSHELLS, GILDED.[7]

Likewise, lay the ground with white shells; wet it with beaten white of egg; wet it with the same as that with which you gild on glass; lay your gold while the ground still draws; let it dry, and burnish with cotton. And this must suffice for this mosaic or Greek work.

A SECTION DEALING WITH MISCELLANEOUS INCIDENTAL OPERATIONS: FIRST, BLOCK PRINTING ON CLOTH.[8]

Inasmuch as the execution of certain products painted on linen cloth, which are good for garments for little boys or children,[9] and

[1] Included in M., CLXXII. [2] See the end of Chapter XXXVI, p. 22, above.

[3] This whole paragraph evidently represents a mere variant of a process previously given in detail in a lost chapter.

[4] Included in M., CLXXII. [5] See n. 1, p. 114, above.

[6] *Sc.,* "or silver." [7] Included in M., CLXXII.

[8] M., CLXXIII.

[9] Their elders, no doubt, wore stuffs in which the figures were integrally woven. The process here described is clearly intended to produce imitations of damask or brocade effects, as could be done by block printing at vastly less expense than on the loom.

for certain church lecterns, still has to do with the profession of the brush, the way to do them is this.

Take a stretcher made as if it were a cloth-covered window, four feet long, two feet wide, with linen or heavy cloth nailed on the slats. When you want to paint your linen, roll up a quantity of four or fourteen yards all together, and lay the heading of this cloth over the stretcher. And take a block of either nut or pear, as long as it is good strong wood, and have it about the size of a tile or a brick; and have this block drawn upon and hollowed out a good line deep; and on it should be drawn whatever style of silk cloth you wish, either leaves or animals. And have it so divided in shape and so drawn that all four faces will come out in a repeat, and make a finished and unified job. And on the other side, which is not engraved, it should have a handle, so that you can lift it and apply it. When you are going to work:

Have a glove on your left hand; and first grind some vine-sprig black, ground very fine with water, then thoroughly dried either by sun or fire, then ground again, dry; and mix it with as much liquid varnish as may be required;[3] and take up some of this black with a little trowel, and spread it out on the palm of your hand, that is, on the glove. And thus you ink up[4] the block with it where it has been engraved, neatly, so that the incision does not get choked up. Set to work, and place it systematically and evenly upon the cloth spread out on the stretcher. And underneath the stretcher take a porringer in your right hand, or a little wooden porringer, and, with the back, rub hard over the space occupied by the incised block; and when you have rubbed until you think that the color has penetrated the cloth or linen thoroughly, lift your block, put color on it over again, and replace it very systematically, in this way, until you finally get the whole cloth done.

This work needs to be embellished with other coloring laid in here and there, to make it look more showy; for this you ought to have colors without body, namely, yellow, red, and green. The yellow: take some saffron, warm it well at the fire, temper it with good strong

[3] Possibly, "varnish enough to make it workable."

[4] *Va' imbrattando:* literally, "muck."

lye. Then take a rather blunt bristle brush. Spread out the painted cloth on a bench or table, and set out, with this yellow, animals or figures or foliage ornaments, as you think best. Next take some brazil-wood, scraped with glass; put it to soak in lye; boil it up with a little rock alum; boil it for a while, until you see that it has acquired its full crimson[5] color. Take it off the fire, so that it does not spoil; then set it out with this brush, just as you did the yellow. Then take some verdigris, ground with vinegar, and a little saffron, tempered with a little weakish size. Set it out with this brush, just as you have done the other colors; and have them so set out that each animal appears in yellow, red, green, and white.

Furthermore, for executing this work it is good to burn linseed oil, as I have shown you before; and temper some of that black, which is very fine, with liquid varnish; and it is a very perfect and fine black; but it is more expensive.

This process[6] is good for working on green cloth, and red, black, and yellow, and blue or pale blue. If it is green, you may work on it in red lead or vermilion. After grinding it very fine with water dry it well; powder it up, and temper it with liquid varnish. Put some of this color on the glove, just as you did with the black, and work in the same way.

If it is red cloth, take some indigo and white lead. After grinding it fine with water, drain it and dry it in the sun; then powder it up; temper it with liquid varnish as usual; and work the way you do with black.

If the cloth is black, you may work on it in quite a light blue, that is, a good deal of white lead and a little indigo, mixed, ground and tempered according to the practice which I have given you for the other colors.

If the cloth is light blue, take some white lead, ground and dried off and tempered like the other colors. And in general, as you find the grounds, so you can find other colors differing from them, lighter and darker, as it seems to you may suit your fancy. For one thing will teach you another, both by experience and by theoretical under-

[5] *Vermiglio.* See n. 6, p. 39, above.

[6] For MS *Al predetto* (my Italian text, I, 111, l. 10) read *Il predetto.*

standing. The reason is that every profession is fundamentally skilled and pleasant. God helps those who help themselves,[7] and contrariwise the same.

HOW TO GILD A STONE FIGURE.[1]

A man in one profession may happen to understand working perfectly at all kinds of things, and especially at things which may bring him reputation; and therefore, not because it is usual, but because I have relished it, for that reason, I will explain it to you. Into your hands comes a stone figure, large or small; you wish to lay it in burnished gold. For this you follow this method: sweep and clean your figure up nicely; then take some of the usual size, that is, of the strength with which you gesso anconas; and get it boiling hot. And when it is boiling so, put a coat or two of it over this figure, and let it dry out well.

After this, take pieces of oak or male-oak charcoal, and pound them; and take a tamis, and sift the dust out of this charcoal with it. Then take a sieve fine enough for grain such as millet to go through, and sift this charcoal, and put the siftings aside; and make enough of them in this way to serve your purpose. When this is done, take linseed oil, cooked and brought to the perfect condition for making a mordant, and mix a third of liquid varnish with it. Boil it all together thoroughly.

When it is quite hot, take a dish; put the siftings of the charcoal into it. After this, put in this mordant: mix it up well, and apply it with a good-sized bristle or minever brush evenly to every part, and all over the figure or other job. When you have done so, put it somewhere to dry thoroughly in the wind or sun, as you please.

When your figure is good and dry, take a little of this same size. Put into it, if there is one glassful of it,[2] one yolk of egg. Mix it up well; and, while quite hot, take a bit of sponge; soak it in this tempera, and, with the sponge not too full, wipe and rub over every place to which

[7] *Chi ne piglia, se n'a.* [1] M., CLXXIV.

[2] From here to "You will run into people," p. 122, below, the text is based on *R* only, owing to a lacuna in *L*. See my Italian text, I, 112, n. 5; also, I, Preface, p. xii, and p. 100, n. 5. (I, 112, l. 26 should be punctuated as follows: *insieme; e, ben chaldo, habbi. . . .*)

you applied the mordant and the charcoal. In explanation of the purpose of applying this mordant, the reason is this: that stone always holds moisture, and when gesso tempered with size becomes aware of it, it promptly rots and comes away and is spoiled: and so the oil and varnish are the instruments and means of uniting the gesso with the stone, and I explain it to you on that account. The charcoal always keeps dry of the moisture of the stone.

Then, when you wish to go on with your work, take gesso grosso and size, tempered in the same way you gesso the flat of a panel or ancona, except that I want you to put in, according to the quantity, one or two or three egg yolks; and then lay it over the job with a slice; and if you mix up with these things a little dust of pounded bricks it will be so much the better. And apply this gesso two or three times with a slice, and let it dry out thoroughly.

When it is perfectly dry, scrape it and clean it up, just as you do on panel or ancona. Then take gesso sottile or gilders' gesso,[3] and temper and grind this gesso with the same size, just as you do for gesso on panel, except that you must put in a certain amount of egg yolk, not so much as you put into the gesso grosso: and begin by putting the first coat of it on the job, rubbing it down with your hand very perfectly. From this coat on, lay the gesso with a brush, four or six coats, just the way you apply gesso on panel, with that same method and diligence. When this is done, and quite dry, scrape it down nicely; then lay it with tempered bole as you do on panel; and follow the same course and method in gilding, and burnishing with stone or crook. And it is as splendid a branch of this profession as there can possibly be. And if you ever have a case in which work gilded in this way has to risk injury from water, you may varnish it; but it is not so handsome, though very much stronger.

THE DANGERS OF A WET WALL FOR FRESCO.[1]

In connection with this kind of work, it is sometimes necessary to

[3] *Gesso sottile o vuoi da oro. Gesso d'oro* signifies in modern Italian "gilders' whiting," a fine grade of levigated chalk. (See F. W. Weber, *Artists' Pigments* . . . [New York: van Nostrand, 1923], pp. 125, 126.) *Gesso da oro* here may mean the same material, a substitute for the more costly gesso sottile.

[1] M., CLXXV.

take steps for jobs to be done on damp walls: so it behooves you to prepare yourself with judgment and sound practice.

Know that moisture has the effect on the wall that oil has on panel; and just as moisture mars the lime mortar, so oil mars the gesso and its temperas: and so it is important to know how this moisture can come to work great damage, since I have told you above that the noblest and strongest tempering which can be done upon a wall consists in working in fresco, that is, on the fresh mortar. And know that no matter how much water ever rained upon the front surface of the wall, it could never do any harm at all; but it is that which rains on the back of the wall, on the other surface, which does great damage; and even the slightest drop which falls on the top of the wall, in the open. And so steps must be taken against this, as follows.

PRELIMINARY PRECAUTIONS AGAINST MOISTURE.[1]

First look over the place where you are working, and see how sound the wall is, and how it is coped; and have it coped with the utmost perfection. And if it is in a place where any water runs through a drain which cannot reasonably be shifted, use the following method:

WATERPROOFING WITH BOILED OIL.[2]

Regardless of the stone the wall is made of, take linseed oil cooked as if for a mordant, and temper pounded brick with it, and wet it up. But first apply some of this oil or mordant to the wall, boiling hot, with a brush or swab. After that, take some of this mixture of pounded brick, and apply it to the wall so that it comes out quite rough. Let it dry for a month or so, until it gets thoroughly dry. Then, with a trowel, take some good fresh slaked lime;[3] equal parts of lime and coarse sand; and, mixing with it some sifted powder of pounded brick, plaster it thoroughly once or twice, leaving the plaster quite rough and uneven. Then, when you wish to paint and work on it,

[1] Included in M., CLXXV. [2] Included in M., CLXXV.

[3] *Calcina di galla* is simply slaked lime, not, as Ilg translates, "mit Galläpfeln bereiteten Kalk." Lady Herringham's "lime prepared with gall nuts" follows Ilg; Mottez and Verkade translate it correctly. See *Vocabolario . . . della Crusca, s.v.* "calcina."

lay up your thin finish coat, just as I showed you how before, for work on the wall.

WATERPROOFING WITH PITCH.[1]

For this same purpose: first take some of this ship pitch, and apply it and smear[2] the wall with it, boiling hot. When you have done this, take some of the same pitch or tar; and take good dry or brand-new brick, pounded up. Pound it up thoroughly, and work a certain amount of it into this pitch. Apply it all over the wall, that is, as far as the dampness extends, and farther. And it is a very perfect plaster. And rough-coat with lime mortar, as I have shown you and told you above.

WATERPROOFING WITH LIQUID VARNISH.[3]

Again, for the same: get a quantity of liquid varnish boiling hot, and applying it to the surface of the damp wall at first, and in the same way applying some of the pounded brick mixed with the aforesaid varnish, makes a very perfect and good remedy.

HOW TO DISTEMPER INSIDE WALLS WITH GREEN.[4]

You sometimes work in rooms, or under porches or galleries, which are not always carried out in fresco, because you find them already plastered. And you want to work in green: for this, take some terreverte, well ground, and tempered with gesso size, not too strong, and apply two or three coats of it to the whole ground, with a large bristle brush. When you have done this, and it is dry, draw with charcoal the way you do on panel, and fix your scenes with ink, or with black color, that is, vine charcoal well worked up and tempered with egg, or even yolk of egg and the white together. And having dusted off the charcoal, take some water in a porringer, or a large basin, or a Tuscan gill; after this, put in as much as a spoonful of honey, and beat it all up thoroughly. Having done this, take a sponge, and plunge it into this water; squeeze it out a little, and run it over the ground laid in green. Then with a wash of black apply your shadows, very delicate

[1] M., CLXXVI.
[2] *Imbratta:* literally, "muck."
[3] Included in M., CLXXVI.
[4] M., CLXXVII.

and soft and blended. Then take white lead ground and tempered with this egg tempera mentioned above, and put the lights on your figures as required by your professional system.

You may put a little coloring on these figures which differs from the green, say with ocher, cinabrese, and orpiment; and embellish any little ornaments, and likewise put in grounds with blue. And know that you may also execute this sort of work in green on panel; and likewise on a wall in fresco, plastering, and laying in with this terre-verte: it is true that the lights should be put on with lime white.

HOW TO VARNISH TERRE-VERTE.[1]

You will run into people[2] who will have you work on panel in greens, and want you to varnish it. I tell you that it is not the custom, and terre-verte does not call for it; but all the same they have to be satisfied. Now follow this method:

Take scrapings of sheep parchment; boil them well with clear water, until it becomes a regular tempera, that is, a size. With a large minever brush put two or three coats of this size nicely and lightly on to your figures or scenes, uniformly all over whatever you have to varnish. When you have applied this size, all clear and clean, and strained well twice, let your work dry out for the space of three or four days. Then varnish all over with your varnish confidently, for you will find that the terre-verte will take the varnish just as the other colors will.

HOW TO CLEAN OFF THE PAINT AFTER YOU HAVE MADE UP A FACE.[3]

In the exercise of the profession, you will sometimes have to stain or paint on flesh, chiefly to paint the face of a man or woman. You may have your colors tempered with egg; or, for making up, with oil, or with liquid varnish, which is the strongest tempera of all. But if you want to wash this color or tempera off the face afterward, take egg yolks; rub them on the face gradually, and chafe it with your

[1] M., CLXXVIII; included in T., CLX.
[2] The text is resumed in *L* again at this point. See n. 2, p. 118, above.
[3] T., CLXI; M., CLXXIX.

hand. Then take hot water, boiled with bran or husks,[2] and wash his face. And then take another egg yolk, and again chafe his face, then taking hot water in the same way, and washing his face again. Do this over and over until the face comes out in its original color. Saying no more about this subject:

THE PERILS OF INDULGENCE IN COSMETICS.[3]

You would have occasion, in the service of young ladies, especially those of Tuscany,[4] to display certain colors to which they take a fancy. And they are in the habit of beautifying themselves with certain waters. But since the Paduan women do not do so; and so as not to give them occasion to reproach me; and likewise because it is contrary to the will of God and of Our Lady; because of all this I shall keep silence. But I will tell you that if you wish to keep your complexion for a long time, you must make a practice of washing in water—spring or well or river: warning you that if you adopt any artificial preparation your countenance soon becomes withered, and your teeth black; and in the end ladies grow old before the course of time; they come out the most hideous old women imaginable. And this will have to be enough discussion of the matter.

THE FINAL SECTION, DEVOTED TO METHODS OF CASTING, BEGINS HERE.[5]

Now it seems to me that I have said enough about all the systems of painting. I will tell you about something else which is very useful and gets you great reputation in drawing, for copying and imitating things from nature: and it is called casting.

[2] *Remola o ver cruscha. Remola* is found only in *L,* and is introduced into the *Vocabolario . . . della Crusca* on the strength of this solitary occurrence. Dr. L. F. Solano, of Harvard University, suggests that *remola* is merely a slip of the pen for *semola,* and I have no doubt that this is the true explanation.

[3] T., CLXII; M., CLXXX.

[4] Cennino married a lady of Cittadella, near Padua, Donna Ricca della Ricca by name, some time before 1398. (See the Milanesi edition, Preface, p. vi.)

[5] T., CLXIII; M., CLXXXI.

HOW TO TAKE A LIFE MASK.[1]

If you wish to have a face of a man or woman, of any rank, adopt this method. Get the young man or woman: or an old man, though you can hardly do the beard or hair; but have the beard shaved off.

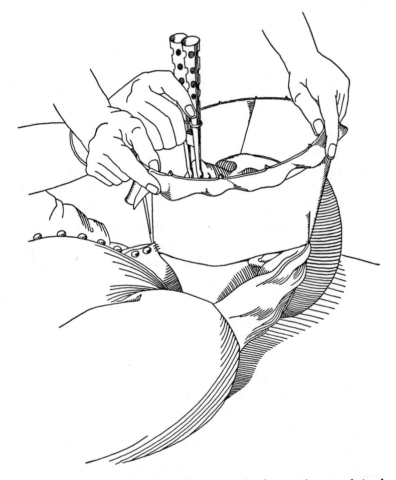

Take rose-scented, perfumed oil; anoint the face with a good-sized minever brush. Put a cap or hood over the head; and have a bandage, about nine inches wide, and as long as from one shoulder to the

[1] T., CLXIV; M., CLXXXII.

other, wound around the top of the head over the cap; and stitch the edge around the cap from one ear to the other.[2] Put a little cotton into each ear, that is, into the hole; and drawing tight the edge of the bandage or cloth, stitch it to the beginning of the collar; and it gives a half turn in the middle of the shoulder, and comes back to the buttons in front.[3] And arrange and stitch it in this way on the other shoulder too; and in that way you get the head shaped up with the bandage. When this is done, stretch the man or woman out on a carpet, on top of a bench or table. Get an iron hoop, one or two fingers in width, with a few teeth on top, like a saw. And have this hoop go around the man's face, and have it two or three fingers longer than the face. Get one of your helpers to keep it hanging away from the face, so that it does not touch the waiting person. Take this bandage, and draw it up, around and around, hooking the edge of it which has not been stitched on to the teeth of this hoop, and then fastening it in the middle of the space between the flesh and the hoop so that the hoop stands as far away from ⟨the edge of⟩ the bandage as from the ⟨edge of the⟩ bandage to the face all around. Let there be two fingers, or a little less, all around, according to how thick you want the mold of plaster to come out; for it is right there that you have to cast it.

THE BREATHING TUBES.[1]

You need to have a goldsmith make two little brass or silver tubes, round on top, and more open than below, the way a trumpet is; and have them each about nine inches long, and one finger in diameter, made up as light as possible. On the other, lower, end they should be made in the shape of the nostrils of the nose; and enough smaller to fit into the nostrils very accurately, without making the nose spread at all. And have them closely perforated with little holes from the center up, and tied together; but at the base, where they go into the

[2] That is, across the forehead. To make clear the somewhat awkward description of this process, my colleague, Lewis E. York, has kindly executed the accompanying drawing.

[3] Experimental investigation of this passage with Mr. York leads me to read *da* for *da'* in the Italian text, I, 117, l. 27, and *a' bottoni* for *a bottoni,* in l. 28.

[1] T., CLXV; M., CLXXXIII.

nose, have them kept apart artificially as far as will equal that space of flesh which lies between the nostrils. After this:

THE OPERATIONS OF CASTING THE MATRIX.[1]

Have the man or the woman stretched out; and have him put these little tubes into the nostrils of his nose, and have him hold them himself, with his hand. Have some plaster of Paris[2] ready, made and roasted, fresh and well sifted. Have some tepid water near you in a basin, and put some of this plaster briskly on top of this water. Work swiftly, for it sets fast; and do not get it either too liquid or not enough so. Take a glass: take some of this preparation, and put it on, and fill in around the face with it. When you have got it evenly filled, keep the eyes to cover after all the rest of the face. Have him keep his mouth and eyes closed—not tightly, for that is not necessary, but as if he were asleep; and when your opening is filled in one finger over the nose, let it stand a while, until it sets. And bear in mind that if this person whom you are casting is very important, as in the case of lords, kings, popes, emperors, you mix this plaster with tepid rose water; and for other people any tepid spring or well or river water is good enough.

When your preparation is good and dry,[3] take a scalpel or a penknife, or scissors, neatly, and cut around the bandage which you stitched on: draw the tubes out of his nose carefully; have him sit up, or stand up, holding between his hands the preparation which he has on his face, working his face about carefully to get it out of this mask or mold. Set it aside, and take great care of it.

HOW TO CAST THIS WASTE MOLD.[4]

When this job is done, take a swaddling cloth, and wind it all around this mold, in such a way that the cloth projects two fingers beyond the edge of the mold. Take a thick minever brush; and with

[1] T., CLXVI, and M., CLXXXIV, begin with the "After this" at the end of the preceding paragraph. I follow here the division marked in the MSS. (See my text I, 118, n. 2.)

[2] Literally, "of Bologna or Volterra." See n. 1, p. 70, above.

[3] *Asciutto e seccho*. See also Italian text, I, 111, l. 17.

[4] Included in T., CLVI; M., CLXXXIV.

any oil you please lubricate the hollow of the mold, very carefully, so as not to spoil anything by accident. And wet up some of the same plaster in the same way. And if you care to mix in some of the powder of pounded brick, it will be much the better for it. And take some of this plaster with the glass, or with a porringer, and put it into the mold; and hold it over a settle, so that when you put in your mixture you may pound gently on the settle with the other hand, so that the plaster has a chance to get into every part evenly, like wax into a seal, and not make bubbles or holes. When the mold is all done and filled up, let it stand for half a day, or a day at the most. Take a little hammer, and deftly feel over and chip off the outside crust, that is, that of the first mold, in such a way as not to break the nose or anything else. And if . . . to find. . . .² ⟨And if you want to make⟩ this mold easier to chip, before you fill it up, take a piece of saw, and saw it in several places on the outside; not so much as to go way through, for that would be too bad. You will find that when it is filled up the least stroke of your little hammer will shatter it neatly. In this way you will take the effigy or physiognomy or casting of every great lord. And know that afterward, once you have the first one, you may have the mask cast from this mold in copper, metal, bronze, silver, lead, and, generally, in any metal you please. Just get capable masters who understand founding and casting.

HOW TO CAST WHOLE FIGURES.¹

Know that if you wish to follow this process into more subtle mastery, I will inform you that you may mold and cast a man in one piece, just as in ancient times. Many good figures and nudes are to be found. Therefore, if you want a whole nude man or woman, you must first have him stand upright in the bottom of a box, which you get built up to the height of the man's chin. And have this box all fit together³ lengthwise halfway from one side to the other. Arrange to

² Some instruction seems to have been lost here, probably through confusion by the scribe of two sentences beginning E[s]se. What is missing may be advice on repairing the nose if it does get broken. Both scribes seem to have had a good deal of trouble with this chapter.

¹ T., CLXVII; M., CLXXXV.

³ R: "fit together, or rather, come apart."

have a thin templet[3] of very thin copper from the middle of the shoulders, starting at the ears, down to the bottom of the box; and have it follow lightly over the flesh of the nude without injury, not pressing on the flesh by so much as a line. And have this templet nailed on to

the edge where this box fits together. And in this way nail on four pieces of templet which will close up together as the edges of the box do. Then grease the nude; stand him up in this box: wet up a great quantity of plaster with quite warm water; and have an assistant, so that if you fill in in front of the man the assistant will fill in in back, so as to get the box full at the same time, up to the throat: because you can do the face separately, as I have shown you. Let the plaster stand until it has hardened thoroughly. Then open and take apart the box; and insert tools and chisels between the edges of the box and the copper or iron templets which you made; and open them up, the way you would a nut, holding on each side these pieces of the box and of the casting which you have made. And you extract the nude

[3] Or "paten" (*piastra*).

gently from it: wash him diligently with clear water, for his flesh will have turned the color of a rose. And in the same way, again, as when you filled in the face, you may cast this mold or casting in any metal you please; but I advise you, in wax. The reason: it enables you to chip the plaster without injury to the figure, because you may remove, add and repair wherever the figure is defective. After this you may add the head to it; and cast everything together, including the whole person. And likewise you may cast separately, member by member, that is, an arm, a hand, a foot, a leg; a bird, a beast, and any sort of animal, fish and other such things. But they have to be dead, because they have neither the natural sense nor the rigidity to stand still and steady.

HOW TO MAKE A CAST OF YOUR OWN PERSON.[1]

On the same subject. You may also cast your own person, as follows.[2] Get ready a quantity of plaster or of clay,[3] well worked over and clean, wet up quite soft, as if it were an ointment; and have it spread out on a good broad table, such as a dining table. Have it placed on the ground; have this plaster or clay spread out on it a foot deep. Fling yourself on it, on whatever side you wish, front or back or side. And if this plaster or clay takes you well, get yourself pulled out of it neatly, pulling yourself out straight, so as not to shift it in any direction. Then let this mold dry.[4] When it is dry, have it cast in lead. And, in the same way, do the other side of your person, that is, the opposite to that which you have done. Then join them together; cast it all at once in lead or in other metals.

CASTINGS IN GESSO FOR USE ON PANEL.[5]

If you want to cast little figures of lead or other metals, first grease

[1] T., CLXVIII; M., CLXXXVI.

[2] The punctuation of this sentence here differs slightly from that used in the Italian text, I, 121, l. 18.

[3] *L, ciera; R, cera:* I think in error for *crea,* i.e., *creta,* "clay." See Italian text I, 121, n. 2; and n. 1, p. 77, above.

[4] This direction, coupled with *intrisa,* "wet up," above, makes it sufficiently clear that clay rather than wax was intended as the molding material.

[5] T., CLXIX; M., CLXXXVII.

your figures, and make molds in clay,[2] and cast them with anything you please. It is true that on panel you sometimes need some reliefs, such as heads of men and lions or other animals, or tiny little figures. Let the mold which you have made in clay[3] get dry: then grease it well with oil.[4] Have some gesso, sottile or grosso, ground with rather strong size: cast some of this gesso, hot, on the mold; let it cool off. When it is cold, separate this gesso a little way from the mold with the point of the penknife. Then blow quite hard into this opening. You catch your little gesso figure in your hand; and it will be finished. And you may make up a lot of them in this way, and keep them on hand. And know that it is better to make them in winter than in summer.

HOW TO CAST MEDALS.[5]

If you wish to cast medals, you may cast them in clay[6] or in plaster. Get them dry, and then melt some sulphur; get it cast in these molds, and it will be done. And if you wish to do them just with plaster, mix ground red lead with it; that is, mix the dry powder with the plaster. And make it as stiff as you think best, to suit yourself.

HOW TO MAKE A MOLD FROM A SEAL OR COIN.[7]

If you wish to cast a seal, or a ducat or other coin, very perfectly, follow this method; and hold it dear, for it is a very perfect thing. Take a little basin half full of clear water, or full, as you please. Take half a porringer of ashes. Throw them into this little basin, and work them over with your hand. Wait a little: before the water clears entirely, empty some of this rather muddy water into another little basin; and do that several times, until you think you have as much of the ashes as you need. Then let it settle until the water is clear and the ashes have all gone to the bottom. Draw off this water, and dry the ashes in the sun, or any way you please. Then wet them up with salt dis-

2 See n. 3, p. 129, above.

3 So R; L has *ciera*. I think erroneously.

4 Literally, "with oil for eating or for burning." See n. 2, p. 77, above.

5 T., CLXX; M., CLXXXVIII.

6 R, *terra*; L, *ciera*.　　　　　7 T., CLXXI; M., CLXXXIX.

solved in water, and make a sort of plaster of them. Then in this plaster cast seals, medals, little figures, coins, and in general anything which you wish to cast. Having done so, let the plaster dry gradually without fire or sun. Then cast lead, silver, or any metal you wish upon this plaster, for this plaster is capable of standing any great weight.

Praying that God All-Highest, Our Lady, Saint John, Saint Luke, the Evangelist and painter, Saint Eustace, Saint Francis, and Saint Anthony of Padua will grant us grace and courage to sustain and bear in peace the burdens and struggles of this world; and as regards the students of this book that They will grant them grace to study well and to retain it well, so that by their labors they may live in peace and keep their families in this world, through grace, and at the end, on high, through glory, *per infinita secula seculorum,* A M E N.[2]

THE BOOK IS FINISHED:
REFERAMUS GRATIA CHRISTI.

[2] The verse which follows in *R* may be rendered in English in some such way as this:

Praise be to God and
to Holy Mary
forever
Virgin.

✠

If you with God's will once your will unite If want constrains you, if you suffer loss,
Your every deepest longing will come right. Seek balm from Christ, by mounting on
the Cross.

After *Referamus gratia Christi,* the scribe of *L* adds the date, 31 July, 1437, and the words "Ex Stincharum, ecc." The transcription of that manuscript, to which alone the date applies, was probably carried out in the Florentine debtors' prison, the "Stinche."

INDEX

A CATALOGUE OF SELECTED DOVER BOOKS
IN ALL FIELDS OF INTEREST

A CATALOGUE OF SELECTED DOVER BOOKS
IN ALL FIELDS OF INTEREST

AMERICA'S OLD MASTERS, James T. Flexner. Four men emerged unexpectedly from provincial 18th century America to leadership in European art: Benjamin West, J. S. Copley, C. R. Peale, Gilbert Stuart. Brilliant coverage of lives and contributions. Revised, 1967 edition. 69 plates. 365pp. of text.

21806-6 Paperbound $3.00

FIRST FLOWERS OF OUR WILDERNESS: AMERICAN PAINTING, THE COLONIAL PERIOD, James T. Flexner. Painters, and regional painting traditions from earliest Colonial times up to the emergence of Copley, West and Peale Sr., Foster, Gustavus Hesselius, Feke, John Smibert and many anonymous painters in the primitive manner. Engaging presentation, with 162 illustrations. xxii + 368pp.

22180-6 Paperbound $3.50

THE LIGHT OF DISTANT SKIES: AMERICAN PAINTING, 1760-1835, James T. Flexner. The great generation of early American painters goes to Europe to learn and to teach: West, Copley, Gilbert Stuart and others. Allston, Trumbull, Morse; also contemporary American painters—primitives, derivatives, academics—who remained in America. 102 illustrations. xiii + 306pp. 22179-2 Paperbound $3.00

A HISTORY OF THE RISE AND PROGRESS OF THE ARTS OF DESIGN IN THE UNITED STATES, William Dunlap. Much the richest mine of information on early American painters, sculptors, architects, engravers, miniaturists, etc. The only source of information for scores of artists, the major primary source for many others. Unabridged reprint of rare original 1834 edition, with new introduction by James T. Flexner, and 394 new illustrations. Edited by Rita Weiss. 6⅝ x 9⅝.

21695-0, 21696-9, 21697-7 Three volumes, Paperbound $13.50

EPOCHS OF CHINESE AND JAPANESE ART, Ernest F. Fenollosa. From primitive Chinese art to the 20th century, thorough history, explanation of every important art period and form, including Japanese woodcuts; main stress on China and Japan, but Tibet, Korea also included. Still unexcelled for its detailed, rich coverage of cultural background, aesthetic elements, diffusion studies, particularly of the historical period. 2nd, 1913 edition. 242 illustrations. lii + 439pp. of text.

20364-6, 20365-4 Two volumes, Paperbound $6.00

THE GENTLE ART OF MAKING ENEMIES, James A. M. Whistler. Greatest wit of his day deflates Oscar Wilde, Ruskin, Swinburne; strikes back at inane critics, exhibitions, art journalism; aesthetics of impressionist revolution in most striking form. Highly readable classic by great painter. Reproduction of edition designed by Whistler. Introduction by Alfred Werner. xxxvi + 334pp.

21875-9 Paperbound $2.50

THE PRINCIPLES OF PSYCHOLOGY, William James. The famous long course, complete and unabridged. Stream of thought, time perception, memory, experimental methods—these are only some of the concerns of a work that was years ahead of its time and still valid, interesting, useful. 94 figures. Total of xviii + 1391pp.
20381-6, 20382-4 Two volumes, Paperbound $8.00

THE STRANGE STORY OF THE QUANTUM, Banesh Hoffmann. Non-mathematical but thorough explanation of work of Planck, Einstein, Bohr, Pauli, de Broglie, Schrödinger, Heisenberg, Dirac, Feynman, etc. No technical background needed. "Of books attempting such an account, this is the best," Henry Margenau, Yale. 40-page "Postscript 1959." xii + 285pp.
20518-5 Paperbound $2.00

THE RISE OF THE NEW PHYSICS, A. d'Abro. Most thorough explanation in print of central core of mathematical physics, both classical and modern; from Newton to Dirac and Heisenberg. Both history and exposition; philosophy of science, causality, explanations of higher mathematics, analytical mechanics, electromagnetism, thermodynamics, phase rule, special and general relativity, matrices. No higher mathematics needed to follow exposition, though treatment is elementary to intermediate in level. Recommended to serious student who wishes verbal understanding. 97 illustrations.
xvii + 982pp.
20003-5, 20004-3 Two volumes, Paperbound $6.00

GREAT IDEAS OF OPERATIONS RESEARCH, Jagjit Singh. Easily followed non-technical explanation of mathematical tools, aims, results: statistics, linear programming, game theory, queueing theory, Monte Carlo simulation, etc. Uses only elementary mathematics. Many case studies, several analyzed in detail. Clarity, breadth make this excellent for specialist in another field who wishes background. 41 figures.
x + 228pp.
21886-4 Paperbound $2.50

GREAT IDEAS OF MODERN MATHEMATICS: THEIR NATURE AND USE, Jagjit Singh. Internationally famous expositor, winner of Unesco's Kalinga Award for science popularization explains verbally such topics as differential equations, matrices, groups, sets, transformations, mathematical logic and other important modern mathematics, as well as use in physics, astrophysics, and similar fields. Superb exposition for layman, scientist in other areas. viii + 312pp.
20587-8 Paperbound $2.50

GREAT IDEAS IN INFORMATION THEORY, LANGUAGE AND CYBERNETICS, Jagjit Singh. The analog and digital computers, how they work, how they are like and unlike the human brain, the men who developed them, their future applications, computer terminology. An essential book for today, even for readers with little math. Some mathematical demonstrations included for more advanced readers. 118 figures. Tables. ix + 338pp.
21694-2 Paperbound $2.50

CHANCE, LUCK AND STATISTICS, Horace C. Levinson. Non-mathematical presentation of fundamentals of probability theory and science of statistics and their applications. Games of chance, betting odds, misuse of statistics, normal and skew distributions, birth rates, stock speculation, insurance. Enlarged edition. Formerly "The Science of Chance." xiii + 357pp.
21007-3 Paperbound $2.50

EAST O' THE SUN AND WEST O' THE MOON, George W. Dasent. Considered the best of all translations of these Norwegian folk tales, this collection has been enjoyed by generations of children (and folklorists too). Includes True and Untrue, Why the Sea is Salt, East O' the Sun and West O' the Moon, Why the Bear is Stumpy-Tailed, Boots and the Troll, The Cock and the Hen, Rich Peter the Pedlar, and 52 more. The only edition with all 59 tales. 77 illustrations by Erik Werenskiold and Theodor Kittelsen. xv + 418pp. 22521-6 Paperbound $3.50

GOOPS AND HOW TO BE THEM, Gelett Burgess. Classic of tongue-in-cheek humor, masquerading as etiquette book. 87 verses, twice as many cartoons, show mischievous Goops as they demonstrate to children virtues of table manners, neatness, courtesy, etc. Favorite for generations. viii + 88pp. 6½ x 9¼.
22233-0 Paperbound $1.25

ALICE'S ADVENTURES UNDER GROUND, Lewis Carroll. The first version, quite different from the final *Alice in Wonderland,* printed out by Carroll himself with his own illustrations. Complete facsimile of the "million dollar" manuscript Carroll gave to Alice Liddell in 1864. Introduction by Martin Gardner. viii + 96pp. Title and dedication pages in color. 21482-6 Paperbound $1.25

THE BROWNIES, THEIR BOOK, Palmer Cox. Small as mice, cunning as foxes, exuberant and full of mischief, the Brownies go to the zoo, toy shop, seashore, circus, etc., in 24 verse adventures and 266 illustrations. Long a favorite, since their first appearance in St. Nicholas Magazine. xi + 144pp. 6⅝ x 9¼.
21265-3 Paperbound $1.75

SONGS OF CHILDHOOD, Walter De La Mare. Published (under the pseudonym Walter Ramal) when De La Mare was only 29, this charming collection has long been a favorite children's book. A facsimile of the first edition in paper, the 47 poems capture the simplicity of the nursery rhyme and the ballad, including such lyrics as I Met Eve, Tartary, The Silver Penny. vii + 106pp. 21972-0 Paperbound $1.25

THE COMPLETE NONSENSE OF EDWARD LEAR, Edward Lear. The finest 19th-century humorist-cartoonist in full: all nonsense limericks, zany alphabets, Owl and Pussycat, songs, nonsense botany, and more than 500 illustrations by Lear himself. Edited by Holbrook Jackson. xxix + 287pp. (USO) 20167-8 Paperbound $2.00

BILLY WHISKERS: THE AUTOBIOGRAPHY OF A GOAT, Frances Trego Montgomery. A favorite of children since the early 20th century, here are the escapades of that rambunctious, irresistible and mischievous goat—Billy Whiskers. Much in the spirit of *Peck's Bad Boy,* this is a book that children never tire of reading or hearing. All the original familiar illustrations by W. H. Fry are included: 6 color plates, 18 black and white drawings. 159pp. 22345-0 Paperbound $2.00

MOTHER GOOSE MELODIES. Faithful republication of the fabulously rare Munroe and Francis "copyright 1833" Boston edition—the most important Mother Goose collection, usually referred to as the "original." Familiar rhymes plus many rare ones, with wonderful old woodcut illustrations. Edited by E. F. Bleiler. 128pp. 4½ x 6⅜. 22577-1 Paperbound $1.25

THE RED FAIRY BOOK, Andrew Lang. Lang's color fairy books have long been children's favorites. This volume includes Rapunzel, Jack and the Bean-stalk and 35 other stories, familiar and unfamiliar. 4 plates, 93 illustrations x + 367pp.
21673-X Paperbound $2.50

THE BLUE FAIRY BOOK, Andrew Lang. Lang's tales come from all countries and all times. Here are 37 tales from Grimm, the Arabian Nights, Greek Mythology, and other fascinating sources. 8 plates, 130 illustrations. xi + 390pp.
21437-0 Paperbound $2.50

HOUSEHOLD STORIES BY THE BROTHERS GRIMM. Classic English-language edition of the well-known tales — Rumpelstiltskin, Snow White, Hansel and Gretel, The Twelve Brothers, Faithful John, Rapunzel, Tom Thumb (52 stories in all). Translated into simple, straightforward English by Lucy Crane. Ornamented with headpieces, vignettes, elaborate decorative initials and a dozen full-page illustrations by Walter Crane. x + 269pp.
21080-4 Paperbound $2.50

THE MERRY ADVENTURES OF ROBIN HOOD, Howard Pyle. The finest modern versions of the traditional ballads and tales about the great English outlaw. Howard Pyle's complete prose version, with every word, every illustration of the first edition. Do not confuse this facsimile of the original (1883) with modern editions that change text or illustrations. 23 plates plus many page decorations. xxii + 296pp.
22043-5 Paperbound $2.50

THE STORY OF KING ARTHUR AND HIS KNIGHTS, Howard Pyle. The finest children's version of the life of King Arthur; brilliantly retold by Pyle, with 48 of his most imaginative illustrations. xviii + 313pp. 6⅛ x 9¼.
21445-1 Paperbound $2.50

THE WONDERFUL WIZARD OF OZ, L. Frank Baum. America's finest children's book in facsimile of first edition with all Denslow illustrations in full color. The edition a child should have. Introduction by Martin Gardner. 23 color plates, scores of drawings. iv + 267pp.
20691-2 Paperbound $2.50

THE MARVELOUS LAND OF OZ, L. Frank Baum. The second Oz book, every bit as imaginative as the Wizard. The hero is a boy named Tip, but the Scarecrow and the Tin Woodman are back, as is the Oz magic. 16 color plates, 120 drawings by John R. Neill. 287pp.
20692-0 Paperbound $2.50

THE MAGICAL MONARCH OF MO, L. Frank Baum. Remarkable adventures in a land even stranger than Oz. The best of Baum's books not in the Oz series. 15 color plates and dozens of drawings by Frank Verbeck. xviii + 237pp.
21892-9 Paperbound $2.25

THE BAD CHILD'S BOOK OF BEASTS, MORE BEASTS FOR WORSE CHILDREN, A MORAL ALPHABET, Hilaire Belloc. Three complete humor classics in one volume. Be kind to the frog, and do not call him names . . . and 28 other whimsical animals. Familiar favorites and some not so well known. Illustrated by Basil Blackwell.
156pp. (USO) 20749-8 Paperbound $1.50

THE PHILOSOPHY OF THE UPANISHADS, Paul Deussen. Clear, detailed statement of upanishadic system of thought, generally considered among best available. History of these works, full exposition of system emergent from them, parallel concepts in the West. Translated by A. S. Geden. xiv + 429pp.

21616-0 Paperbound **$3.50**

LANGUAGE, TRUTH AND LOGIC, Alfred J. Ayer. Famous, remarkably clear introduction to the Vienna and Cambridge schools of Logical Positivism; function of philosophy, elimination of metaphysical thought, nature of analysis, similar topics. "Wish I had written it myself," Bertrand Russell. 2nd, 1946 edition. 160pp.

20010-8 Paperbound **$1.50**

THE GUIDE FOR THE PERPLEXED, Moses Maimonides. Great classic of medieval Judaism, major attempt to reconcile revealed religion (Pentateuch, commentaries) and Aristotelian philosophy. Enormously important in all Western thought. Unabridged Friedländer translation. 50-page introduction. lix + 414pp.

(USO) 20351-4 Paperbound **$3.50**

OCCULT AND SUPERNATURAL PHENOMENA, D. H. Rawcliffe. Full, serious study of the most persistent delusions of mankind: crystal gazing, mediumistic trance, stigmata, lycanthropy, fire walking, dowsing, telepathy, ghosts, ESP, etc., and their relation to common forms of abnormal psychology. Formerly *Illusions and Delusions of the Supernatural and the Occult.* iii + 551pp. 20503-7 Paperbound **$3.50**

THE EGYPTIAN BOOK OF THE DEAD: THE PAPYRUS OF ANI, E. A. Wallis Budge. Full hieroglyphic text, interlinear transliteration of sounds, word for word translation, then smooth, connected translation; Theban recension. Basic work in Ancient Egyptian civilization; now even more significant than ever for historical importance, dilation of consciousness, etc. clvi + 377pp. $6\frac{1}{2}$ x $9\frac{1}{4}$.

21866-X Paperbound **$3.95**

PSYCHOLOGY OF MUSIC, Carl E. Seashore. Basic, thorough survey of everything known about psychology of music up to 1940's; essential reading for psychologists, musicologists. Physical acoustics; auditory apparatus; relationship of physical sound to perceived sound; role of the mind in sorting, altering, suppressing, creating sound sensations; musical learning, testing for ability, absolute pitch, other topics. Records of Caruso, Menuhin analyzed. 88 figures. xix + 408pp.

21851-1 Paperbound **$3.50**

THE I CHING (THE BOOK OF CHANGES), translated by James Legge. Complete translated text plus appendices by Confucius, of perhaps the most penetrating divination book ever compiled. Indispensable to all study of early Oriental civilizations. 3 plates. xxiii + 448pp. 21062-6 Paperbound **$3.00**

THE UPANISHADS, translated by Max Müller. Twelve classical upanishads: Chandogya, Kena, Aitareya, Kaushitaki, Isa, Katha, Mundaka, Taittiriyaka, Brhadaranyaka, Svetasvatara, Prasna, Maitriyana. 160-page introduction, analysis by Prof. Müller. Total of 670pp. 20992-X, 20993-8 Two volumes, Paperbound **$6.50**

ALPHABETS AND ORNAMENTS, Ernst Lehner. Well-known pictorial source for decorative alphabets, script examples, cartouches, frames, decorative title pages, calligraphic initials, borders, similar material. 14th to 19th century, mostly European. Useful in almost any graphic arts designing, varied styles. 750 illustrations. 256pp. 7 x 10. 21905-4 Paperbound $4.00

PAINTING: A CREATIVE APPROACH, Norman Colquhoun. For the beginner simple guide provides an instructive approach to painting: major stumbling blocks for beginner; overcoming them, technical points; paints and pigments; oil painting; watercolor and other media and color. New section on "plastic" paints. Glossary. Formerly *Paint Your Own Pictures.* 221pp. 22000-1 Paperbound $1.75

THE ENJOYMENT AND USE OF COLOR, Walter Sargent. Explanation of the relations between colors themselves and between colors in nature and art, including hundreds of little-known facts about color values, intensities, effects of high and low illumination, complementary colors. Many practical hints for painters, references to great masters. 7 color plates, 29 illustrations. x + 274pp.
20944-X Paperbound $2.75

THE NOTEBOOKS OF LEONARDO DA VINCI, compiled and edited by Jean Paul Richter. 1566 extracts from original manuscripts reveal the full range of Leonardo's versatile genius: all his writings on painting, sculpture, architecture, anatomy, astronomy, geography, topography, physiology, mining, music, etc., in both Italian and English, with 186 plates of manuscript pages and more than 500 additional drawings. Includes studies for the Last Supper, the lost Sforza monument, and other works. Total of xlvii + 866pp. 7⅞ x 10¾.
22572-0, 22573-9 Two volumes, Paperbound $10.00

MONTGOMERY WARD CATALOGUE OF 1895. Tea gowns, yards of flannel and pillow-case lace, stereoscopes, books of gospel hymns, the New Improved Singer Sewing Machine, side saddles, milk skimmers, straight-edged razors, high-button shoes, spittoons, and on and on . . . listing some 25,000 items, practically all illustrated. Essential to the shoppers of the 1890's, it is our truest record of the spirit of the period. Unaltered reprint of Issue No. 57, Spring and Summer 1895. Introduction by Boris Emmet. Innumerable illustrations. xiii + 624pp. 8½ x 11⅝.
22377-9 Paperbound $6.95

THE CRYSTAL PALACE EXHIBITION ILLUSTRATED CATALOGUE (LONDON, 1851). One of the wonders of the modern world—the Crystal Palace Exhibition in which all the nations of the civilized world exhibited their achievements in the arts and sciences—presented in an equally important illustrated catalogue. More than 1700 items pictured with accompanying text—ceramics, textiles, cast-iron work, carpets, pianos, sleds, razors, wall-papers, billiard tables, beehives, silverware and hundreds of other artifacts—represent the focal point of Victorian culture in the Western World. Probably the largest collection of Victorian decorative art ever assembled— indispensable for antiquarians and designers. Unabridged republication of the Art-Journal Catalogue of the Great Exhibition of 1851, with all terminal essays. New introduction by John Gloag, F.S.A. xxxiv + 426pp. 9 x 12.
22503-8 Paperbound $4.50

PLANETS, STARS AND GALAXIES: DESCRIPTIVE ASTRONOMY FOR BEGINNERS, A. E. Fanning. Comprehensive introductory survey of astronomy: the sun, solar system, stars, galaxies, universe, cosmology; up-to-date, including quasars, radio stars, etc. Preface by Prof. Donald Menzel. 24pp. of photographs. 189pp. 5¼ x 8¼.
21680-2 Paperbound $1.75

TEACH YOURSELF CALCULUS, P. Abbott. With a good background in algebra and trig, you can teach yourself calculus with this book. Simple, straightforward introduction to functions of all kinds, integration, differentiation, series, etc. "Students who are beginning to study calculus method will derive great help from this book." Faraday House Journal. 308pp. 20683-1 Clothbound $2.50

TEACH YOURSELF TRIGONOMETRY, P. Abbott. Geometrical foundations, indices and logarithms, ratios, angles, circular measure, etc. are presented in this sound, easy-to-use text. Excellent for the beginner or as a brush up, this text carries the student through the solution of triangles. 204pp. 20682-3 Clothbound $2.50

BASIC MACHINES AND HOW THEY WORK, U. S. Bureau of Naval Personnel. Originally used in U.S. Naval training schools, this book clearly explains the operation of a progression of machines, from the simplest—lever, wheel and axle, inclined plane, wedge, screw—to the most complex—typewriter, internal combustion engine, computer mechanism. Utilizing an approach that requires only an elementary understanding of mathematics, these explanations build logically upon each other and are assisted by over 200 drawings and diagrams. Perfect as a technical school manual or as a self-teaching aid to the layman. 204 figures. Preface. Index. vii + 161pp. 6½ x 9¼. 21709-4 Paperbound $2.50

THE FRIENDLY STARS, Martha Evans Martin. Classic has taught naked-eye observation of stars, planets to hundreds of thousands, still not surpassed for charm, lucidity, adequacy. Completely updated by Professor Donald H. Menzel, Harvard Observatory. 25 illustrations. 16 x 30 chart. x + 147pp. 21099-5 Paperbound $1.50

MUSIC OF THE SPHERES: THE MATERIAL UNIVERSE FROM ATOM TO QUASAR, SIMPLY EXPLAINED, Guy Murchie. Extremely broad, brilliantly written popular account begins with the solar system and reaches to dividing line between matter and nonmatter; latest understandings presented with exceptional clarity. Volume One: Planets, stars, galaxies, cosmology, geology, celestial mechanics, latest astronomical discoveries; Volume Two: Matter, atoms, waves, radiation, relativity, chemical action, heat, nuclear energy, quantum theory, music, light, color, probability, antimatter, antigravity, and similar topics. 319 figures. 1967 (second) edition. Total of xx + 644pp. 21809-0, 21810-4 Two volumes, Paperbound $5.50

OLD-TIME SCHOOLS AND SCHOOL BOOKS, Clifton Johnson. Illustrations and rhymes from early primers, abundant quotations from early textbooks, many anecdotes of school life enliven this study of elementary schools from Puritans to middle 19th century. Introduction by Carl Withers. 234 illustrations. xxxiii + 381pp.
21031-6 Paperbound $3.50

How to Know the Wild Flowers, Mrs. William Starr Dana. This is the classical book of American wildflowers (of the Eastern and Central United States), used by hundreds of thousands. Covers over 500 species, arranged in extremely easy to use color and season groups. Full descriptions, much plant lore. This Dover edition is the fullest ever compiled, with tables of nomenclature changes. 174 full-page plates by M. Satterlee. xii + 418pp. 20332-8 Paperbound $2.75

Our Plant Friends and Foes, William Atherton DuPuy. History, economic importance, essential botanical information and peculiarities of 25 common forms of plant life are provided in this book in an entertaining and charming style. Covers food plants (potatoes, apples, beans, wheat, almonds, bananas, etc.), flowers (lily, tulip, etc.), trees (pine, oak, elm, etc.), weeds, poisonous mushrooms and vines, gourds, citrus fruits, cotton, the cactus family, and much more. 108 illustrations. xiv + 290pp. 22272-1 Paperbound $2.50

How to Know the Ferns, Frances T. Parsons. Classic survey of Eastern and Central ferns, arranged according to clear, simple identification key. Excellent introduction to greatly neglected nature area. 57 illustrations and 42 plates. xvi + 215pp. 20740-4 Paperbound $2.00

Manual of the Trees of North America, Charles S. Sargent. America's foremost dendrologist provides the definitive coverage of North American trees and tree-like shrubs. 717 species fully described and illustrated: exact distribution, down to township; full botanical description; economic importance; description of subspecies and races; habitat, growth data; similar material. Necessary to every serious student of tree-life. Nomenclature revised to present. Over 100 locating keys. 783 illustrations. lii + 934pp. 20277-1, 20278-X Two volumes, Paperbound $6.00

Our Northern Shrubs, Harriet L. Keeler. Fine non-technical reference work identifying more than 225 important shrubs of Eastern and Central United States and Canada. Full text covering botanical description, habitat, plant lore, is paralleled with 205 full-page photographs of flowering or fruiting plants. Nomenclature revised by Edward G. Voss. One of few works concerned with shrubs. 205 plates, 35 drawings. xxviii + 521pp. 21989-5 Paperbound $3.75

The Mushroom Handbook, Louis C. C. Krieger. Still the best popular handbook: full descriptions of 259 species, cross references to another 200. Extremely thorough text enables you to identify, know all about any mushroom you are likely to meet in eastern and central U. S. A.: habitat, luminescence, poisonous qualities, use, folklore, etc. 32 color plates show over 50 mushrooms, also 126 other illustrations. Finding keys. vii + 560pp. 21861-9 Paperbound $3.95

Handbook of Birds of Eastern North America, Frank M. Chapman. Still much the best single-volume guide to the birds of Eastern and Central United States. Very full coverage of 675 species, with descriptions, life habits, distribution, similar data. All descriptions keyed to two-page color chart. With this single volume the average birdwatcher needs no other books. 1931 revised edition. 195 illustrations. xxxvi + 581pp. 21489-3 Paperbound $5.00

THE ARCHITECTURE OF COUNTRY HOUSES, Andrew J. Downing. Together with Vaux's *Villas and Cottages* this is the basic book for Hudson River Gothic architecture of the middle Victorian period. Full, sound discussions of general aspects of housing, architecture, style, decoration, furnishing, together with scores of detailed house plans, illustrations of specific buildings, accompanied by full text. Perhaps the most influential single American architectural book. 1850 edition. Introduction by J. Stewart Johnson. 321 figures, 34 architectural designs. xvi + 560pp.

22003-6 Paperbound $4.00

LOST EXAMPLES OF COLONIAL ARCHITECTURE, John Mead Howells. Full-page photographs of buildings that have disappeared or been so altered as to be denatured, including many designed by major early American architects. 245 plates. xvii + 248pp. 7⅞ x 10¾.

21143-6 Paperbound $3.50

DOMESTIC ARCHITECTURE OF THE AMERICAN COLONIES AND OF THE EARLY REPUBLIC, Fiske Kimball. Foremost architect and restorer of Williamsburg and Monticello covers nearly 200 homes between 1620-1825. Architectural details, construction, style features, special fixtures, floor plans, etc. Generally considered finest work in its area. 219 illustrations of houses, doorways, windows, capital mantels. xx + 314pp. 7⅞ x 10¾.

21743-4 Paperbound $4.00

EARLY AMERICAN ROOMS: 1650-1858, edited by Russell Hawes Kettell. Tour of 12 rooms, each representative of a different era in American history and each furnished, decorated, designed and occupied in the style of the era. 72 plans and elevations, 8-page color section, etc., show fabrics, wall papers, arrangements, etc. Full descriptive text. xvii + 200pp. of text. 8⅜ x 11¼.

21633-0 Paperbound $5.00

THE FITZWILLIAM VIRGINAL BOOK, edited by J. Fuller Maitland and W. B. Squire. Full modern printing of famous early 17th-century ms. volume of 300 works by Morley, Byrd, Bull, Gibbons, etc. For piano or other modern keyboard instrument; easy to read format. xxxvi + 938pp. 8⅜ x 11.

21068-5, 21069-3 Two volumes, Paperbound $10.00

KEYBOARD MUSIC, Johann Sebastian Bach. Bach Gesellschaft edition. A rich selection of Bach's masterpieces for the harpsichord: the six English Suites, six French Suites, the six Partitas (Clavierübung part I), the Goldberg Variations (Clavierübung part IV), the fifteen Two-Part Inventions and the fifteen Three-Part Sinfonias. Clearly reproduced on large sheets with ample margins; eminently playable. vi + 312pp. 8⅛ x 11.

22360-4 Paperbound $5.00

THE MUSIC OF BACH: AN INTRODUCTION, Charles Sanford Terry. A fine, nontechnical introduction to Bach's music, both instrumental and vocal. Covers organ music, chamber music, passion music, other types. Analyzes themes, developments, innovations. x + 114pp.

21075-8 Paperbound $1.25

BEETHOVEN AND HIS NINE SYMPHONIES, Sir George Grove. Noted British musicologist provides best history, analysis, commentary on symphonies. Very thorough, rigorously accurate; necessary to both advanced student and amateur music lover. 436 musical passages. vii + 407 pp.

20334-4 Paperbound $2.75

"ESSENTIAL GRAMMAR" SERIES

All you really need to know about modern, colloquial grammar. Many educational shortcuts help you learn faster, understand better. Detailed cognate lists teach you to recognize similarities between English and foreign words and roots—make learning vocabulary easy and interesting. Excellent for independent study or as a supplement to record courses.

ESSENTIAL FRENCH GRAMMAR, Seymour Resnick. 2500-item cognate list. 159pp.
(EBE) 20419-7 Paperbound $1.25

ESSENTIAL GERMAN GRAMMAR, Guy Stern and Everett F. Bleiler. Unusual shortcuts on noun declension, word order, compound verbs. 124pp.
(EBE) 20422-7 Paperbound $1.25

ESSENTIAL ITALIAN GRAMMAR, Olga Ragusa. 111pp.
(EBE) 20779-X Paperbound $1.25

ESSENTIAL JAPANESE GRAMMAR, Everett F. Bleiler. In Romaji transcription; no characters needed. Japanese grammar is regular and simple. 156pp.
21027-8 Paperbound $1.25

ESSENTIAL PORTUGUESE GRAMMAR, Alexander da R. Prista. vi + 114pp.
21650-0 Paperbound $1.35

ESSENTIAL SPANISH GRAMMAR, Seymour Resnick. 2500 word cognate list. 115pp.
(EBE) 20780-3 Paperbound $1.25

ESSENTIAL ENGLISH GRAMMAR, Philip Gucker. Combines best features of modern, functional and traditional approaches. For refresher, class use, home study. x + 177pp.
21649-7 Paperbound $1.35

A PHRASE AND SENTENCE DICTIONARY OF SPOKEN SPANISH. Prepared for U. S. War Department by U. S. linguists. As above, unit is idiom, phrase or sentence rather than word. English-Spanish and Spanish-English sections contain modern equivalents of over 18,000 sentences. Introduction and appendix as above. iv + 513pp.
20495-2 Paperbound $2.75

A PHRASE AND SENTENCE DICTIONARY OF SPOKEN RUSSIAN. Dictionary prepared for U. S. War Department by U. S. linguists. Basic unit is not the word, but the idiom, phrase or sentence. English-Russian and Russian-English sections contain modern equivalents for over 30,000 phrases. Grammatical introduction covers phonetics, writing, syntax. Appendix of word lists for food, numbers, geographical names, etc. vi + 573 pp. 6⅛ x 9¼.
20496-0 Paperbound $4.00

CONVERSATIONAL CHINESE FOR BEGINNERS, Morris Swadesh. Phonetic system, beginner's course in Pai Hua Mandarin Chinese covering most important, most useful speech patterns. Emphasis on modern colloquial usage. Formerly *Chinese in Your Pocket.* xvi + 158pp.
21123-1 Paperbound $1.75

VISUAL ILLUSIONS: THEIR CAUSES, CHARACTERISTICS, AND APPLICATIONS, Matthew Luckiesh. Thorough description and discussion of optical illusion, geometric and perspective, particularly; size and shape distortions, illusions of color, of motion; natural illusions; use of illusion in art and magic, industry, etc. Most useful today with op art, also for classical art. Scores of effects illustrated. Introduction by William H. Ittleson. 100 illustrations. xxi + 252pp.

21530-X Paperbound $2.00

A HANDBOOK OF ANATOMY FOR ART STUDENTS, Arthur Thomson. Thorough, virtually exhaustive coverage of skeletal structure, musculature, etc. Full text, supplemented by anatomical diagrams and drawings and by photographs of undraped figures. Unique in its comparison of male and female forms, pointing out differences of contour, texture, form. 211 figures, 40 drawings, 86 photographs. xx + 459pp. 5⅜ x 8⅜.

21163-0 Paperbound $3.50

150 MASTERPIECES OF DRAWING, Selected by Anthony Toney. Full page reproductions of drawings from the early 16th to the end of the 18th century, all beautifully reproduced: Rembrandt, Michelangelo, Dürer, Fragonard, Urs, Graf, Wouwerman, many others. First-rate browsing book, model book for artists. xviii + 150pp. 8⅜ x 11¼.

21032-4 Paperbound $2.50

THE LATER WORK OF AUBREY BEARDSLEY, Aubrey Beardsley. Exotic, erotic, ironic masterpieces in full maturity: Comedy Ballet, Venus and Tannhauser, Pierrot, Lysistrata, Rape of the Lock, Savoy material, Ali Baba, Volpone, etc. This material revolutionized the art world, and is still powerful, fresh, brilliant. With *The Early Work*, all Beardsley's finest work. 174 plates, 2 in color. xiv + 176pp. 8⅛ x 11.

21817-1 Paperbound $3.00

DRAWINGS OF REMBRANDT, Rembrandt van Rijn. Complete reproduction of fabulously rare edition by Lippmann and Hofstede de Groot, completely reedited, updated, improved by Prof. Seymour Slive, Fogg Museum. Portraits, Biblical sketches, landscapes, Oriental types, nudes, episodes from classical mythology—All Rembrandt's fertile genius. Also selection of drawings by his pupils and followers. "Stunning volumes," *Saturday Review*. 550 illustrations. lxxviii + 552pp. 9⅛ x 12¼.

21485-0, 21486-9 Two volumes, Paperbound $10.00

THE DISASTERS OF WAR, Francisco Goya. One of the masterpieces of Western civilization—83 etchings that record Goya's shattering, bitter reaction to the Napoleonic war that swept through Spain after the insurrection of 1808 and to war in general. Reprint of the first edition, with three additional plates from Boston's Museum of Fine Arts. All plates facsimile size. Introduction by Philip Hofer, Fogg Museum. v + 97pp. 9⅜ x 8¼.

21872-4 Paperbound $2.00

GRAPHIC WORKS OF ODILON REDON. Largest collection of Redon's graphic works ever assembled: 172 lithographs, 28 etchings and engravings, 9 drawings. These include some of his most famous works. All the plates from *Odilon Redon: oeuvre graphique complet,* plus additional plates. New introduction and caption translations by Alfred Werner. 209 illustrations. xxvii + 209pp. 9⅛ x 12¼.

21966-8 Paperbound $4.00

TWO LITTLE SAVAGES; BEING THE ADVENTURES OF TWO BOYS WHO LIVED AS INDIANS AND WHAT THEY LEARNED, Ernest Thompson Seton. Great classic of nature and boyhood provides a vast range of woodlore in most palatable form, a genuinely entertaining story. Two farm boys build a teepee in woods and live in it for a month, working out Indian solutions to living problems, star lore, birds and animals, plants, etc. 293 illustrations. vii + 286pp.

20985-7 Paperbound $2.50

PETER PIPER'S PRACTICAL PRINCIPLES OF PLAIN & PERFECT PRONUNCIATION. Alliterative jingles and tongue-twisters of surprising charm, that made their first appearance in America about 1830. Republished in full with the spirited woodcut illustrations from this earliest American edition. 32pp. 4½ x 6⅜.

22560-7 Paperbound $1.00

SCIENCE EXPERIMENTS AND AMUSEMENTS FOR CHILDREN, Charles Vivian. 73 easy experiments, requiring only materials found at home or easily available, such as candles, coins, steel wool, etc.; illustrate basic phenomena like vacuum, simple chemical reaction, etc. All safe. Modern, well-planned. Formerly *Science Games for Children*. 102 photos, numerous drawings. 96pp. 6⅛ x 9¼.

21856-2 Paperbound $1.25

AN INTRODUCTION TO CHESS MOVES AND TACTICS SIMPLY EXPLAINED, Leonard Barden. Informal intermediate introduction, quite strong in explaining reasons for moves. Covers basic material, tactics, important openings, traps, positional play in middle game, end game. Attempts to isolate patterns and recurrent configurations. Formerly *Chess*. 58 figures. 102pp. (USO) 21210-6 Paperbound $1.25

LASKER'S MANUAL OF CHESS, Dr. Emanuel Lasker. Lasker was not only one of the five great World Champions, he was also one of the ablest expositors, theorists, and analysts. In many ways, his Manual, permeated with his philosophy of battle, filled with keen insights, is one of the greatest works ever written on chess. Filled with analyzed games by the great players. A single-volume library that will profit almost any chess player, beginner or master. 308 diagrams. xli x 349pp.

20640-8 Paperbound $2.75

THE MASTER BOOK OF MATHEMATICAL RECREATIONS, Fred Schuh. In opinion of many the finest work ever prepared on mathematical puzzles, stunts, recreations; exhaustively thorough explanations of mathematics involved, analysis of effects, citation of puzzles and games. Mathematics involved is elementary. Translated by F. Göbel. 194 figures. xxiv + 430pp. 22134-2 Paperbound $3.00

MATHEMATICS, MAGIC AND MYSTERY, Martin Gardner. Puzzle editor for Scientific American explains mathematics behind various mystifying tricks: card tricks, stage "mind reading," coin and match tricks, counting out games, geometric dissections, etc. Probability sets, theory of numbers clearly explained. Also provides more than 400 tricks, guaranteed to work, that you can do. 135 illustrations. xii + 176pp.

20338-2 Paperbound $1.50

AMERICAN FOOD AND GAME FISHES, David S. Jordan and Barton W. Evermann. Definitive source of information, detailed and accurate enough to enable the sportsman and nature lover to identify conclusively some 1,000 species and sub-species of North American fish, sought for food or sport. Coverage of range, physiology, habits, life history, food value. Best methods of capture, interest to the angler, advice on bait, fly-fishing, etc. 338 drawings and photographs. 1 + 574pp. 6⅝ x 9⅜.

22383-1 Paperbound $4.50

THE FROG BOOK, Mary C. Dickerson. Complete with extensive finding keys, over 300 photographs, and an introduction to the general biology of frogs and toads, this is the classic non-technical study of Northeastern and Central species. 58 species; 290 photographs and 16 color plates. xvii + 253pp.

21973-9 Paperbound $4.00

THE MOTH BOOK: A GUIDE TO THE MOTHS OF NORTH AMERICA, William J. Holland. Classical study, eagerly sought after and used for the past 60 years. Clear identification manual to more than 2,000 different moths, largest manual in existence. General information about moths, capturing, mounting, classifying, etc., followed by species by species descriptions. 263 illustrations plus 48 color plates show almost every species, full size. 1968 edition, preface, nomenclature changes by A. E. Brower. xxiv + 479pp. of text. 6½ x 9¼.

21948-8 Paperbound $5.00

THE SEA-BEACH AT EBB-TIDE, Augusta Foote Arnold. Interested amateur can identify hundreds of marine plants and animals on coasts of North America; marine algae; seaweeds; squids; hermit crabs; horse shoe crabs; shrimps; corals; sea anemones; etc. Species descriptions cover: structure; food; reproductive cycle; size; shape; color; habitat; etc. Over 600 drawings. 85 plates. xii + 490pp.

21949-6 Paperbound $3.50

COMMON BIRD SONGS, Donald J. Borror. 33⅓ 12-inch record presents songs of 60 important birds of the eastern United States. A thorough, serious record which provides several examples for each bird, showing different types of song, individual variations, etc. Inestimable identification aid for birdwatcher. 32-page booklet gives text about birds and songs, with illustration for each bird.

21829-5 Record, book, album. Monaural. $2.75

FADS AND FALLACIES IN THE NAME OF SCIENCE, Martin Gardner. Fair, witty appraisal of cranks and quacks of science: Atlantis, Lemuria, hollow earth, flat earth, Velikovsky, orgone energy, Dianetics, flying saucers, Bridey Murphy, food fads, medical fads, perpetual motion, etc. Formerly "In the Name of Science." x + 363pp.

20394-8 Paperbound $2.00

HOAXES, Curtis D. MacDougall. Exhaustive, unbelievably rich account of great hoaxes: Locke's moon hoax, Shakespearean forgeries, sea serpents, Loch Ness monster, Cardiff giant, John Wilkes Booth's mummy, Disumbrationist school of art, dozens more; also journalism, psychology of hoaxing. 54 illustrations. xi + 338pp.

20465-0 Paperbound $2.75

MATHEMATICAL PUZZLES FOR BEGINNERS AND ENTHUSIASTS, Geoffrey Mott-Smith. 189 puzzles from easy to difficult—involving arithmetic, logic, algebra, properties of digits, probability, etc.—for enjoyment and mental stimulus. Explanation of mathematical principles behind the puzzles. 135 illustrations. viii + 248pp.
20198-8 Paperbound $1.75

PAPER FOLDING FOR BEGINNERS, William D. Murray and Francis J. Rigney. Easiest book on the market, clearest instructions on making interesting, beautiful origami. Sail boats, cups, roosters, frogs that move legs, bonbon boxes, standing birds, etc. 40 projects; more than 275 diagrams and photographs. 94pp.
20713-7 Paperbound $1.00

TRICKS AND GAMES ON THE POOL TABLE, Fred Herrmann. 79 tricks and games—some solitaires, some for two or more players, some competitive games—to entertain you between formal games. Mystifying shots and throws, unusual caroms, tricks involving such props as cork, coins, a hat, etc. Formerly *Fun on the Pool Table*. 77 figures. 95pp.
21814-7 Paperbound $1.00

HAND SHADOWS TO BE THROWN UPON THE WALL: A SERIES OF NOVEL AND AMUSING FIGURES FORMED BY THE HAND, Henry Bursill. Delightful picturebook from great-grandfather's day shows how to make 18 different hand shadows: a bird that flies, duck that quacks, dog that wags his tail, camel, goose, deer, boy, turtle, etc. Only book of its sort. vi + 33pp. 6½ x 9¼. 21779-5 Paperbound $1.00

WHITTLING AND WOODCARVING, E. J. Tangerman. 18th printing of best book on market. "If you can cut a potato you can carve" toys and puzzles, chains, chessmen, caricatures, masks, frames, woodcut blocks, surface patterns, much more. Information on tools, woods, techniques. Also goes into serious wood sculpture from Middle Ages to present, East and West. 464 photos, figures. x + 293pp.
20965-2 Paperbound $2.00

HISTORY OF PHILOSOPHY, Julián Marias. Possibly the clearest, most easily followed, best planned, most useful one-volume history of philosophy on the market; neither skimpy nor overfull. Full details on system of every major philosopher and dozens of less important thinkers from pre-Socratics up to Existentialism and later. Strong on many European figures usually omitted. Has gone through dozens of editions in Europe. 1966 edition, translated by Stanley Appelbaum and Clarence Strowbridge. xviii + 505pp. 21739-6 Paperbound $3.00

YOGA: A SCIENTIFIC EVALUATION, Kovoor T. Behanan. Scientific but non-technical study of physiological results of yoga exercises; done under auspices of Yale U. Relations to Indian thought, to psychoanalysis, etc. 16 photos. xxiii + 270pp.
20505-3 Paperbound $2.50

Prices subject to change without notice.
Available at your book dealer or write for free catalogue to Dept. GI, Dover Publications, Inc., 180 Varick St., N. Y., N. Y. 10014. Dover publishes more than 150 books each year on science, elementary and advanced mathematics, biology, music, art, literary history, social sciences and other areas.